MW00789213

TRANSFORMATIONS

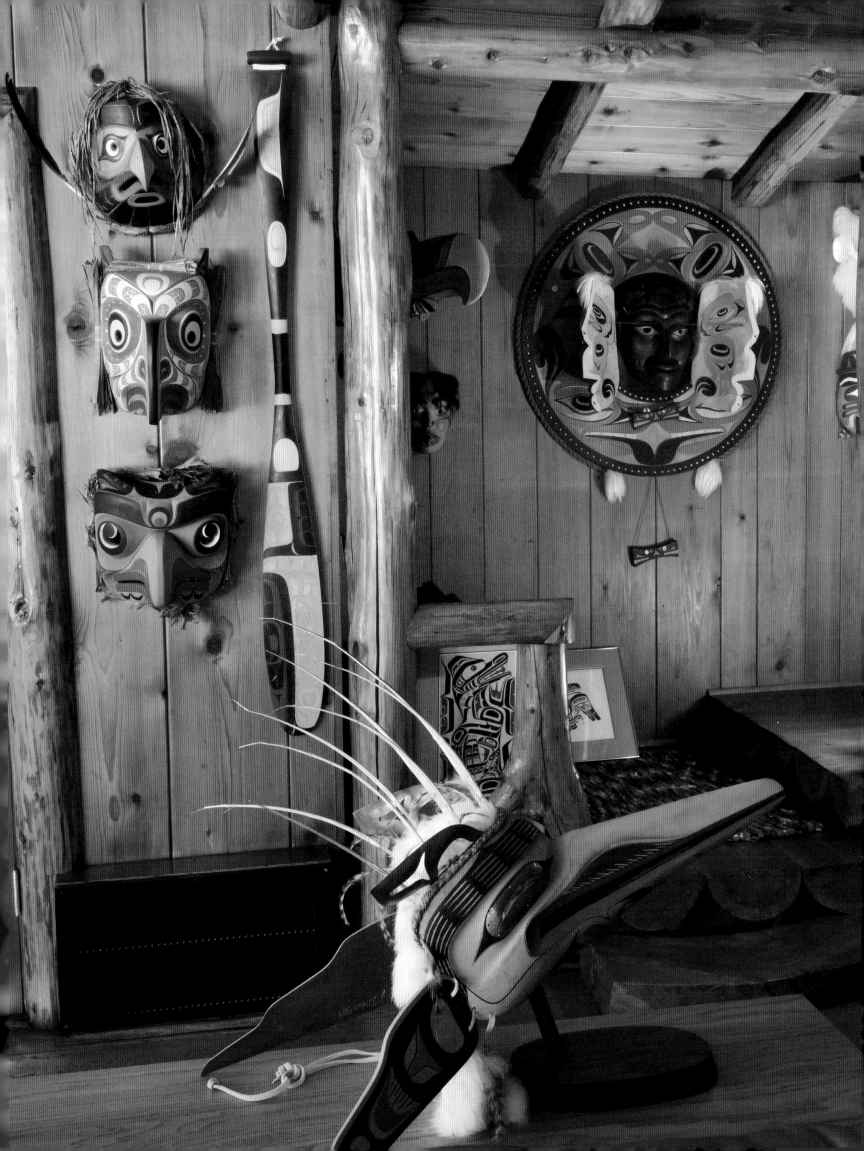

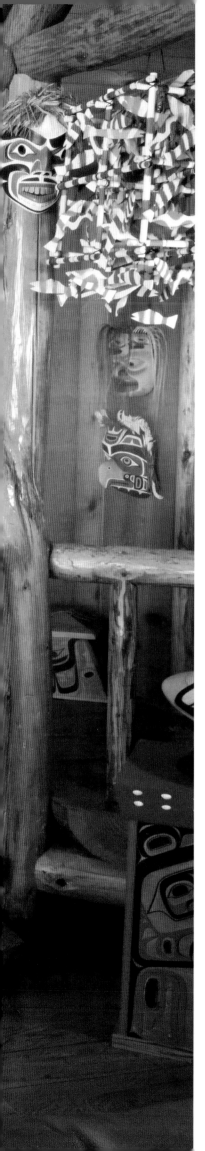

TRANSFORMATIONS

The George and Colleen Hoyt Collection
of Northwest Coast Art

Rebecca J. Dobkins
with Tasia D. Riley

HALLIE FORD MUSEUM OF ART
WILLAMETTE UNIVERSITY
SALEM, OREGON

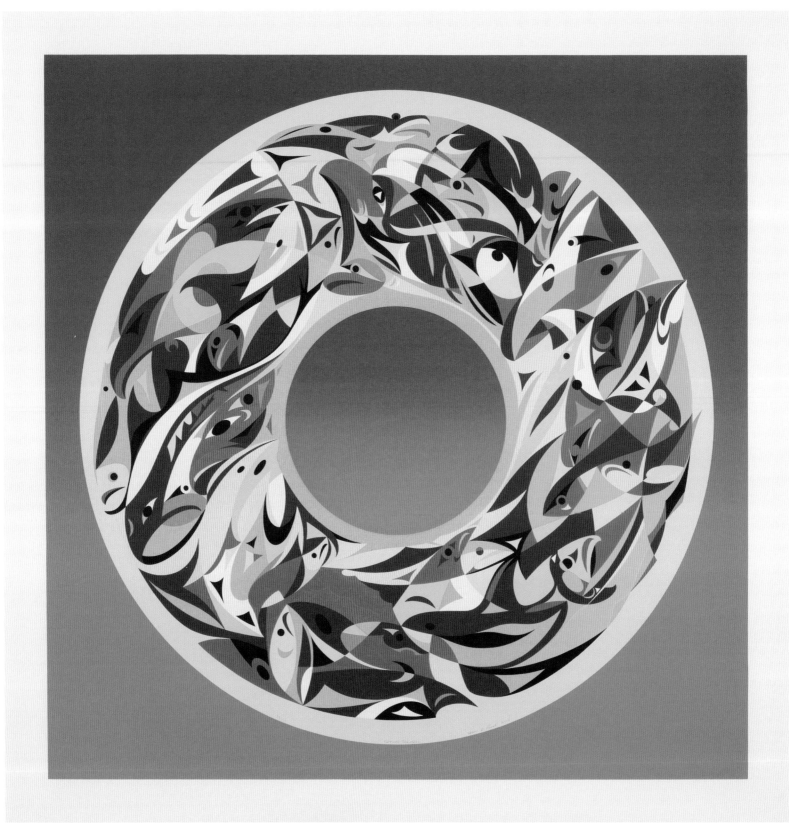

CONTENTS

Preface/Acknowledgments

7

Living with Beauty: The George and Colleen Hoyt Collection
of Northwest Coast Art

11

Works from the Collection

36

Selected Bibliography and Further Reading

205

Index of Artists

211

About the Authors

215

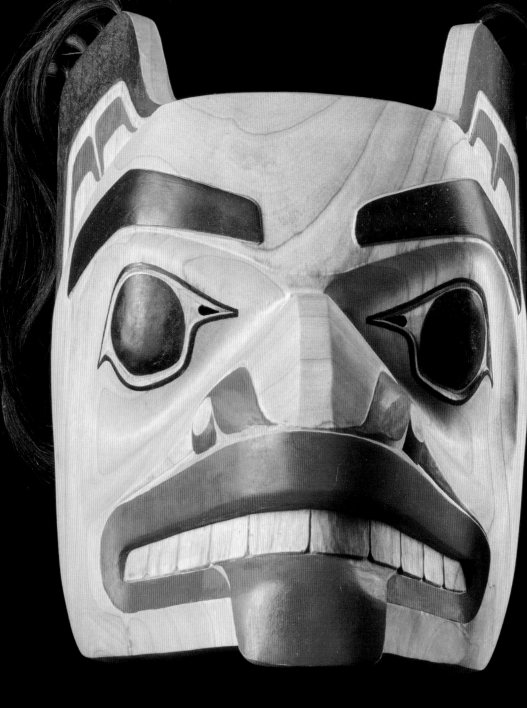

Northwest Coast Native art, as practiced by tribes from the mouth of the Columbia River to British Columbia and Southeast Alaska, is considered one of the great sculptural traditions of the world. Historically, objects ranged from masks and totem poles to bentwood boxes and other types of utilitarian objects and were characterized by the use of formlines and shapes referred to as ovoids, U forms, and S forms. The most common materials used were cedar, stone, and copper, and the most common colors were red and black. The subject matter of these sculptures and other objects included humans and animals that made up the rich, vibrant, and dynamic legacy of Northwest Coast mythology, including myths associated with Raven and Thunderbird.

During the first half of the twentieth century, when Canadian and US government repression was at its height, relatively few Native artists were producing traditional Northwest Coast Native art, but by the late 1940s, a handful of artists and academics such as Mungo Martin, Charles Gladstone, Bill Holm, and Bill Reid spearheaded a resurgence of traditional Northwest Coast art forms and designs. Over the past seventy-five years, the tradition has continued to thrive and prosper as one generation of artists has trained the next in carving and printmaking techniques. On a personal level, I still recall watching Mungo Martin carve a totem pole in Thunderbird Park in Victoria, British Columbia, when my parents took me on a vacation there in 1958.

Over the last thirty-five years, George and Colleen Hoyt have amassed one of the finest private collections of Northwest Coast Native art in the United States. *TRANSFORMATIONS: The George and Colleen Hoyt Collection of Northwest Coast Art* traces the history of contemporary Northwest Coast Native art from the 1950s to the present and features a selection of works by key artists who have played a pivotal role in this powerful story of renewal. Included in the exhibition are works by some of the foremost Northwest Coast Native artists of our region, including Doug Cranmer, Robert Davidson, Beau Dick, and Susan Point, among countless others. The collection is a promised gift from George and Colleen Hoyt to the Hallie Ford Museum of Art.

On behalf of the faculty, staff, and students at Willamette University and myself, I want to express my thanks and appreciation to a number of people without whose help this project would not have been possible. First and foremost, I would like to thank my friend and

colleague Rebecca Dobkins, professor of anthropology at Willamette University and curator of Indigenous art at the Hallie Ford Museum of Art, for her commitment to the collection, exhibition, preservation, and interpretation of Indigenous art over the past twenty-four years; for curating the current exhibition from the Hoyts' collection; and for writing the informative essay that appears in this book.

As always, I would like to thank graphic designer Phil Kovacevich for his beautiful design and layout of the book (our twenty-ninth book together at the Hallie Ford Museum of Art); copy-editor Nick Allison for his skillful editing of Rebecca's text; and photographer Frank Miller for his stunning photographs of the artworks featured in the publication. At Willamette University, I would like to thank President Stephen Thorsett and Provost Carol Long for their ongoing support of the Hallie Ford Museum of Art as an important institutional, artistic, intellectual, and cultural resource.

At the Hallie Ford Museum of Art, I would like to thank my dedicated and hardworking staff for their help with various aspects of the project, especially Collections and Exhibitions Curator Jonathan Bucci and Registrar Sara Swanborn, for their work in getting the Hoyts' extensive collection inventoried, cataloged, photographed, and properly stored in preparation for the exhibition and book, as well as contract preparators Silas Cook and Fred Soelzer for their help with the collection at the Hoyts' home in Sandy, Oregon, and for their beautiful installation of the exhibition at the Hallie Ford Museum of Art in Salem.

Other staff members who assisted with the project included Education Curator Elizabeth Garrison, who worked with Rebecca to develop education programs in conjunction with the exhibition; Membership and Public Relations Manager Andrea Foust, who helped promote and market the exhibition and book; Assistant to the Director Jennifer Stier, who assisted with various aspects of the project; Gallery Receptionists Dana Eckfield and Leslie Whitaker and Security Officer Jason Lazafami, who always create a welcoming and secure environment for visitors and the artwork alike; and Custodian Maria Valdez for keeping the building and galleries spotless throughout.

In addition to my acknowledgments, Rebecca would like to thank current and former students who contributed to the project, including Delaney Kevyn Buchanan, Natalie Ford, Joanna Gold, Maddie Malone, and Tasia Riley. Tasia Riley in particular has made a major contribution to this book by writing the artist biographies and many of the descriptions of individual artworks; we could not have completed the book or exhibition without her keen attention to detail. In addition, Rebecca would like to thank the Sitka Center for Art and Ecology in Otis, Oregon, for a residency in December 2021 that provided time for scholarly research, and her colleagues in the Department of Anthropology at Willamette University, who have been exceptionally supportive of her work as museum curator, even when that work competed with her departmental role.

The Hallie Ford Museum of Art would not have been able to organize the exhibition or publish this book without the support of the George and Colleen Hoyt Northwest Coast Native Art

Fund, and we are most grateful to the Hoyts for their philanthropy and vision. Additional financial support was provided by an endowment gift from the Confederated Tribes of Grand Ronde, through their Spirit Mountain Community Fund; by gifts from several anonymous donors through the HFMA Exhibition Fund; by advertising support from the *Oregonian*/Oregon Live; and by general operating support grants from the City of Salem's Transient Occupancy Tax funds and the Oregon Arts Commission.

Finally, and by no means least, I would like to thank George and Colleen Hoyt for their dedication to building a world-class collection of contemporary Northwest Coast Native art; for their steadfast commitment to quality throughout; for their ongoing support of the Native artists of our region, especially those represented in their collection; for their warmth, passion, enthusiasm, knowledge, and grace; and for their generosity of spirit and eagerness to donate their collection to the Hallie Ford Museum of Art, where it will become an important artistic and educational resource that will be studied and enjoyed by faculty, staff, students, and others for generations to come.

JOHN OLBRANTZ
THE MARIBETH COLLINS DIRECTOR

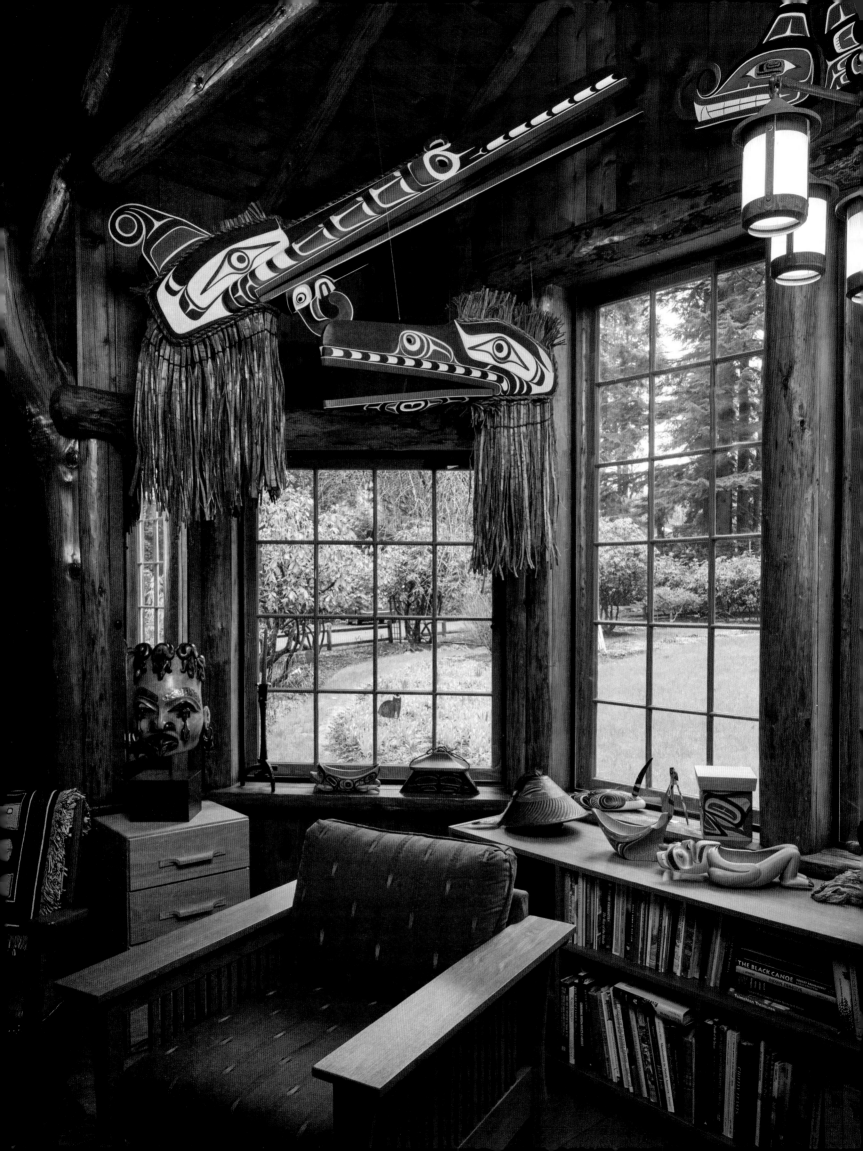

Living With Beauty:
The George and Colleen Hoyt Collection of Northwest Coast Art

Rebecca J. Dobkins

I. AN INTRODUCTION

In the midst of an old-growth forest, just a few miles west of the summit of Mount Hood, lies the Lodge on Cedar Creek, since 1994 the home of George and Colleen Hoyt. The rambling peeled-log structure began life as a fishing cabin in the 1920s, but has grown to over 4,700 square feet, extending out from a two-story "lodge room" anchored by a massive basalt fireplace. Down the hill from the lodge, Cedar Creek makes its way westward to the Sandy River, itself a tributary of the Columbia, the mighty shaper of ecosystems from the Rocky Mountains of British Columbia through the gorge to the Pacific at what is now Astoria, Oregon. In this way, the Hoyts' home is fittingly linked to the vast network of waterways, forests, mountains, and ocean that interconnect the greater Northwest Coast.

George and Colleen chose this house as a place for their retirement, after their lives and careers had taken them around the country, and as a home for what has become an extensive collection of contemporary Northwest Coast masks, carvings, and prints. From inside the house one sees the echoes of the forest, in the organic structure of the home itself as well as in the artwork that finds place within it. The home is a product of, and is inseparable from, the Hoyts' partnership, their art collection, and the broader ecosystem it inhabits. The house and the Hoyts live with the art.

George W. Hoyt IV descends from the Hoyts of Portland, one of the city's first non-Native families. George's great-grandfather, George Washington Hoyt (1828–1892), arrived in Oregon in the early 1850s from upstate New York by way of the California Gold Rush. George W. Hoyt I joined brothers Richard and Henry, both of whom were riverboat captains; the three Hoyt brothers eventually became involved in commerce and the new city's civic life. The Hoyt family name is associated with Hoyt Arboretum in Portland's Washington Park and Hoyt Street in the city's northwest quadrant. George IV's grandfather George W. Hoyt II (1866–1947) was involved in banking until the financial collapse of the Great Depression; he then became clerk for the Multnomah County District Courts. George IV's father, George W. Hoyt III (1907–1968), was

Inside the Hoyt house, 2022. The Hoyts commissioned the Hamat'sa dance masks (top) from Tom Hunt, who completed them in 1997.

a partner in the Packer-Scott Company, an office and paper supply business. Perhaps ironically, given the prominence of his paternal line, it was George's mother who provided the immediate model of a life of community service and charitable giving.[1]

Isabell Murray Hoyt was born in Portland in 1909 and married George Washington Hoyt III in 1933. George IV, born in 1936, was the first of three children. In 1942, while George and his sisters were still very young, his parents divorced; the children remained with their mother. Isabell Hoyt went on to have a career in radio and television marketing and became well known as a writer and public speaker. She was active in charitable organizations, especially the Sunshine Division of the Portland Police Bureau, founded in the 1920s to supply food and clothing to those in need, particularly at Christmastime. Having lived through the Depression, she valued this kind of service. George remembers helping to raise money with his sisters Lorcy Ann and Martha for the Sunshine Division while still in high school, and in retirement has served on its board of directors. Today, son Bryan Hoyt continues the family's tradition of service to the organization.

At Willamette University, George majored in economics, graduating in 1958. After basic military training in California, George went on to serve in the Oregon National Guard through 1962. Following in his mother's footsteps, he went into media, first selling advertising for the *Tigard (OR) Times*. In these early years of his business career, he also married Joanna McGilvra and had two sons, Brian and Mark. After earning an MBA from the University of Oregon in 1963, George became general manager for the Times Publications; by 1970, he and the family moved to Chicago, where he became president of Pioneer Press, a group of seventeen suburban Chicago newspapers then owned by Time Inc. After Chicago, George became publisher of the *Washington Star* in DC from 1978 to 1981, and then moved to New York City to work for Time Inc., where he was responsible for the production of several monthly magazines, including *Life* and *Fortune*. The last decade of his career was spent in California as president of Lesher Communications in Contra Costa County (1985–91) and then of the San Gabriel Valley Publishing Company in Los Angeles (1991–94).

Raised in West Virginia, Colleen Mullin Hoyt (b. 1940) began her career at the *Washington Star* newspaper, where she worked for twenty-two years, the last four as director of promotion and public relations. After leaving the *Star*, she worked as vice president for accounts at a Washington advertising agency, where she oversaw the PBS account, among others. George and Colleen first met at the *Washington Star*, but it was not until later that they reconnected, getting married in 1982. When George took the Time Inc. job in New York City in the early 1980s, Colleen began volunteering at the Brooklyn YWCA, where she stepped in as executive director at a very challenging time for the organization, turning down a salary and donating her time. She brought her business and marketing acumen to this nonprofit community center and left it in significantly better operating condition than she found it. She again applied these skills to nonprofit work when they moved to California and she became a board member and co-manager of the Valley Art Gallery in Walnut Creek, a well-regarded, all-volunteer art gallery and artist co-op of two hundred San Francisco Bay Area artists.

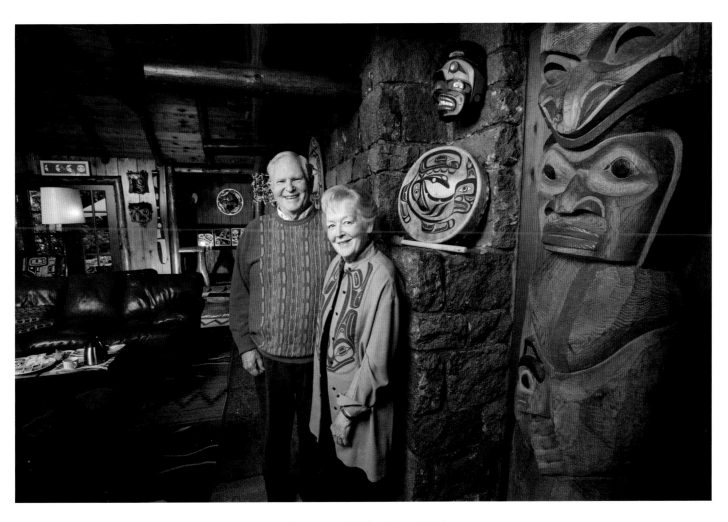

George and Colleen Hoyt, 2015

When George and Colleen retired to Sandy in 1994, both found nonprofit organizations to which to devote their talents and experience. Colleen is a member of the Friends of Sandy Library and has been centrally involved in supporting the Friends bookstore, which she has managed for nearly two decades, volunteering weekly. George, too, has devoted himself to the Sandy Library and was instrumental in the 2008 voter-supported creation of a service district providing dedicated property-tax revenue to support libraries in Clackamas County (which includes Sandy). In addition, he has served on the Sandy River Basin Watershed Council and with the Sandy Main Street Project, a downtown revitalization initiative. In 2008, he was named Citizen of the Year by the Sandy Chamber of Commerce.

From 1989 onward, George served on Willamette University's board of trustees and in that capacity became particularly involved in supporting the university's Atkinson Graduate School of Management. In addition, he and Colleen have been benefactors of Willamette's Hallie Ford Museum of Art since its founding in 1998 and, among other gifts, have endowed a fund to support the acquisition of contemporary Native American weaving arts.

The other constant in their lives since retiring to the Lodge on Cedar Creek has been their careful study and collecting of contemporary Northwest Coast art.[2] George traces his introduction

to the distinctive power of this art to a visit to the Ariel, Washington, cultural center operated by Don "Lelooska" Smith and family, where he took his then-elementary-school-age sons around 1970. Smith (1933-1996), an Oregon-raised self-taught artist who claimed Cherokee heritage, had been adopted by a prominent Kwakwaka'wakw family, the Sewids of Alert Bay, British Columbia. Though not of Northwest Coast tribal heritage, Smith was considered a significant enough carver in the 1960s to be included in the historically important *Arts of the Raven* exhibition at the Vancouver Art Gallery in 1969. The Lelooska Foundation and Cultural Center, as it came to be called, was host to hundreds of thousands of schoolchildren and families over the decades, offering Smith's interpretations of Northwest Coast storytelling and dance performances.[3]

Reflecting recently, George has described how he is drawn to the aesthetic effects of Northwest Coast formline design. He has said that the art, with its flowing lines and careful composition, "makes you feel comfortable," and both George and Colleen speak of being "captured" by the complexity, variation, and sheer talent involved in the creation of the work. When they were living in California in the late 1980s and early '90s, they made trips to Vancouver, BC, including when the city hosted Expo 86, where contemporary Northwest Coast art was prominently featured. During the same period, on visits to the Portland area, they started frequenting the city's Quintana Gallery, founded in 1972 and long a primary source of contemporary Native American art.[4] It was here they first met David A. Boxley, from whom they purchased *Legend Adaox* (1988) in 1989, their first significant piece, one that has hung over the fireplace of each of their homes since that time.

In 1990, when still living in Walnut Creek, Colleen and George attended the launch of a canoe carved by Haida sculptor Reg Davidson, as part of the Haida Project, a series of events hosted at the Headlands Center for the Arts in Marin County.[5] This dramatic event further sparked their interest, and during this period the Hoyts returned to Vancouver and began regularly visiting galleries selling contemporary Northwest Coast art in what Colleen laughingly refers to as the gallery "trapline." At around this same time, they went on a cruise of the Northwest Coast's Inside Passage, stopping at the World Heritage Site at Glacier Bay, Alaska, among other places. They were both very moved by the majesty of the landscape and its interrelationship with the art.

As George and Colleen recall, they quickly became students of Northwest Coast arts, learning especially from gallery owners, particularly Nigel Reading, one of the co-founders of Spirit Wrestler Gallery in Vancouver.[6] Reading enthusiastically shared his knowledge of the artists, the relationships among them, how they learned and from whom, the evolution of Northwest Coast art forms, and the stories and meanings attached to masks. Gary Wyatt, also of Spirit Wrestler Gallery and a scholar of Northwest Coast art, speaks of the Hoyts as never abandoning their stance as students.[7] Wyatt recalls that when he first met the Hoyts they presented themselves as brand-new students, admiring of the work, and even as they became very knowledgeable over the years, they "managed to keep that ... youthful perspective" of being a "student forever."[8]. One reflection of their commitment to learning is the library they have amassed of over five hundred titles dealing with the Northwest Coast and its arts.

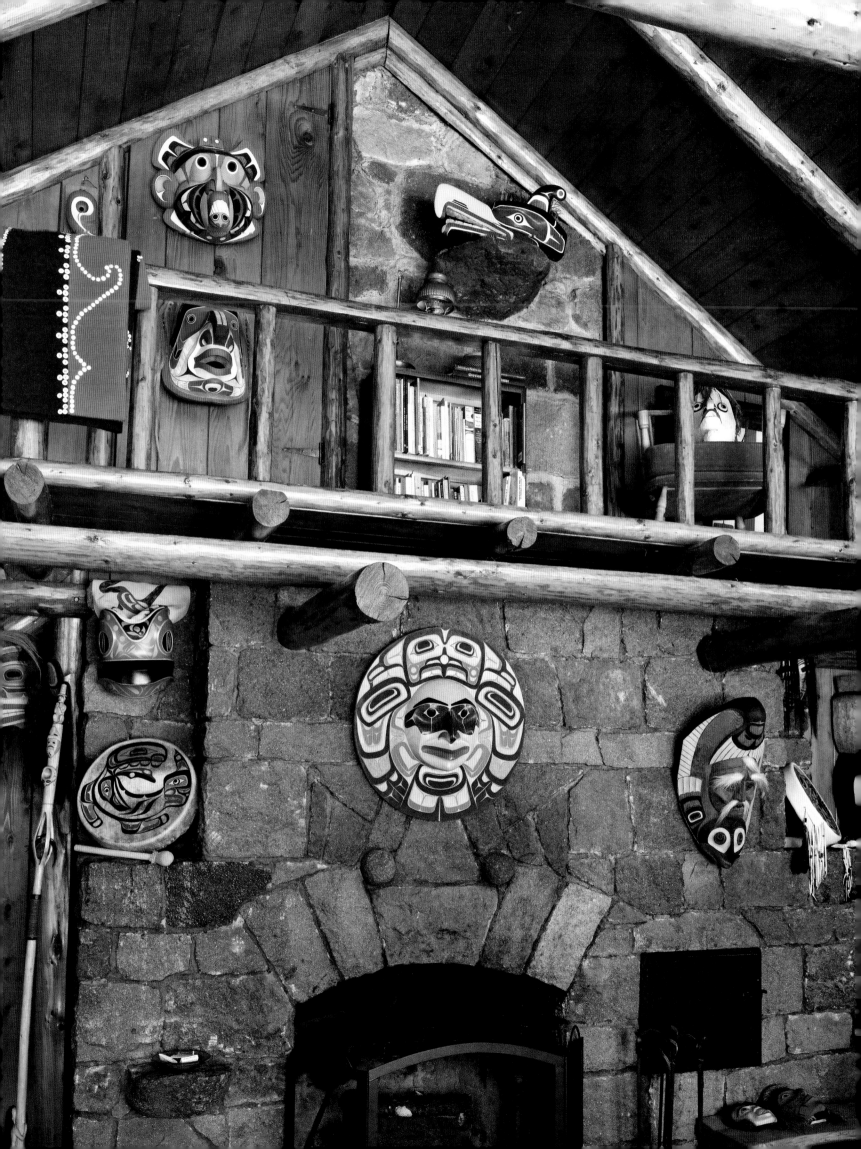

Eventually, an organizing principle for their collecting emerged. Along the way, they became acquainted with a book entitled *The Legacy: Tradition and Innovation in Northwest Coast Indian Art*, published in association with an ambitious exhibition project that spanned the 1970s and early 1980s, organized by the Royal British Columbia Museum.[9] This project, described in greater detail below, identified about forty artists from British Columbia working in the Northwest Coast style in the twentieth century; the museum had commissioned work from many of them for the exhibition, which toured across Canada and to the UK. The list of *Legacy* artists became a benchmark for collecting, a group vetted and evaluated by the curators for the degree to which they reflected the conventions of the artistic heritage of their respective Northwest Coast nations and for their relationships to one another and to elders such as Mungo Martin (Kwakwaka'wakw, 1881–1962), who mentored many in the rising generation. With this focus, and with the clear aim of building a collection to gift to the Hallie Ford Museum of Art, George began setting targets for each *Legacy* artist, acquiring a certain number of prints and masks for each one, over the span of their careers. Colleen spoke of the teamwork between them in choosing work for the collection as it grew, "looking for a different . . . aspect to make [each work] unique in its own right."[10]

Although throughout their decades of collecting, the Hoyts have considered the *Legacy* artists the touchstones by which to develop their collection, they have not rigidly limited themselves to this group. For example, the *Legacy* list did not include Northwest Coast artists outside British Columbia, such as Tlingit and Tsimshian artists from southeast Alaska or Coast Salish artists from the Puget Sound area. Even Coast Salish artists from British Columbia were minimally represented in the project.[11] To address these gaps, the Hoyts expanded their collecting mandate to include significant artists from these omitted groups and today the collection numbers nearly 600 works of art by over one hundred artists. It is to the background of this collection this essay now turns.

Within and around the Lodge on Cedar Creek, the forest reverberates: the house's hand-chosen features, with still-vibrant twists and curves of the once-living trees framing openings and edges, stir the dweller to imagine the transformations—by nature in concert with human hand—required for the making of the house. It is a marvelous vessel for contemporary Northwest Coast art, an art that at its core is about the dynamics of transformation—between life stages, between human and animal realms, between the intangible spiritual world and that of the material.

II. THE NORTHWEST COAST

The Northwest Coast is a vast and diverse region extending from the Gulf of Alaska all the way along the North Pacific coast to the Klamath River in what is currently known as California. The moniker "Northwest" refers to the region's position hugging the northwest edge of the North American continent. As archaeologists Kenneth Ames and Herbert Maschner have written, "land and sea are roped together by the great rivers" of the coast, rivers that for millennia have hosted great runs of salmon coming back to their birthplaces from the ocean's expanse, feeding

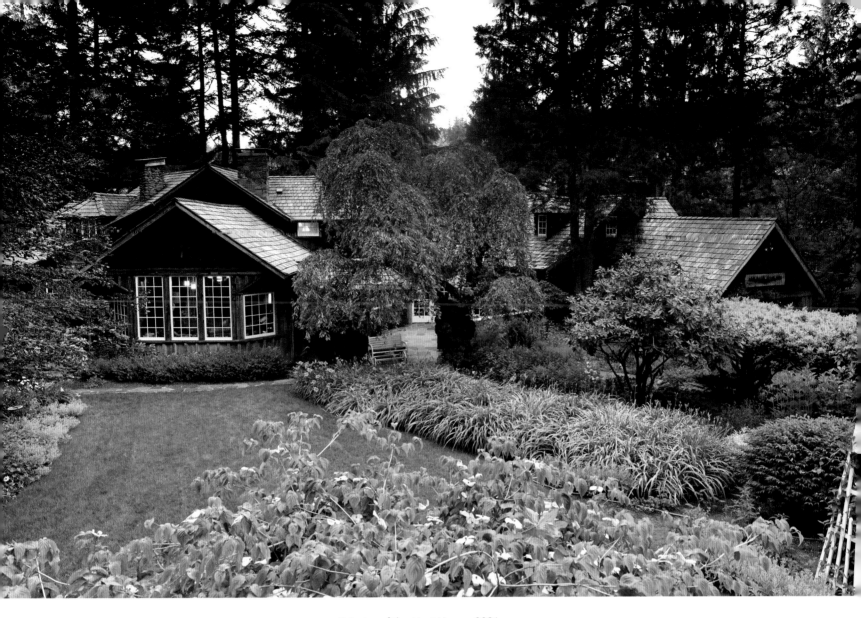

Exterior of the Hoyt House, 2021.

the people, the creatures, and the land in the process.[12] The temperate climate, known for its lush rain forests, plant resources, and abundant marine life and game, has been home to innumerable Indigenous communities since time immemorial. The Northwest Coast is characterized by great linguistic diversity and cultural variation, bridged by similar subsistence systems based on complex stewarding of food resources and extensive trade networks. The Indigenous cultures of the region all place strong emphasis upon genealogy, kinship, and inherited rank, and many Northwest nations have complex clan systems with associated social and ritual responsibilities.

The Northwest Coast is not a monolith; it is considered to have three subareas, the northern, central, and southern coasts, each containing significant cultural and linguistic variation.[13] Artistic practices also vary across the region; cultures of the northern coast (the Tlingit, Haida and Tsimshian) are associated with classic formline design, while those of the central coast (speakers of the Wakashan language family as well as the Salish-speaking Nuxalk) have elements of formline design but adhere less strictly to the conventions that govern the north.[14] The southern coast area includes the Coast Salish as well as the Chinookan-speaking peoples of the Lower Columbia and the many linguistic groups south of the Columbia and west of the Cascades extending to northern California; these groups have their own aesthetic systems that

are distinct from yet clearly related to those of their northern neighbors.[15] For many reasons, these southern arts are lesser known by the non-Native public, yet persist through the efforts of new generations of artists.[16] This important topic will be revisited in the Coda below.

Even those unfamiliar with the complexities of Northwest Coast cultures have likely heard of the potlatch. Potlatches, occasions for feasting, dancing, and abundant gift-giving, are more than just periodic events; potlatching has to be understood as a legal and economic system essential to Northwest Coast social life and its perpetuation and renewal. Potlatches are ways that hosts and attendees express their social positions by fulfilling responsibilities and exercising privileges of rank and clan. They are held for many reasons, including the dedication of a house, a memorial for a loved one, the naming of a child, or to celebrate a marriage. Guests not only receive an abundance of gifts but incur the responsibility of witnessing and remembering the events that transpire and their significance.[17]

Regalia worn and art displayed during potlatches and other gatherings are integral to those events and to the very being of Northwest Coast people themselves. Kwakwa̱ka̱'wakw scholar Daisy Sewid-Smith writes powerfully about the significance of her people's carvings and representations: "They are alive: they teach, they reveal knowledge of the past. The symbols and carvings cause a spasmodic action in the brain, and torrents of stories and meanings flow to the surface of our remembrance. They explain our existence in the universe. They reveal who we are, where we originated, who our ancestors were, and whom and what they encountered."[18]

Artists, thus, play an exceptionally critical role in Northwest Coast life, past, present, and future. Evidence of the region's complex carved, painted, and woven arts go back thousands of years. These arts have drawn the attention and judgment of explorers, colonizers, and missionaries, who became enmeshed in the trade and removal of art from their first arrival in the 1700s.[19] The potlatch—where so much of the art was worn, performed, and displayed—came to be seen as destructive excess and was banned by the Canadian government in 1885, a ban not lifted until 1951. While Northwest Coast communities continued to hold potlatches, often in secret, there is no doubt that the ban suppressed the practice and intergenerational transfer of artistic expression. From the 1950s onward, Northwest Coast artists rebounded from these decades of submersion and, drawing on the knowledge of elder mentors, sparked an ever-deepening and -broadening expansion of Northwest Coast artistic expression.

Central to the practice and appreciation of Northwest Coast art is an understanding of its visual vocabulary. Undoubtedly there were Indigenous ways of communicating about the conventions of this art, as contemporary Haida artist Gwaai Edenshaw (b. 1977) reminds us. Edenshaw, with his brother and fellow artist Jaalen (b. 1980), have been working to research their Indigenous language to develop Haida ways to speak about the design elements of their art. They've relied especially on a grammatical element of Haida language called Shape Classifiers to do so; Shape Classifiers modify Haida words "according to the shape they bear."[20] An example is the Haida term *kunjuu* that is used instead of the English "U form." Gwaai Edenshaw explains that the

Shape Classifier *kun* can "describe a whale's fin, a bump in the road, a point of land, or the nose on your face." He makes the point that *kun* can describe "any object that comes off another body," and so reflects an "intrinsic property" of this element of Haida design, known in English as the U form.[21] The Edenshaws' efforts, and those of other artists surely to come, will be inspiring to follow.

For the time being, however, the predominant way Northern Northwest Coast–style art continues to be described is through the English-language nomenclature developed by art historian and artist Bill Holm in his seminal 1965 book, *Northwest Coast Indian Art: An Analysis of Form.*[22] Holm first coined the term *formline*, referring to the flowing black and red lines that form the primary and secondary basis of most designs. Formlines are accompanied by other design elements referred to as *ovoids* (rounded rectangles often appearing as eyes, eye sockets, and joints), U forms (serving as feathers, fins, ears, or decorative elements), and S and T shapes (referred to as *trigons*) that further delineate space. Thus, not only is Northwest Coast design written about *in* English, but the names given to some of its elements (e.g., U, S, and T) are themselves symbols used in the Roman alphabet, the standard script of the English language.

Bill Holm's unquestionably brilliant analysis has been highly influential, serving as an invaluable technical handbook, or as Gwaii Edenshaw writes, "a tool that artists in our field have employed as the principal language that we have used to expand our understanding of the art."[23] Holm's work spawned countless formal analyses by scholars and provided a means to identify the hands of individual artists to provide attribution to unsigned historic work. Holm's terminology has been applied to Northwest Coast art styles generally, even though he stressed that his analysis was based primarily upon northern style (Tlingit, Haida, and Tsimshian); in actuality, the conventions of representation and composition vary significantly from north to south. Holm's book has had a perhaps unintended consequence of creating standards of "authenticity," experienced by some contemporary artists as confining. Yet art historian Kathryn Bunn-Marcuse, in reflecting on the place of formal analysis in the field, argues that considerations of form accompanied by social, historical, and even familial contexts remain an important dimension of Northwest Coast art studies, significant both for scholars and for the communities from which the art arises.[24] Bunn-Marcuse reminds us that Holm himself called for more consideration of the performance contexts in which Northwest Coast art is used, to more deeply appreciate and understand the connections between the visual forms of the art and the kinesthetic movement of dance.[25]

For an Indigenous artist-practitioner, Northwest Coast art is a process of lifelong inquiry, involving questions of how to use space and material, how to interpret inherited conventions, and how to employ one's work for community well-being. Those of us who are viewers become witnesses to this inquiry and, in the process, are invited to develop growing appreciation of the art's visual language, historical contexts, and conceptual challenges.

The Hoyts have centered their collecting around the group of about forty artists who were included in *The Legacy: Tradition and Innovation in Northwest Coast Indian Art* book and exhibition project organized by the Royal British Columbia Museum in Victoria. What was the *Legacy* project and how and why did it come to be? To answer, we need to turn to the historical context of the repression, renewal, and eventual rebirth—or upsurgence, a term I'm using for reasons that will be clear below—of Northwest Coast arts in twentieth-century Canada and the US.

In Canada, as noted above, the potlatch was banned from 1885 to 1951, a measure explicitly intended to eliminate Indigenous cultural, economic, and legal systems, as the potlatch had long been inseparable from the self-governance of Northwest societies.[26] Despite the potlatch ban, many communities never stopped ceremonial gatherings, and on Christmas Day 1921, Kwakwaka'wakw chief Dan Cranmer hosted a particularly large potlatch on Village Island, British Columbia, at which significant amounts of household goods were given away.[27] The local government Indian agent, William Halliday, was informed of the event, and attendees were coerced into either giving up their regalia or going to jail. The confiscated masks and other regalia became known as the "Potlatch Collection"; some were sold by agent Halliday to American collector George Heye (founder of the collection that has since become the Smithsonian's National Museum of the American Indian) and others were taken by museums across Canada. In the late twentieth century, after decades of advocacy, Kwakwaka'wakw citizens, including Dan Cranmer's daughter Gloria Cranmer Webster, were successful in getting much of the Potlatch Collection repatriated, after first founding two tribal museums and cultural centers, the Nuyumbalees Cultural Centre and the U'Mista Cultural Centre, to receive them.[28]

It took fully until the mid-twentieth century (1951) to lift the ban on the potlatch. Yet it took even longer to end Canada's residential school system, which had been removing First Nations and Inuit children from their homes since the 1800s in order to assimilate them into mainstream society. As in the US and other settler-colonial nations originally part of the British empire, in the nineteenth century Canada utilized a residential school system as part of its official strategy to control Indigenous peoples and disrupt their ability to maintain and strengthen their families, lifeways, religions, and languages. In Canada, the residential schools, which were established by the federal government and administered by churches, were characterized by emotional, physical, and sexual abuse, patterns that came to light in school survivors' testimony beginning in the 1980s and that led to the Indian School Settlement Agreement in 2006 and the subsequent Truth and Reconciliation Commission, which gathered more testimony.[29] Many of the artists who ultimately became part of the *Legacy* project (and thus of the Hoyt Collection) directly experienced the residential school system; all endured its impacts.

Despite all this and more, Northwest Coast artists continued to work throughout the twentieth century.[30] One of the artists who played a very significant role in the persistence of artistic customs was Mungo Martin (Kwakwaka'wakw, 1881–1962) of Fort Rupert, BC, who had learned

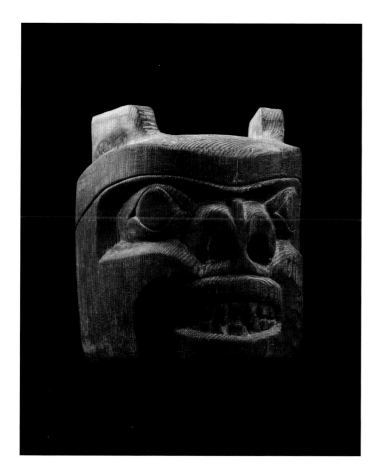 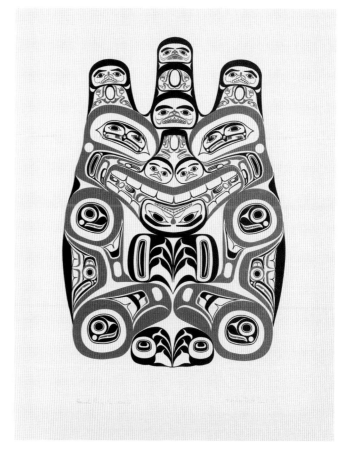

Mungo Martin (Kwakwa̱ka̱'wakw, 1881–1962), *Bear Mask*, 1950s, Alder; 6 ½ x 6 ½ x 5 in.
Collection of George and Colleen Hoyt 315

Bill Reid (Haida, 1920-1998), *Haida Grizzly Bear Huaji*, 1973. Silkscreen; 23 x 17 in. Ed. 260/600.
Collection of George and Colleen Hoyt 154

carving from his stepfather Charlie James (Kwakwa̱ka̱'wakw, 1870–1938). In the late 1940s, Martin played a pivotal role by working to restore poles then held at the University of British Columbia Museum of Anthropology, work for which he had been recommended by his niece, Ellen Neel, herself a carver and one of the first Northwest Coast artists to start experimenting with printmaking. Then, beginning in 1952 and continuing for a decade, Martin was hired by the Royal British Columbia Museum in Victoria, where he not only carved poles and masks and built a ceremonial house but also shared his knowledge with younger carvers who worked along-side him. These artists included Henry Hunt (Kwakwa̱ka̱'wakw, 1923–1985); Hunt's son Tony (b. 1942), still a young boy in the 1950s; Doug Cranmer (Kwakwa̱ka̱'wakw, 1927–2006); and Bill Reid (Haida, 1920–1998), one of the most significant twentieth-century Canadian artists of any background.[31] Martin's efforts—working with and for museums on restoration and replication projects with teams of fellow carver-apprentices—laid a foundation that many others then built upon to extend and recharge the knowledge of carving. Reid and Cranmer, for example, carved poles and built two Haida-style houses for the Museum of Anthropology at the University of British Columbia in 1959–61.[32] In the late 1960s, Reid in turn mentored a young Robert Davidson (Haida, b. 1946), who has become one of the most well-regarded and innovative of Northwest Coast artists. Each of these artists is represented in the Hoyt Collection.

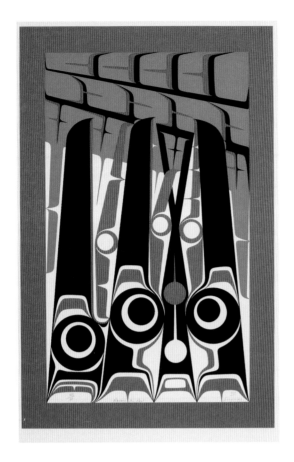
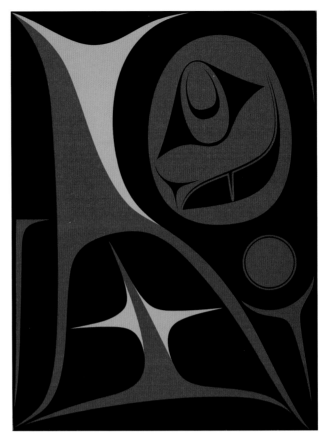

Doug Cranmer (Kwakwa̱ka̱'wakw, 1927-2006), *Ravens in Nest*, 2005, Silkscreen; 30 x 20½ in., Ed. 46/80
Collection of George and Colleen Hoyt 47

Robert Davidson (Haida, b. 1946), *U and I*, 2013. Silkscreen; 40 × 30 in., Ed. 40/67
Collection of George and Colleen Hoyt 261

(opposite page) **Freda Diesing** (Haida, 1925-2002), *Male Portrait Mask*, 1990, Alder, paint, human hair; 7 x 10 x 4 in.,
Collection of George and Colleen Hoyt 123

Simultaneous with and integral to these developments in the 1960s and '70s were the broader social movements for Indigenous rights, the renewed commitments of Northwest Coast peoples to their own cultural activities and autonomy, and the assertion of land rights by British Columbia First Nations, who had never ceded their ancestral lands. As art historian Aldona Jonaitis has written, the arrival of Bill Holm's *Analysis of Form* in 1965, which undoubtedly contributed to the acceleration of Northwest Coast art production, did not occur in a vacuum.[33] Artists had long participated in apprentice systems, learning from and with one another. They added to this experiential learning the study of texts (such as Holm's and other scholarly publications) as well as of artworks in museum collections. The renewal of ceremonies and gatherings required the production of regalia, masks, and gifts; later, in the 1980s, when the Canoe Journey movement began gaining what has become a massive following across the Northwest Coast, canoe building had to be relearned as well.[34]

One important center of teaching and learning was the K'san Centre in Hazelton, BC, which opened in 1970, and which housed the Kitanmax School of Northwest Coast Indian Art.

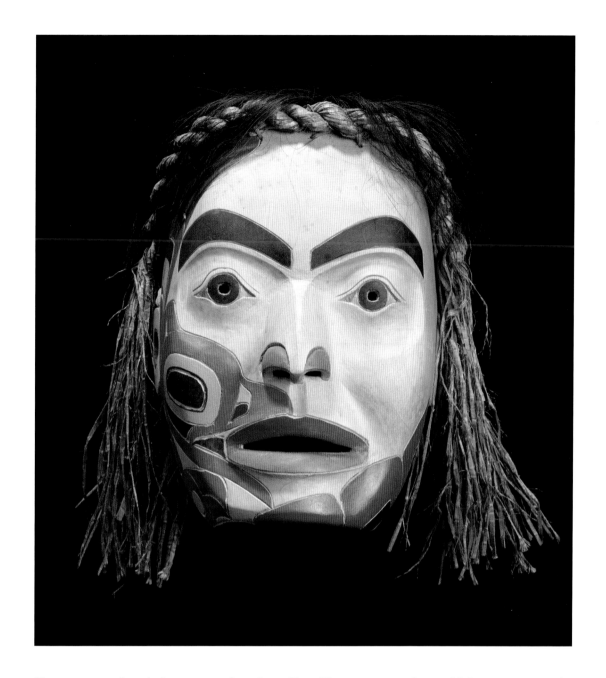

Kitanmax was founded to train and graduate First Nations artists who could then go on to make a living in the arts. In addition to non-Native artists Bill Holm and Duane Pasco, Indigenous artists Doug Cranmer and Robert Davidson taught there. Initial students included Freda Diesing (Haida, 1925–2002), Walter Harris (Gitxsan, 1931–2009), and Earl Muldoe (Gitxsan, 1936–1922), all of whom went on to teach at Kitanmax. Other Northwest Coast artists associated with K'san, as teachers or students or both, include Dempsey Bob (Tahltan/Tlingit, b. 1948), Robert Jackson (Gitxsan, b. 1948), Gerry Marks (Haida, 1949–2020), Vernon Stephens (Gitxsan, b. 1948), and Norman Tait (Nisg̱a'a, 1941–2016), all of whom were included in the *Legacy* project and are part of the Hoyt Collection.

Meanwhile, four Nuu-chah-nulth artists from Vancouver Island's West Coast—Joe David, Ḳi-ḳe-in (a.k.a. Ron Hamilton), Art Thompson, and Tim Paul—had become active carvers by the late 1960s and early '70s, learning in dialogue with one another as well as alongside other Northwest Coast artists, especially those who congregated around Arts of the Raven Gallery in Victoria. Arts of the Raven was owned and run by brothers Tony and Richard Hunt, alongside

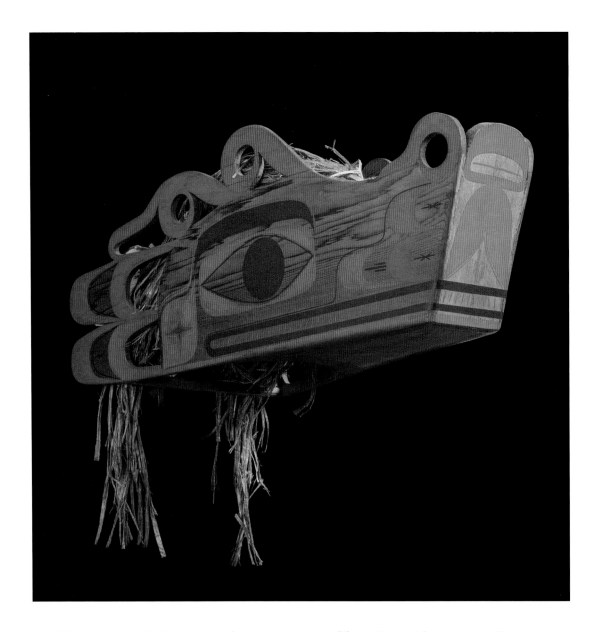

non-Native artist John Livingston, from 1969 to 1990.[35] The gallery sold prints as well as carvings, reflecting the expansion of Northwest Coast artists into the world of printmaking. While Ellen Neel (Kwakwaka'wakw, 1916–1966), Mungo Martin's niece, is credited with initiating Northwest Coast silkscreen printing by creating formline designs on cloth in the 1940s, it was not until the 1960s, when other Northwest Coast artists began experimenting with printmaking, that the art form—and a market for it—started to take hold.[36] Kwakwaka'wakw carver Doug Cranmer began experimenting with printmaking on a variety of media, from burlap bags to paper to cotton muslin, early in the 1960s and continued to turn to printmaking throughout his career.[37] Robert Davidson began printmaking in 1968, and has become known for his exceptionally innovative prints and paintings. The city of Victoria—through the presence of Mungo Martin, his apprentices, and subsequent carvers—had become a center for the promotion and sale of Northwest Coast art, and a group of artists from Northwest Coast communities opened Open Pacific Graphics (which became Pacific Editions Limited) in 1968 as a commercial print studio in Victoria. In 1977, a group of artists founded the Northwest Coast Indian Artists Guild, which particularly promoted graphic arts and sought recognition of Indigenous design.[38] Prints were portable, affordable, and more easily acquired by tourists and collectors than were wood carvings.[39]

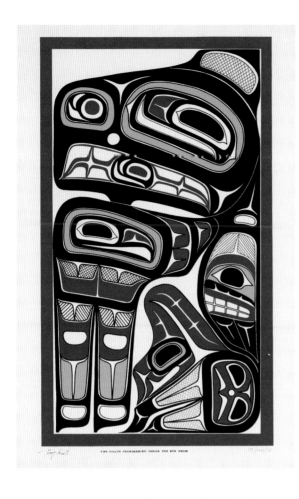

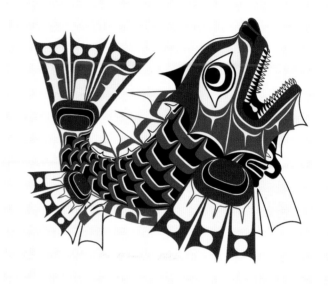

(opposite page) **Art Thompson** (Ditidaht/Nuu-chah-nulth, 1948–2003) *Nitinat Sea Monster Headdress*, twentieth century. Wood, paint, cedar bark; 9½ × 10½ × 24 in. Collection of George and Colleen Hoyt 183

Tony Hunt Sr. (Kwakwa̱ka̱'wakw, 1942–2017) *Kwa Giulth Thunderbird Design for Box Drum*, 1974. Silkscreen; 23 × 15 in. Ed. 39/400. Collection of George and Colleen Hoyt 118

Richard Hunt (Kwakwa̱ka̱'wakw, b. 1951) *Red Snapper*, 1989. Silkscreen. 20½ × 24 in., Ed. 6/150 Collection of George and Colleen Hoyt 234

This move to printmaking marked a very important transition in the Northwest Coast art market, according to scholar Ira Jacknis, who has made the point that prints are "an almost purely aesthetic form," though of course based upon conventional graphic design and often treating traditional subjects.[40] This is in contrast to masks, rattles, and other carvings, which have their origins in ritual use. But some artists—beginning at least with Mungo Martin in the 1950s— began making masks specifically for sale, not intending them for ceremonial use. This, Jacknis writes, was the "aestheticization of a ritual form": masks, once made for ritual only, became transformed into market-bound art forms, in part to enable the artist to continue working, including to make masks for community ceremonial use. On the other hand, prints, first made primarily for sale, have, according to Jacknis, made the "opposite move, toward ritualization," as they became used as invitations and gifts for potlatches.[41]

It was in this historical context that the idea for the *Legacy* exhibit emerged in 1970 at the Royal British Columbia Museum in Victoria, spearheaded by then curator of ethnology Peter Macnair.[42] The project began as Macnair's contribution to the celebration of the centennial of British Columbia's entry into the Canadian Confederation in 1871; he wished to highlight the vitality of the province's Indigenous arts. He invited two other curators of Northwest Coast art, Wilson Duff, anthropologist at UBC, and Gloria Cranmer Webster, then curator at UBC's Museum of Anthropology, to join him in locating and interviewing artists; in time, they had developed a list of artists and had commissioned dozens of works.[43]

The exhibition was on display in Victoria in 1971–72, then from 1975 to '77 traveled across Canada. Periodic refinements were made, but the exhibit maintained its emphasis upon contemporary art. It returned to British Columbia, where it toured until spring 1980, and then it eventually traveled to the Edinburgh Festival in Scotland, in a version that included historic pieces from the RBCM collection. It was this version that returned to Canada for its final venues at UBC's Museum of Anthropology and one last time at the RBCM; this became the basis of the catalog published in 1980 and 1984.[44]

It is a remarkable trajectory for a museum exhibition to travel for a decade, all the while being edited and revised and, in that process, reflecting and encouraging Northwest Coast art production. Jacknis writes that this was possible precisely "because of the change and vitality in contemporary Northwest Coast Indian art" itself.[45] Gary Wyatt has recently said the building and reformation of the *Legacy* exhibit not only represented the rapid growth of Northwest Coast art but also provided evidence of the older artists' acceptance of the critical responsibility they had to teach rising generations.[46] Jacknis asserts that the *Legacy* exhibit "marked the shift in anthropological appreciation of Northwest Coast Indian traditions from that of a completed, 'classical' state to that of a living art."[47] While there were certainly many other factors contributing to this shift, most centrally the artists and communities themselves as they demanded to be seen and understood as fully contemporary peoples, the *Legacy* was a key benchmark of the era. Karen Duffek, a scholar of the Northwest Coast art market since 1965, has written that the *Legacy* "may be unsurpassed in the impact of its institutional validation of contemporary Northwest Coast art for a worldwide audience, at a time when the new work was not widely appreciated."[48] By choosing this group of artists as the core of their collection, yet continuing to collect beyond the timeframe of the exhibition's end in the early 1980s, the Hoyts were responding to, and elaborating upon, this valuation.

Absent from the *Legacy* exhibit project were Northwest Coast artists outside of British Columbia (such as the Tlingit of Southeast Alaska). Nor did the curators include much Coast Salish art, which they asserted remained (as of the early 1980s) "in a tenuous position, awaiting the kind of rediscovery experienced recently by the Haida, Tsimshian and Westcoast peoples."[49] One Coast Salish artist they did include was Simon Charlie (Cowichan, 1919–2005), who played an important role similar to Mungo Martin's by instructing and inspiring a younger generation of artists, and who is represented with several works in the Hoyt Collection.[50] Fortunately, the Hoyts have followed this unfolding rediscovery and have included in their collection Coast Salish artists who have flourished since the early 1980s.

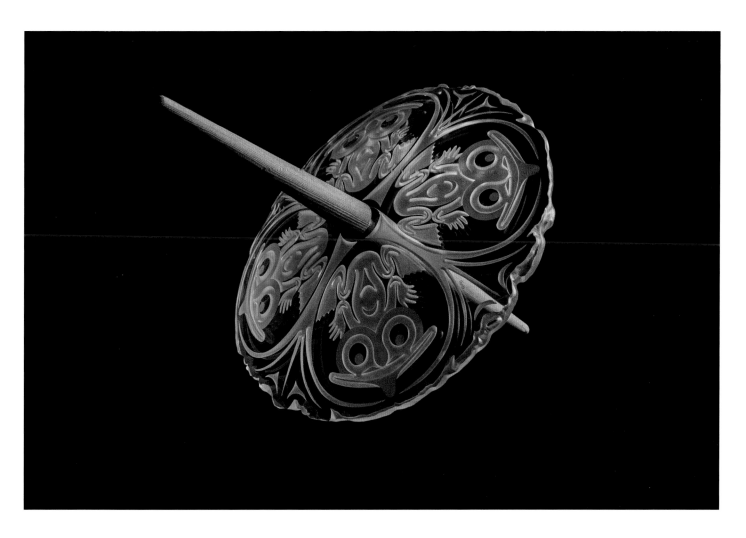

Susan Point (Musqueam/Coast Salish, b. 1952) *Four Frogs Spindle Whorl*, 1994. Glass, wood; 17 × 17 × 7 in. Ed. 5/5
Collection of George and Colleen Hoyt 69

Central among these is Susan Point (Musqueam, b. 1952), who began working first in silver engraving in the 1980s, moving on to carving, glass, metalwork, and printmaking. Point has become one of the Northwest's most prolific public artists, with significant work in both Vancouver, her Musqueam people's home territory, and Seattle, also Coast Salish homelands.[51] Other significant Coast Salish artists represented in the Hoyt Collection include Floyd Joseph (Squamish, b. 1953), Doug LaFortune (Tsawout/Lummi, b. 1953), Andy Wilbur-Peterson (Skokomish, b. 1955), Manual Salazar (Cowichan, b. 1966), Qwalsius (a.k.a. Shaun Peterson) (Puyallup, b. 1975) and Andrea Wilbur-Sigo (Squaxin Island, b. 1975), all of whom were also featured in the first major art museum exhibition and publication focusing on Coast Salish arts, the Seattle Art Museum's 2008 *S'abadeb: The Gifts, Pacific Coast Salish Art and Artists*, curated by art historian Barbara Brotherton.[52]

Beginning in the 1970s, spurred on in no small part by the *Legacy* exhibit itself, art critics and scholars started speaking of what was then happening in Northwest Coast contemporary arts as a "renaissance." Anthropologist Aaron Glass is one of many scholars critiquing this use of the discourse of renaissance or rebirth as not being "as neutral as it might seem," since it implies a "return to Indigenous cultural production after a period of hiatus."[53] Glass astutely argues that such "renaissance" discourse makes it difficult to see at least two dynamics in play. For one, the

language of "renaissance" obscures the fact that it was the destructive and unjust impact of colonialism that resulted in any "hiatus"—a woefully inadequate term for the disruption and theft of culture that had transpired. Secondly, Glass argues, what was happening in the 1960s and beyond was in a very real sense *new*: "the emergence of a new field of evaluation for Indigenous objects, a new mode of perception and appreciation"—in other words, "a new Northwest Coast art world."[54] Further, Glass draws our attention to the broader global political struggle for Indigenous rights, one that was predicated not upon the concept of a renaissance, but upon the argument of deep historical ties, cultural persistence, and often unrecognized claims to land and sovereign rights.[55]

To this end, I prefer to term what has been happening in Northwest Coast arts since the mid-twentieth century an "upsurgence." Derived from *upsurge*, defined by Merriam-Webster as "a rapid or sudden increase," *upsurgence* connotes a rapid rise in the strength of an underlying force. To follow an upsurgence, one needs to trace the direction of flow, but the term also evokes *uprising*, with its more overt association with politics and power. While it is beyond the scope of this essay or exhibition to unpack all the possibilities that this way of looking at contemporary Northwest Coast arts may offer, the term *upsurgence* invites us to think more expansively about the forces associated with the art of the Hoyt Collection than the term *renaissance* allows.

IV. THE COLLECTION

As of April 2022, the Hoyt Collection nears six hundred works, about two-thirds of which are prints and the rest three-dimensional carvings. Of the original forty artists identified by name in the *Legacy* publication of 1984, the Hoyts have collected work by thirty.[56] An additional eighty Native Northwest Coast artists are represented in the collection, many of whom have associations with the original *Legacy* artists and/or are part of the upsurgence of Coast Salish arts since the 1970s. The dates of the work range from a Charles George Jr. mask made in the 1930s to prints and masks made from the 1970s to the 2020s. In this way, the Hoyt Collection offers a means to follow the development of several individual Northwest Coast artists over time; as just one example, the Hoyts have about twenty works by Nuu-chah-nulth artist Joe David, dating from 1970 to 2017.

In doing research on the *Legacy* project and its significance, I learned from Ira Jacknis's careful scholarship that Royal British Columbia Museum curator Peter Macnair had hoped to have the financial resources annually to "acquire at least one piece from the original Legacy artists and to add the work of other artists" to museum's collection.[57] While he was able to do so for a while, as prices rose this goal became impossible. Similarly, Macnair wished to "acquire a copy of each silkscreen print produced," but the sheer volume of prints constrained that dream.[58] Even though these institutional collecting goals may never have been realistic and were not fully met, what Macnair was foreseeing was the significance of the explosion in contemporary Northwest Coast arts and the value in documenting their trajectory. Though not as temporally consistent in the way Macnair envisioned, the Hoyt Collection offers significant long-term insights into the now six decade-long production of Northwest Coast arts.

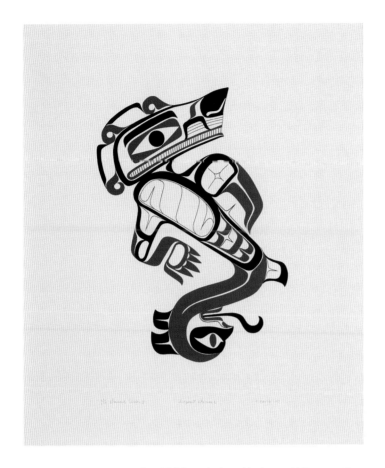
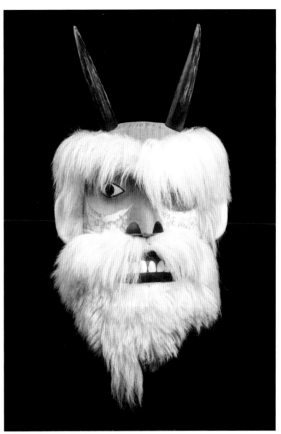

Joe David (Nuu-chah-nulth, b. 1946) *Serpent Dancer*, 1979. Silkscreen; 19 × 16 in. Ed. 62/195
Collection of George and Colleen Hoyt 159

Joe David (Nuu-chah-nulth, b. 1946) *Mountain Goat Mask*, 2017. Red cedar, goat hair, operculum shell, paint; 17 × 12 × 9 in.
Collection of George and Colleen Hoyt 335

As noted above, while masks and other carved objects may have their historic origins in ritual use, virtually all the art in the Hoyt Collection was made for the art market. Duffek, in writing about the history of the contemporary Northwest Coast art market and its shifting discourses, argues that the very "revival" of such arts was partially fueled by the existence of an art market directed primarily at non-Natives—a market enlarged in no small part because of the *Legacy* exhibition itself.[59] Perhaps a future scholar will be able to utilize the Hoyt Collection as a window into the dynamics of this market over the last half-century. One of the collection's tremendous strengths is its documentation: for each of the hundreds of objects acquired, George created a page that generally included a thumbnail image of the work, a photo of the artist, a description (when available) of the artwork and biography of the artist, and at bottom, information about where and when the work was purchased and the purchase price. He maintained his records scrupulously and assigned each acquisition a number, representing the order in which each was acquired. Thus it is possible to trace the sequence in which the work was brought into the Hoyt Collection and through which galleries or other avenues.

In the pages that follow, a selection of work by about sixty artists is organized by birth year of the artist. This birth-order principle allows the viewer to consider the generational flow of the

collection. Brief biographical information is provided for each artist, authored by Hallie Ford Museum of Art research assistant Tasia Riley, and selected works are accompanied by descriptions, based when possible upon artist-provided statements.

This book and the exhibition it accompanies are an inaugural introduction of the Hoyt Collection to a wider audience. For decades to come, the collection, through its reflection of a formative period in Indigenous art history, will continuously instruct and inspire.

V. CODA: THE TRANSFORMATIVE POWER OF A GIFT

How might the gift of the Hoyt Collection transform the work of the Hallie Ford Museum of Art? Certainly, the gift's scale alone is transformative, and it will significantly expand the museum's holdings of twentieth- and twenty-first-century Indigenous art. The subject matter of its works provides limitless possibilities for thematically exploring Northwest Coast oral literature, human relationships with the natural world, Indigenous resistance, and even notions of Indigenous futures.

The Hoyt Collection also provides a platform from which to look beyond it, toward work by Northwest Coast artists who may depart from conventions of formline design. Art historian Aldona Jonaitis, in the second edition of her seminal *Art of the Northwest Coast*, writes thoughtfully about artists who engage new media, including film, photography, and performance art, and who employ innovative imagery that may not have recognizable "visual association with the Northwest Coast," yet persist in their "connections to Northwest Coast Indigenous art and history."[60] As an early example, Jonaitis writes of artist James Schoppert (Tlingit, 1948–1992), who intentionally rearranged formline designs to create original compositions that went beyond canonical northern Northwest Coast design principles.[61] At the core of many such artists' innovations is a desire to "disrupt previously unexamined attitudes of non-Natives" and to confront colonizing notions of Indigeneity.[62] Jonaitis introduces the reader to a wide range of artists practicing across multiple media, including a significant number of women artists who have historically been omitted from the Northwest Coast canon, given that carving—the pinnacle of the canon—is conventionally the province of men. The Hallie Ford Museum of Art collection already holds work by three of the artists Jonaitis discusses, Haida weaver Lisa Telford (b. 1952), Tlingit/Nisga'a photographer and printmaker Larry McNeil (b. 1955), and Tlingit multimedia artist Nicholas Galanin (b. 1979). The gift of the Hoyt Collection challenges us to make future acquisitions to demonstrate the ongoing vitality and diversity of contemporary Northwest Coast art.

Another way that the Hoyt Collection gift will be transformative is by renewing and deepening the museum's relationship with artists Indigenous to the lands on which we are situated, those of the Kalapuya. To commemorate the *Transformations: The George and Colleen Hoyt Collection of Northwest Coast Art* exhibition and the promise of the gift of the collection, the Hallie Ford Museum of Art is commissioning a Welcome Figure by Kalapuyan artist Bobby Mercier, member of the Confederated Tribes of Grand Ronde, which will permanently grace the museum's

interior entrance. The Welcome Figure will be carved in Chinookan art style, a style originally shared by many peoples indigenous to the Lower Columbia River region and one that is considered related to yet distinct from the Northwest Coast art styles to the north.[63] In fall 2022, Mercier will be convening a gathering of carvers working in Chinookan style at the Hallie Ford Museum of Art with the aim of strengthening ties among them and deepening the public's understanding of the iconographic and design principles associated with the cultures indigenous to our immediate region.

The theme of transformation is central to Northwest Coast cultures; the depiction of transformation is ubiquitous in its art. The rituals associated with the masks of Northwest Coast art have the power to transform both participants and audience. In carvings and prints, multiple beings occupy the same space: they are at once themselves and interrelated with other beings. Human figures have elements of the not-human, whether animal, bird, or spirit being; the reverse is true as well. The oral literature from which the depicted figures rise tells of transformational movements between realms of land, sea, and sky. The George and Colleen Hoyt Collection of Northwest Coast Art offers endlessly rewarding inquiry even as it spurs transformations we have yet to imagine.

NOTES

1 This background information about the Hoyt family is based upon several sources, including genealogical and family history conducted and privately published by George Hoyt IV, ongoing conversations between the author and George and Colleen Hoyt since first meeting in the late 1990s, and recorded interviews conducted in November 2021 and February 2022.

2 George and Colleen Hoyt, interview with the author, Nov. 27, 2021, Lodge on Cedar Creek, Sandy, Oregon.

3 For information on Don "Lelooska" Smith's life and its complexities, as well as on the impact of the cultural center that the Lelooska family still operates at Ariel, Washington, see Chris Friday, *Lelooska: The Life of a Northwest Coast Artist* (Seattle: University of Washington Press, 2003).

4 Quintana transitioned from a storefront to online gallery in 2015. It continues to specialize in Northwest Coast and Chinookan style contemporary art, as well as other Native arts; see https://quintanagalleries.com.

5 The Haida Project brought Reg Davidson and Jim Hart to the San Francisco Bay Area for extended residencies in fall 1990. For more information, see https://californiarevealed.org/islandora/object/cavpp%3A17183. And for information about the canoe carved by Davidson (which returned to Haida Gwaii at the end of the residency), see https://www.donsmaps.com/canoesnwc.html.

6 Nigel Reading ran Spirit Wrestler Gallery in Vancouver, B.C., from 1995-2019 with partners Gary Wyatt and Derek Norton. The Hoyts credit Reading with helping them develop a greater understanding of contemporary Northwest Coast art and of guiding them in the development of their collection. I interviewed Reading via phone for this project on March 21, 2022.

7 Gary Wyatt attended the Alberta College of Art and the University of British Columbia, where he studied Northwest Coast art. Wyatt was a curator at the Inuit Gallery and then at the Spirit Wrestler Gallery in Vancouver, BC, for nearly three decades, and is the author of many books about Northwest Coast art, including *Spirit Faces: Contemporary Masks of the Northwest Coast* (Vancouver: Douglas and McIntyre, 1994). I interviewed Wyatt via Zoom for this project on March 3, 2022.

8 Gary Wyatt, interview with author, March 3, 2022.

9 Peter L. Macnair, Alan L. Hoover, and Kevin Neary, *The Legacy: Tradition and Innovation in Northwest Indian Art* (Seattle: University of Washington Press in association with Royal British Columbia Museum, 1984).

10 Colleen Hoyt, interview with author, November 27, 2021. While over the years George and Colleen worked with several galleries, including Spirit Wrestler Gallery of Vancouver, owned by Gary Wyatt and Nigel Reading, they relied upon their own research a great deal. Gallery dealers helped them, as Colleen has said, "shape around the edges," but they actively and independently sought pieces to add to the collection. And while they enjoyed learning about artists and meeting them when the opportunities arose, they focused on building professional relationships, as when they commissioned artists to make certain pieces. The one exception may be Susan Point, whom the Hoyts have sought out to visit at her home studio, and with whom they conversed at length about acquisitions.

11 Macnair, Hoover, and Neary, *The Legacy*, 110.

12 Kenneth M. Ames and Herbert D. G. Maschner, *Peoples of the Northwest Coast: Their Archaeology and Prehistory* (London: Thames and Hudson, 1999), 17.

13 Ames and Maschner, *Peoples of the Northwest Coast*, 18–19. In the early twentieth century anthropology's "culture area" concept, which divided Indigenous North America into geographic areas that presumably shared "cultures" as well as ecosystems, was a predominant way of categorizing knowledge in the discipline and was also used to explain differences between Indigenous groups. It has since been critiqued as being arbitrary, lacking in explanatory power, and obscuring of real distinctions; nevertheless, culture area labels continue to be used as they facilitate the organization of and communication about Indigenous North American history and contemporary life.

14 An exploration of the stylistic variations of Northwest Coast art is beyond the scope of this essay and it is with great hesitation that I provide any general statements at all. For an accessible yet nuanced study of the complex history and stylistic qualities of Northwest Coast art, see Aldona Jonaitis, *Art of the Northwest Coast, Second Edition* (Seattle: University of Washington Press, 2021).

15 Ames and Maschner integrate the whole stretch of the Northwest Coast, at least to present-day northwest Oregon, in their chapter on "Northwest Coast Art," 219–48. In it, they describe the southernmost art styles, including Lower Chinookan, as "more variable, more naturalistic" (248), as have other scholars.

16 For more information about Lower Chinookan art styles, see Tony A. Johnson and Adam McIsaac, "Lower Columbia River Art," in Robert T. Boyd, Kenneth M. Ames, and Tony A. Johnson, eds., *Chinookan Peoples of the Lower Columbia* (Seattle: University of Washington Press, 2013), 199–225. For information regarding the contemporary Chinook Nation, including its arts, see Jon Daehnke, *Chinook Resilience: Heritage and Cultural Revitalization on the Lower Columbia River* (Seattle: University of Washington Press, 2017).

17 I imagine I am not alone in wondering about the parallels between the flamboyant "giveaway" performed by salmon as they go upstream to spawn—as they turn brilliant red and give their very bodies to make the next generation, nourishing many other species in the process—and the lavish potlatches of Northwest Coast peoples who co-reside in salmon habitat and witness this seasonal migration and distribution of resource wealth.

18 Daisy Sewid-Smith, "Interpreting Cultural Symbols of the People from the Shore," in Charlotte Townsend-Gault, Jennifer Kramer, and Ḳi-ḳe-in, eds., *Native Art of the Northwest Coast: A History of Changing Ideas* (Vancouver: University of British Columbia Press, 2013), 16. I'm grateful to my colleague Kathryn Bunn-Marcuse for guiding me to this essay. Art historian Sheila Farr also writes of the "job" of Northwest coast art: "In Northwest Coast traditions, art always has a job to do. It identifies clans and strengthens the community through shared stories and visions. It's an essential part of seasonal ceremonies, dance, shamanism, and the rituals of daily life. Art functions as a kind of ectoplasm tethering the natural world to the supernatural." In Sheila Farr, "Beyond the Totem: Modernism, Northwest Coast Native Art, and Robert Davidson," in *Abstract Impulse: Robert Davidson* (Seattle: Seattle Art Museum in association with University of Washington Press, 2013), 34.

19 Ames and Maschner, *Peoples of the Northwest Coast*, 219–44, and Jonaitis, *Art of the Northwest Coast, Second Edition*, 35—56.

20 See Gwaii Edenshaw, "The Power of Speech," in Christopher Patrello, *Northwest Coast and Alaska Native Art* (Denver: Denver Art Museum, 2020), 54–55. See also Kathryn Bunn-Marcuse's discussion of scholarly and artistic sources related to Indigenous discourse about Northwest Coast art styles in "Form First, Function Follows: The Use of Formal Analysis in Northwest Coast Art History," in Townsend-Gault, Kramer, and Ḳi-ḳe-in, *Native Art of the Northwest Coast*, 404–13.

21 Edenshaw, "Power of Speech," 55.

22 Bill Holm, *Northwest Coast Indian Art: An Analysis of Form* (Seattle: University of Washington Press, 1965).

23 Edenshaw, "Power of Speech," 55.

24 Bunn-Marcuse, "Form First, Function Follows," 404–13.

25 Bunn-Marcuse, "Form First, Function Follows," 423–25. I am grateful to Bunn-Marcuse for drawing attention to this dimension of Holm's scholarship.

26 For more information about the potlatch ban as well as historic photographs of twentieth-century potlatches taking place in spite of the ban, see Simon Fraser University's Bill Reid Centre for Northwest Coast Studies: https://www.sfu.ca/brc/online_exhibits/masks-2-0/the-potlatch-ban.html.

27 Jonaitis, *Art of the Northwest Coast*, 224. For more on the Cranmer potlatch, ensuing confiscation of masks, and eventual repatriation of many of those masks, see the website of the U'Mista Cultural Centre in Alert Bay, BC: https://www.umista.ca/pages/collection-history.

28 For discussion about the ongoing evolution of the relationship between museums and Indigenous peoples, see Matthew McRae, "Bringing the Potlatch Home: Museums, Repatriation, and the Cranmer Potlatch," n.d., Canadian Museum for Human Rights, https://humanrights.ca/story/bringing-the-potlatch-home.

29 Eric Hanson, Daniel P. Games, and Alexa Manuel, "The Residential School System," Indigenous Foundations, https://indigenousfoundations.arts.ubc.ca/residential-school-system-2020/. For an introduction to the Indian Residential School Settlement Agreement and the Truth and Reconciliation Commission's work from 2007 to 2015, see "The Indian Residential School Settlement Agreement," the Indian Residential School History and Dialogue Centre, University of British Columbia, https://irshdc.ubc.ca/learn/the-indian-residential-school-settlement-agreement/.

30 For a thoughtful overview of Northwest Coast art in the first half of the twentieth century, see "Persistence of Artistic Traditions, 1900 to 1960," in Jonaitis, *Art of the Northwest Coast*, 219–47. In addition, Gloria Cranmer-Webster, daughter of Dan Cranmer and inaugural director of the U'Mista Cultural Centre, writes movingly of the carvers who continued to create even after the 1922 potlatch trials and of the role that Mungo Martin played as a "slender thread" connecting Kwakwa̱ka̱'wakw arts to their now-thriving future. See Gloria Cranmer Webster, "The Dark Years," in Townsend-Gault, Kramer, and Ḵi-ḵe-in, *Native Art of the Northwest Coast*, 265–69.

31 For a brief discussion of Martin's work and influence, see Jonaitis, *Art of the Northwest Coast*, 241–43.

32 Jennifer Kramer with Gloria Cranmer Webster and Solen Roth, *Kesu: The Art and Life of Doug Cranmer* (Vancouver: Museum of Anthropology at the University of British Columbia, in association with University of Washington Press, 2012), 29–33.

33 Jonaitis, *Art of the Northwest Coast*, 253–55.

34 David Neel, 1995, *The Great Canoes: Reviving a Northwest Coast Tradition* (Vancouver: Douglas and McIntyre).

35 Jonaitis, *Art of the Northwest Coast*, 258.

36 Edwin S. Hall Jr., Margaret B. Blackman, and Vincent Rickard, *Northwest Coast Indian Graphics: An Introduction to Silk Screen Prints* (Seattle: University of Washington Press, 1981), 50. It's important to note, however, that well before the 1960s, some Northwest Coast artists (notably Henry Speck, Kwakwaka'wakw) had been experimenting with works on paper, including watercolor and colored pencils. Hall, Blackman, and Rickard also note that some Northwest Coast artists (such as Robert Davidson) became determined to take up printmaking as a way of correcting the inaccurate representations of Northwest Coast design popularized in the 1950s by non-Native Canadian artist Charles B. Greul (represented in the Hoyt Collection), who sold crudely-rendered silkscreen prints on the tourist market.

37 Kramer and Roth, "The Pragmatist: 'Better than Working for a Living,'" in Kramer with Webster and Roth, *Kesu*, 40.

38 Hall, Blackman, and Rickard, *Northwest Coast Indian Graphics*, 50.

39 An important recent effort to present and assess the last six decades of Northwest Coast printmaking is the exhibition *Cultural ImPRINT: Northwest Coast Prints*, curated by India Rael Young in collaboration with Faith Brower of the Tacoma Art Museum, in 2017. This follows other projects, including the exhibition *Out of the Frame: Salish Printmaking* at the University of Victoria Legacy Art Gallery in 2016. See the online catalogue of the same title by Andrea N. Walsh and India Rael Young, http://uvac.uvic.ca/gallery/outoftheframe/catalogue.

40 Ira Jacknis, *The Storage Box of Tradition: Kwakiutl Art, Anthropologists, and Museums, 1881–1981* (Washington, DC: Smithsonian Institution Press, 2002).

41 Jacknis, *Storage Box*, 184.

42 I am grateful for the careful research of Ira Jacknis, who recounts the story of the *Legacy* project in his book *The Storage Box of Tradition*, assembled from his interviews with Peter Macnair and his thorough archival research. See Jacknis, *Storage Box*, 207–13.

43 Jacknis, *Storage Box*, 207.

44 Macnair, Hoover, and Neary, *The Legacy*, 9; Jacknis, *Storage Box*, 208–9.

45 Jacknis, *Storage Box*, 209.

46 Wyatt, interview with author.

47 Jacknis, *Storage Box*, 209.

48 Karen Duffek, "Value Added: The Northwest Coast Art Market since 1965," in Townsend-Gault Kramer, and Ḳi-ḳe-in, *Native Art of the Northwest Coast*, 600.

49 Macnair, Hoover, and Neary, *The Legacy*, 110. See Barbara Brotherton, ed., *S'abadeb: The Gifts, Pacific Coast Salish Art and Artists* (Seattle: Seattle Art Museum in association with University of Washington Press, 2008) for one of the first comprehensive publications regarding Coast Salish arts. In that volume, see Wayne Suttles, "The Recognition of Coast Salish Art," 50–67, for a discussion and analysis of why Coast Salish art has been undervalued.

50 Barbara Brotherton, "How Did It All Get There? Tracing the Path of Salish Art in Collections," in Brotherton, ed., *S'abadeb: The Gifts*, 116–17.

51 Gary Wyatt, ed., *Susan Point: Coast Salish Artist* (Seattle: University of Washington Press, 2000), with essays by Michael Kew (anthropologist and uncle to Susan Point by marriage), Peter Macnair, Susan Point as told to Vesta Giles, and Bill McLennan.

52 See Brotherton, *S'abadeb*.

53 Aaron Glass, "History and Critique of the 'Renaissance' Discourse," in Townsend-Gault, Kramer, and Ḳi-ḳe-in, *Native Art of the Northwest Coast*, 487.

54 Glass, "History and Critique," 492.

55 Glass, "History and Critique," 494.

56 The *Legacy* artists not represented include six who had already passed by the 1970s, including Ellen Curley, Charles Edenshaw, Gwaytihl, Willie Seaweed, Charles Walkus, and Charlie James; their work is rarely available for acquisition by private collectors. Three of the other artists not included were women who were either button-blanket makers or weavers or both: Florence Davidson (mother of Robert and Reginald Davidson), Shirley Floyd, and Jessie Webster. While the Hoyts do have one unsigned button blanket and five unattributed baskets in their collection, they have focused on prints and carvings. One of the strengths of the Hallie Ford Museum of Art's existing Native American collection is weaving; since the early 2000s, the Hoyts have played an important role in building this collection by creating the Hoyt Weaving Arts Acquisition Fund. Our ongoing goal will be to complement the Hoyt's focus on prints and carvings by seeking fiber work—conventionally gendered as women's arts—for inclusion in our presentation of Northwest Coast arts.

57 Jacknis, *Storage Box*, 212.

58 Jacknis, *Storage Box*, 213. Important collections of Northwest Coast prints are held at University of Victoria Museum, the Burke Museum (the Blackman Hall Northwest Coast Print Collection), the Seattle Art Museum, and the Museum of Anthropology at the University of British Columbia.

59 Duffek, "Value Added," 590–632. See especially Duffek's discussion of the impact of the *Legacy* exhibition on the art market, 599–600.

60 Jonaitis, *Art of the Northwest Coast*, 301.

61 Jonaitis, *Art of the Northwest Coast*, 302–3.

62 Jonaitis, *Art of the Northwest Coast*, 301.

63 Tony A. Johnson and Adam McIsaac with Kenneth M. Ames and Robert T. Boyd, "Lower Columbia River Art," in Robert T. Boyd, Kenneth M. Ames, and Tony A. Johnson, eds., *Chinookan Peoples of the Lower Columbia* (Seattle: University of Washington Press, 2013), 199–225.

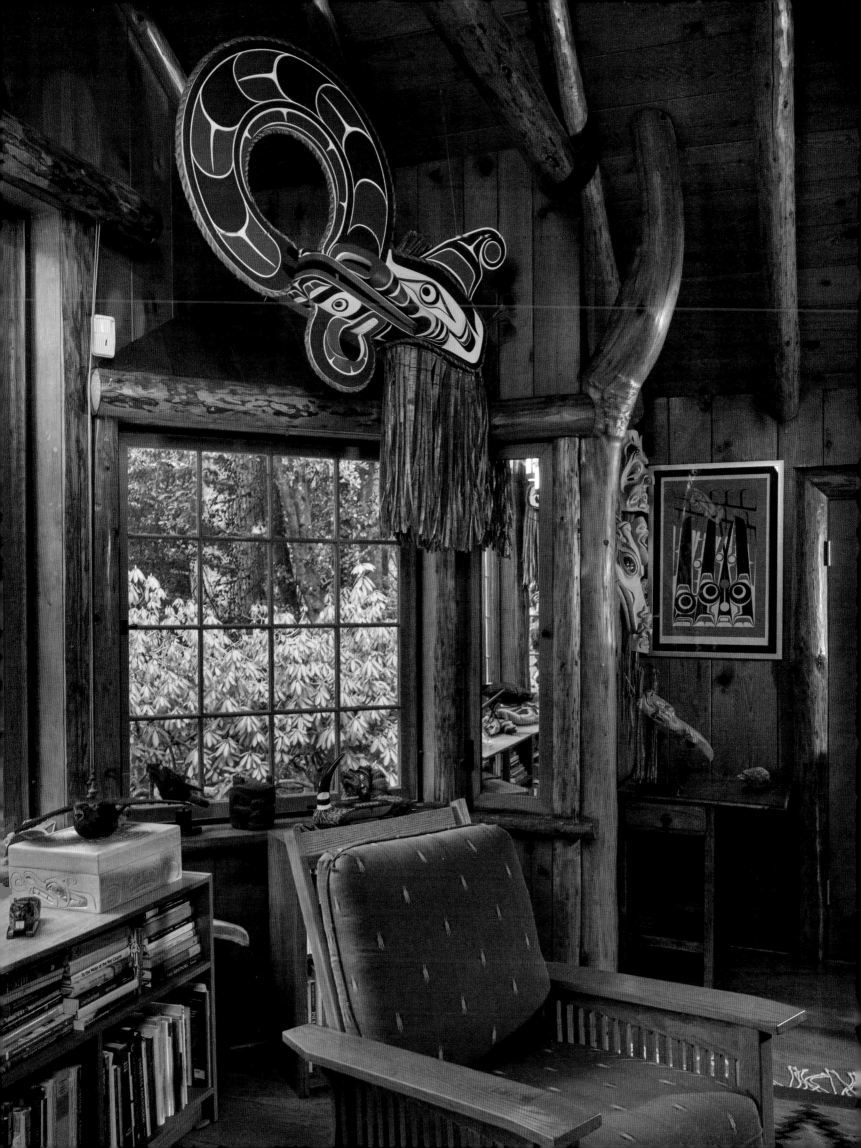

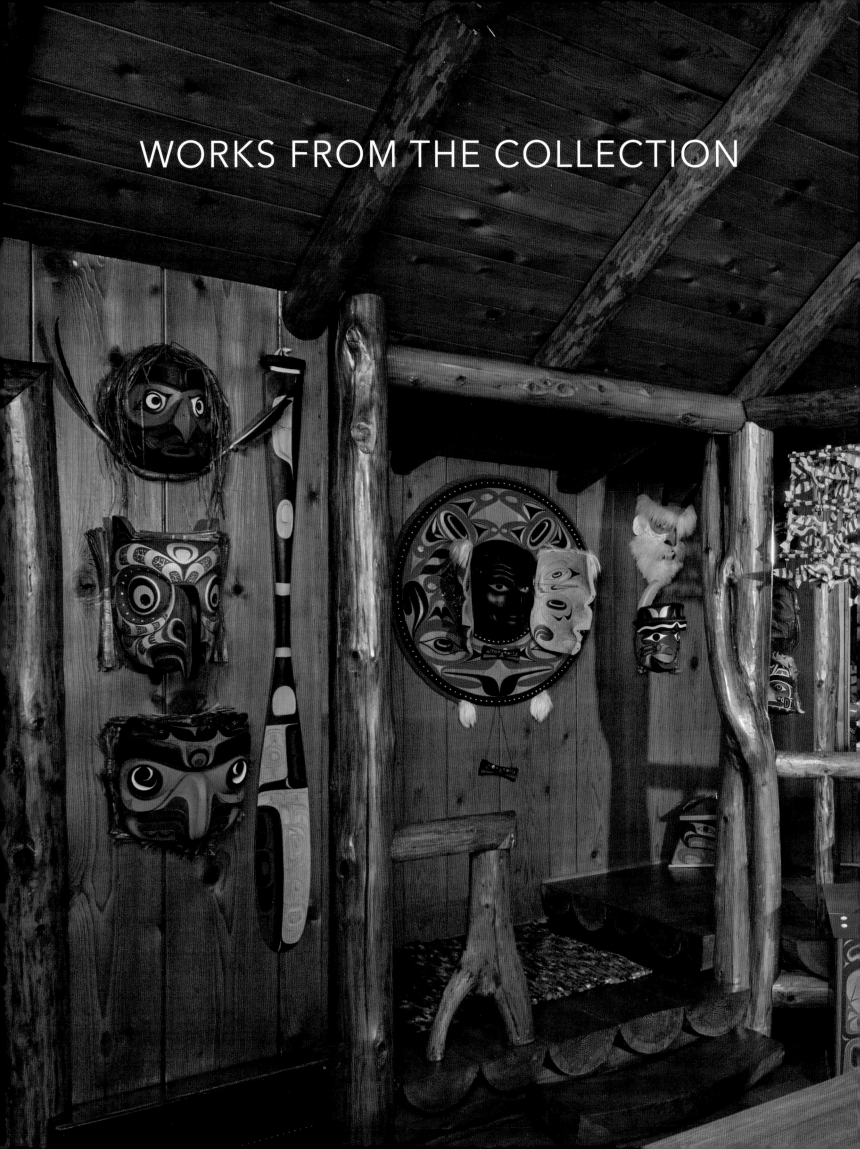

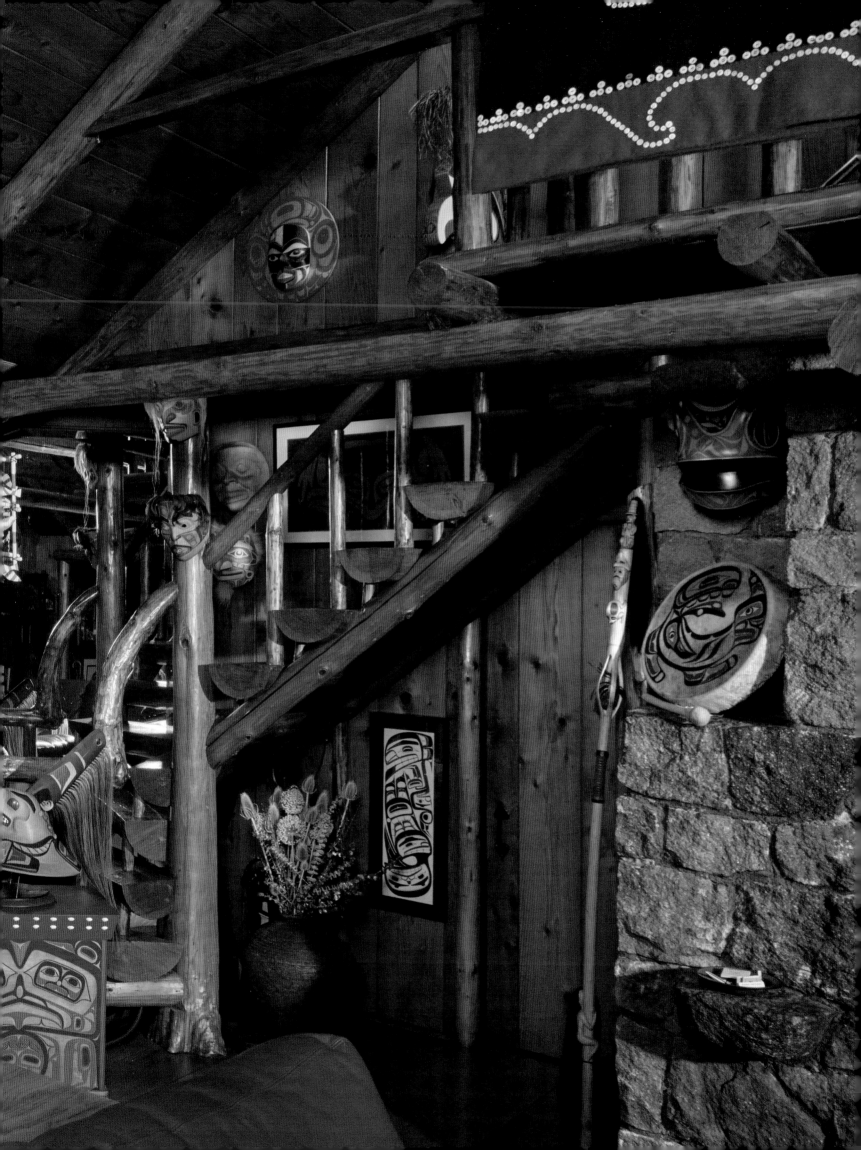

Mungo Martin
(Kwakwa̱ka̱'wakw, 1881–1962)

Mungo Martin was a central figure in the twentieth-century resurgence of Northwest Coast art. He was born at Fort Rupert, British Columbia, in 1881 and began carving as a boy, learning from stepfather Charlie James (Kwakwa̱ka̱'wakw). In the late 1940s, he began working on restoration projects at the University of British Columbia's Museum of Anthropology. Then in 1952, Martin was asked to lead a totem-pole restoration project in Victoria's Thunderbird Park by the Royal British Columbia Museum. His knowledge, work, and mentorship of apprentice carvers helped to revitalize many aspects of Kwakwa̱ka̱'wakw culture in the mid-twentieth century.

Bear Mask, 1950s
Alder; 6 ½ x 6 ½ x 5 in.
Collection of George and Colleen Hoyt 315

Acquired in the 1950s by a Royal Canadian Mounted Police officer then serving at the Royal BC Museum in Victoria, this mask was carved by renowned elder Mungo Martin while he was working for the museum, creating replicas as well as new art at Thunderbird Park. The mask remained in the officer's family until 2017, when the Hoyts purchased it.

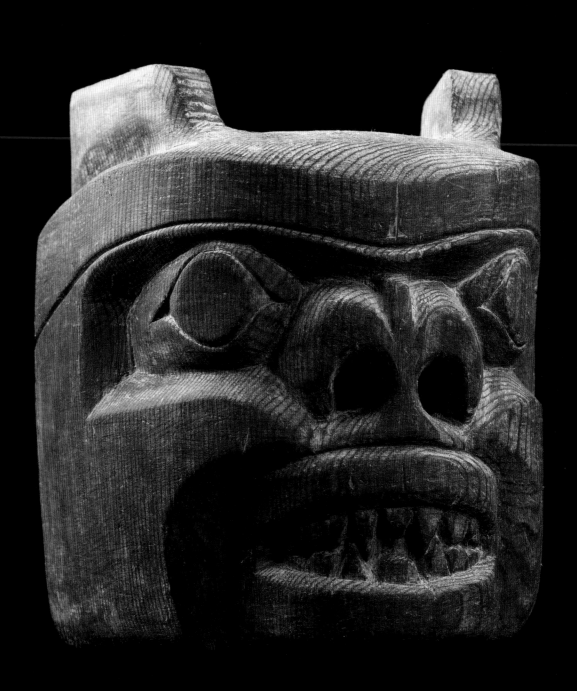

Charles George Jr.
(Kwakwaka'wakw, 1910-1982)

Charles George Jr. was a Nakwaktokw artist from Blunden Harbour, British Columbia, who began his career in the 1930s. George studied under his father, Charles "Charlie" George Sr., who taught him many carving techniques, including the Blunden Harbour/Smith Inlet substyle, a distinct variation that often involves a white ground color and elaborate designs. Examples of this style can also be seen in works by Willie Seaweed, Mungo Martin, George Walkus, and Ellen Neel. During his career, George created many ceremonial objects such as masks and rattles as well as model poles and masks to sell to tourists. Unfortunately, George suffered a stroke in 1970 that paralyzed the entire right side of his body, ending his career as a carver.

Warrior Mask, 1930s
Wood, paint; 11 × 7 × 7 in.
Collection of George and Colleen Hoyt 517

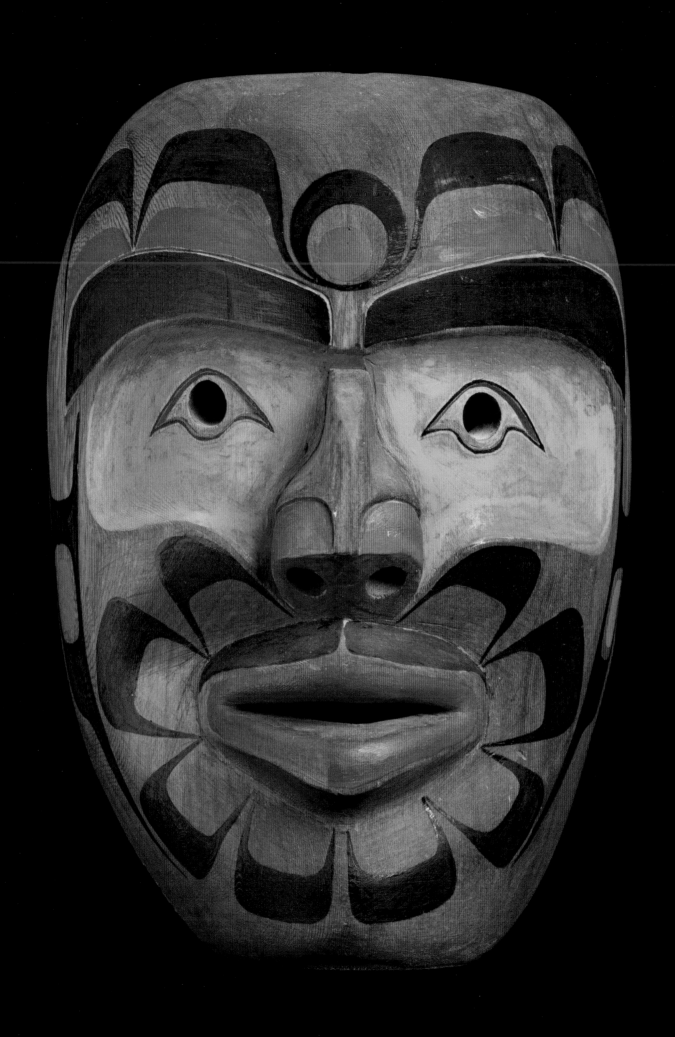

Simon Charlie

(Coast Salish/Cowichan, 1919–2005)

Simon Charlie, or Hwunumetse', was a renowned master carver born near Duncan, British Columbia. He was a primarily self-taught artist who played a significant role in the preservation and revival of traditional Coast Salish art. Some of his techniques included adding faces to the feet of bear figures and extra texture to emphasize animal fur and scales. During his career, he also carved numerous totem poles and sculptures for institutions in Canada, the United States, Holland, New Zealand, and Australia. Charlie's work earned him honors for his contributions to education and to the preservation of his cultural heritage, including the National Centennial Medal (1967), the Order of British Columbia (2001), and the Order of Canada (2003).

Eagle Rattle, 1990
Wood, paint; 4 × 18 × 20 in.
Collection of George and Colleen Hoyt 297

Eagles are abundant in many Northwest Coast myths and legends and are associated with power and prestige. This eagle rattle is an example of Charlie's naturalistic Coast Salish style of carving.

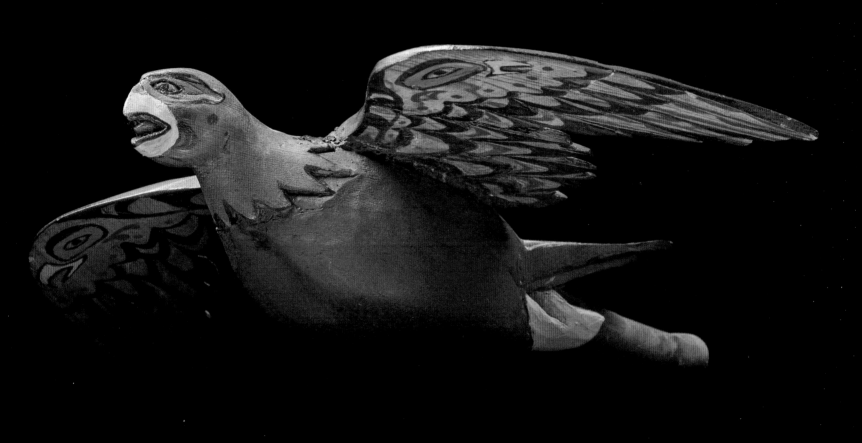

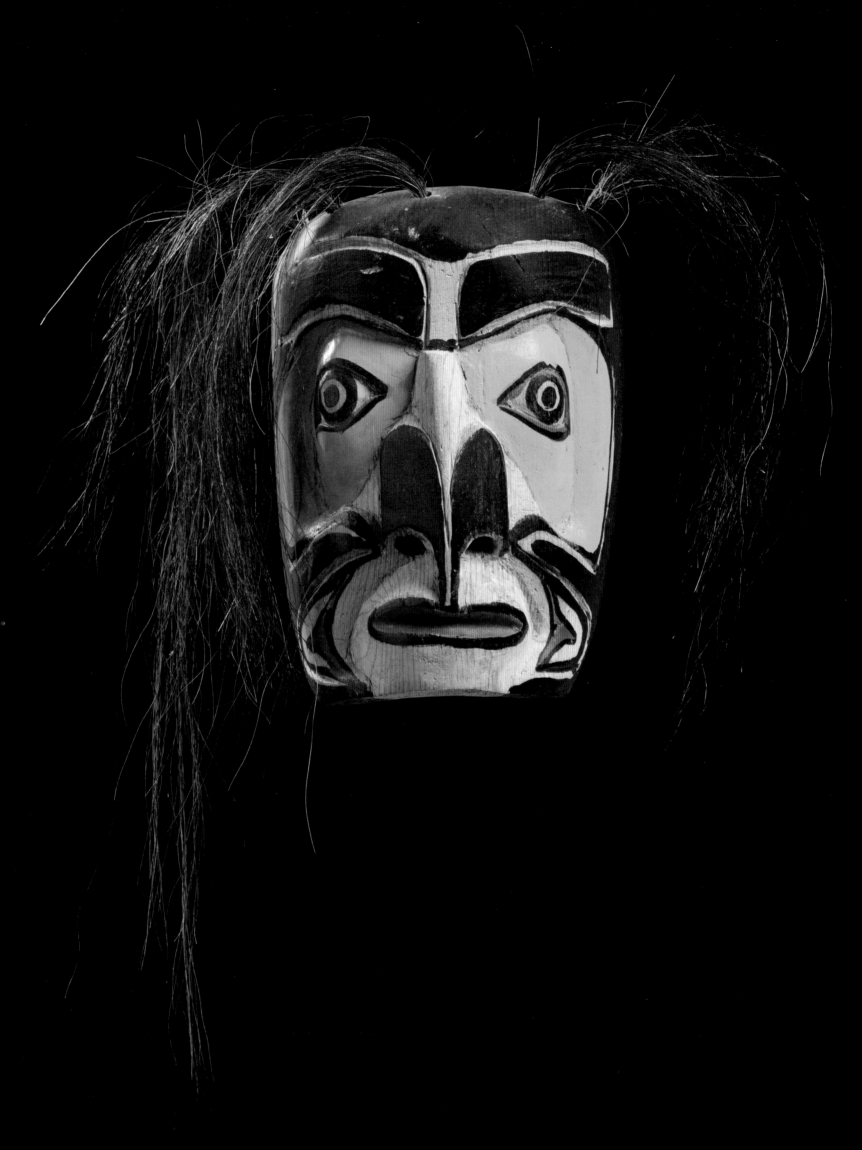

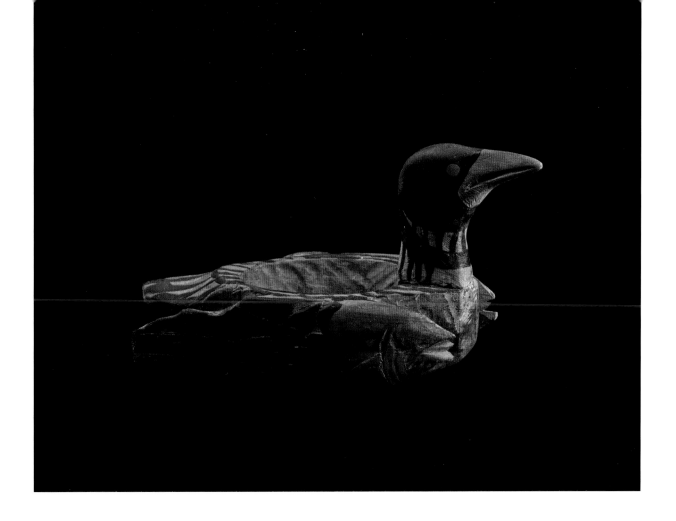

(opposite page) *Wildman Mask*, 2002
Wood, paint, horsehair; 7½ × 5½ × 3 in.
Collection of George and Colleen Hoyt 306

Wild Man of the Woods, known as Ba̱k'wa̱s by the
Kwakwa̱ka̱'wakw and found under different names
across the Northwest, is a spirit who wanders through
forests offering foods to humans with the aim of turn-
ing them into ghostly creatures, subject to eternal wan-
dering. Ba̱k'wa̱s is closely related to the Wild Man of
the Sea, and stories about the two sometimes overlap
with one another.

(above) *Cedar Loon Bowl*, 2005
Cedar, paint; 9¼ × 4 × 4 in.
Collection of George and Colleen Hoyt 308

(right) *Cod Lure*, twentieth century
Wood, paint, fiber; 7½ in.
Collection of George and Colleen Hoyt 307

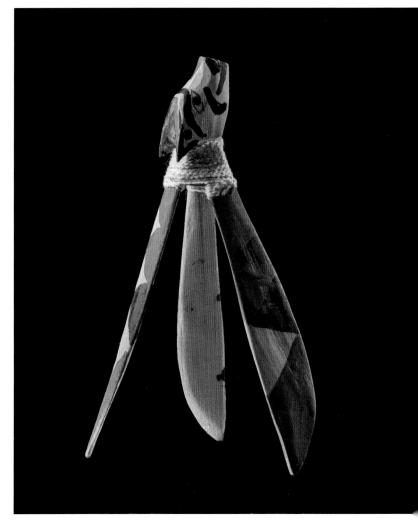

Bill Reid

(Haida, 1920–1998)

Bill Reid was born in Victoria, British Columbia, in 1920, the same year Canada's Indian Act was amended to require all children of Indigenous status to attend residential school. Reid was of Scottish-German descent on his father's side and so escaped this requirement. In 1948, he began to study jewelry and engraving at Ryerson University in Toronto. Eventually, he learned from his mother about his Haida ancestry and of his great-great uncle Charles Edenshaw, a renowned Haida carver and sculptor. Reid then taught himself how to re-create deteriorating sculptures and poles by making educated guesses about techniques and designs. His efforts to preserve Haida art and culture, particularly in public art projects, have brought him international acclaim.

Children of the Raven, 1977
Silkscreen; 24 × 18 in.
Ed. 93/195
Collection of George and Colleen Hoyt 520

This print depicts a Haida creation myth in which Raven gives life to human forms and brings them out into the world, a subject Reid returned to many times. Ravens are transformers, creators, and tricksters in Northwest Coast arts.

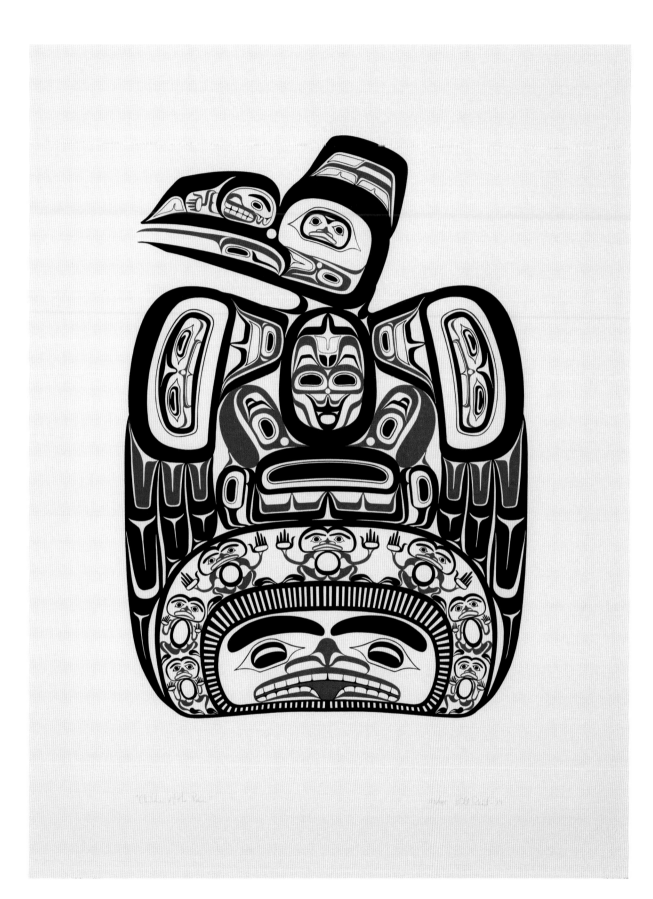

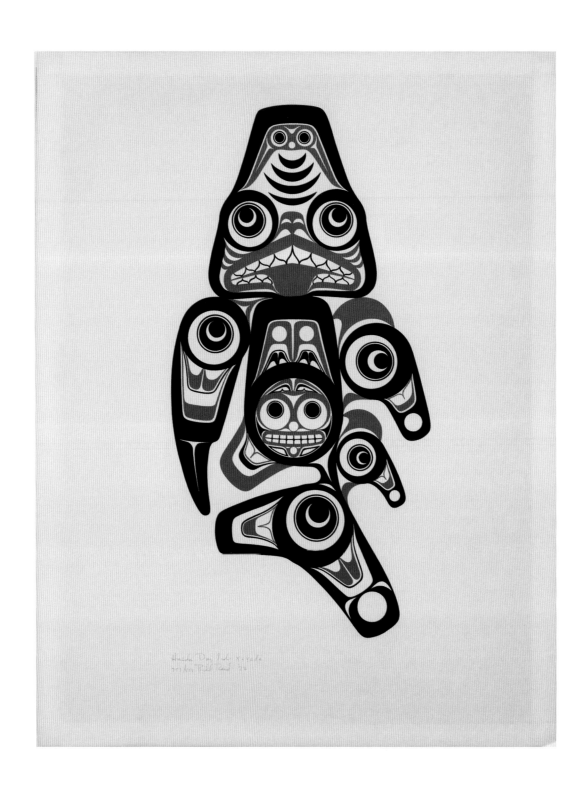

Haida Dogfish, 1972
Silkscreen; 26 × 20 in.
Ed. 353/450
Collection of George and Colleen Hoyt 182

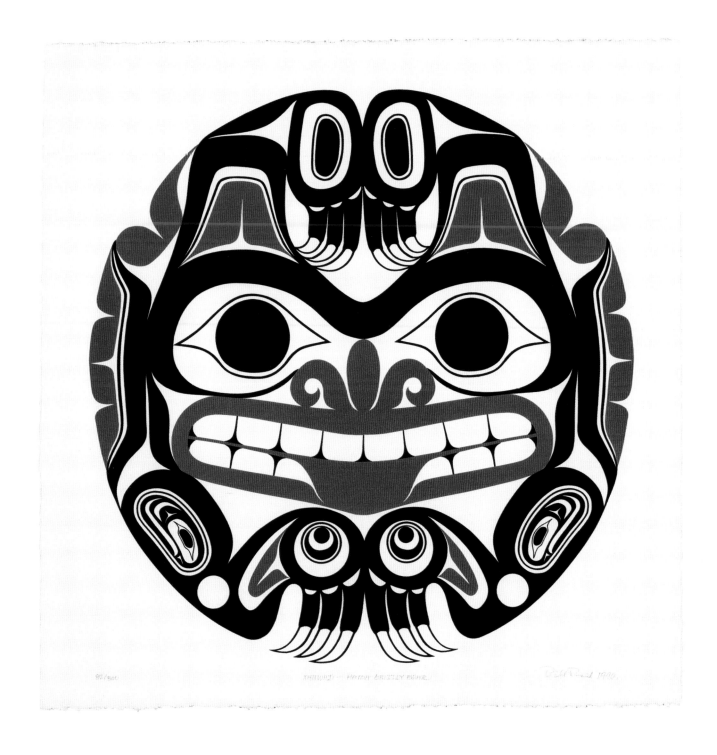

Xhuwati – Haida Grizzly Bear, 1990
Silkscreen; 22 × 22 in.
Ed. 92/300
Collection of George and Colleen Hoyt 299

Henry Hunt
(Kwakw_aka_'wakw, 1923–1985)

Born in Fort Rupert, British Columbia, Henry
Hunt became an artist later in life, after he mar-
ried Helen Nelson, Mungo Martin's daughter.
Hunt was mentored by his father-in-law and
worked alongside him when he was enlisted
to help with the Thunderbird Park pole project
in Victoria. Originally the project was meant to
last only a few years; however, the park exists
to this day as a place for the restoration and
preservation of Indigenous art. During his
time working on the project, Hunt passed his
knowledge on to his three sons, Tony, Stan, and
Richard. Together their efforts at Thunderbird
Park and within their respective communi-
ties have helped to protect and promote
Kwakw_aka_'wakw artwork, stories, and artistic
techniques.

Speaker Mask, twentieth century
Cedar, paint; 9 × 6 × 3 in.
Collection of George and Colleen Hoyt 98

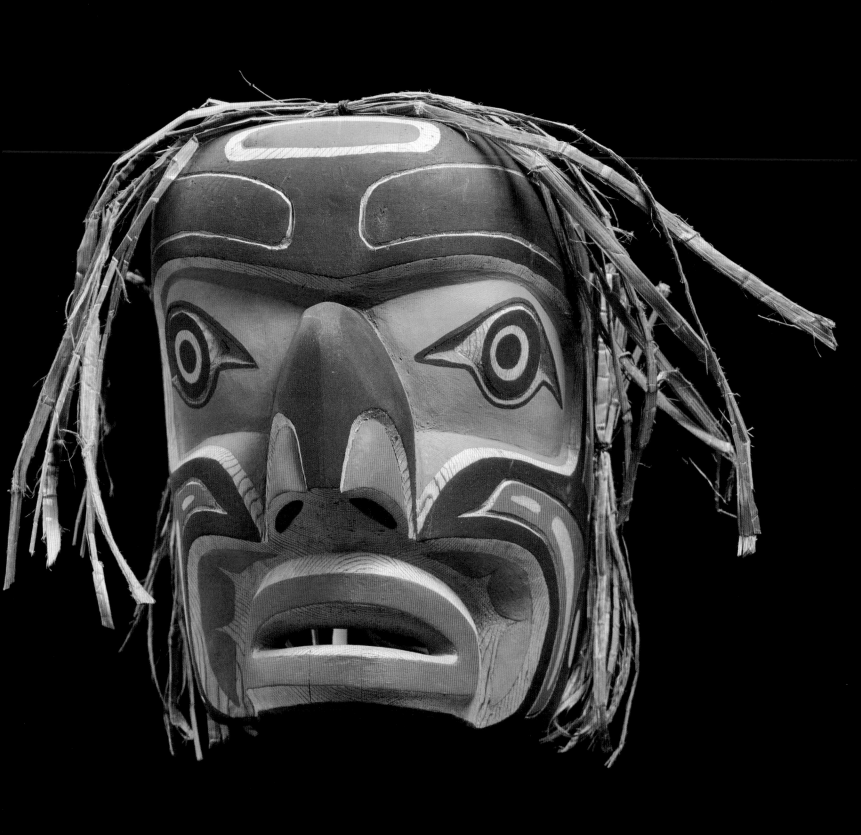

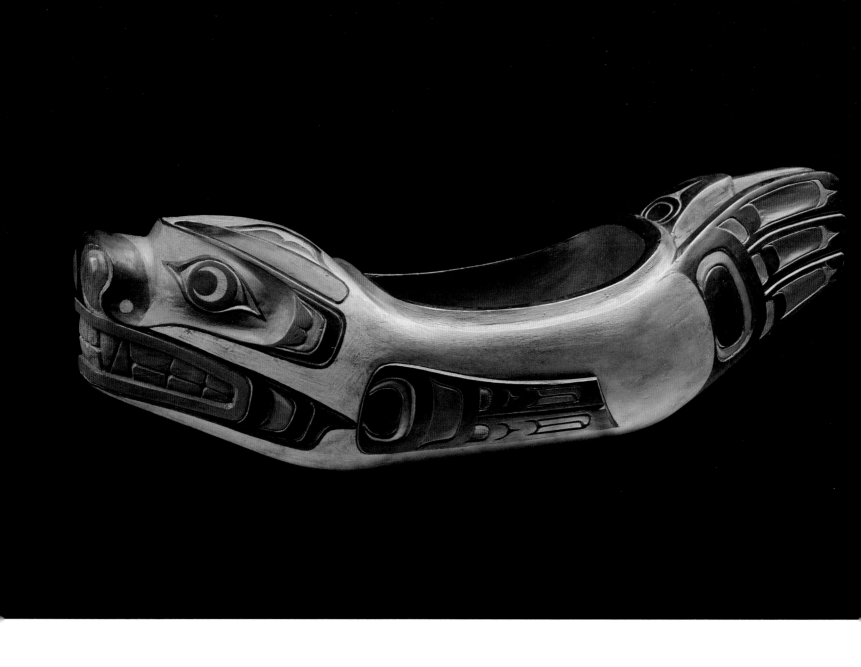

Wild Woman of the Woods, 1971
Wood, paint; 11 × 9 × 8 in.
Collection of George and Colleen Hoyt 405

Dzunuḵ'wa (Kwakwa̱ka̱'wakw and Nuu-chah-nulth),
Wild Woman of the Woods, is a mythological creature
who kidnaps children who wander too far from home
and carries them away in her basket. She is usually
depicted as double the size of a human being with
enlarged, pursed lips that are said to mimic the sound
of the wind.

Seal Bowl, 1965–1970
Wood, paint; 7 × 7 × 20 in.
Collection of George and Colleen Hoyt 396

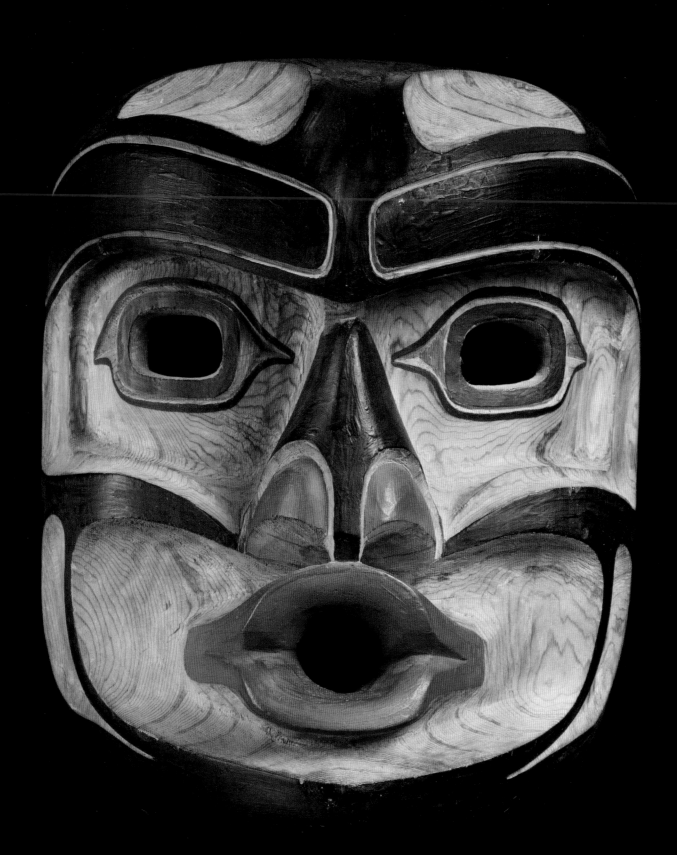

Claude Davidson

(Haida, 1924–1991)

Claude Davidson was born in Old Massett, British Columbia. He was the grandson of Haida artist Charles Edenshaw and the son of cultural leader Robert Davidson Sr. Claude Davidson began carving in the 1950s after working as a fisherman in his youth. He originally began working with yellow cedar, but switched to argillite, a black slate stone exclusive to the Haida Gwaii archipelago. His father was one of his primary mentors, and Claude would later go on to teach both of his sons, celebrated Haida artists Robert Davidson Jr. and Reg Davidson. In 1969, he and his sons Reg and Robert helped to realize the first totem pole raising in Masset's living memory.

Box Design, 1980
Silkscreen; 10 × 16 in.
Ed. 16/75
Collection of George and Colleen Hoyt 345

Box-design prints are important because they can replicate and preserve older designs or serve as a blueprint for carvers. The figures depicted tend to fill the entire space and are stretched out into wider proportions than they would be in standard prints. Many chests and boxes consist of designs that encompass the entire surface, including all four sides and the lid.

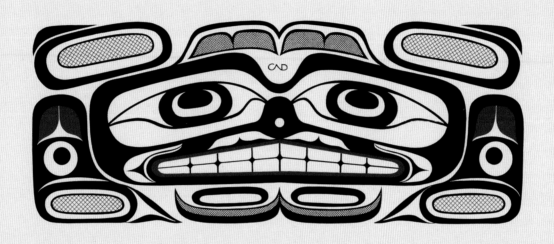

Freda Diesing

(Haida, 1925–2002)

Freda Diesing was born in Prince Rupert, British Columbia. Inspired by Kwakwaka'wakw carver Ellen Neel's work, Diesing decided to pursue woodworking in her forties. During her time at the Emily Carr College of Art and Design (now the Emily Carr University of Art + Design) and the Kitanmax School of Northwest Coast Indian Art, Diesing was mentored by many well-known carvers, including Robert Davidson, Bill Holm, and Tony Hunt Sr. She developed her own style and is often credited as one of the many artists responsible for the 1960s reawakening of Northwest Coast art and culture throughout the entire region. Later in life, Diesing mentored other artists including Dempsey Bob, Norman Tait, Phil Janzé, and her nephew Don Yeomans. In 2002, she received both an Indspire Award and an honorary doctorate from the University of Northern British Columbia.

Male Portrait Mask, 1990
Alder, paint, human hair; 7 × 10 × 4 in.
Collection of George and Colleen Hoyt 123

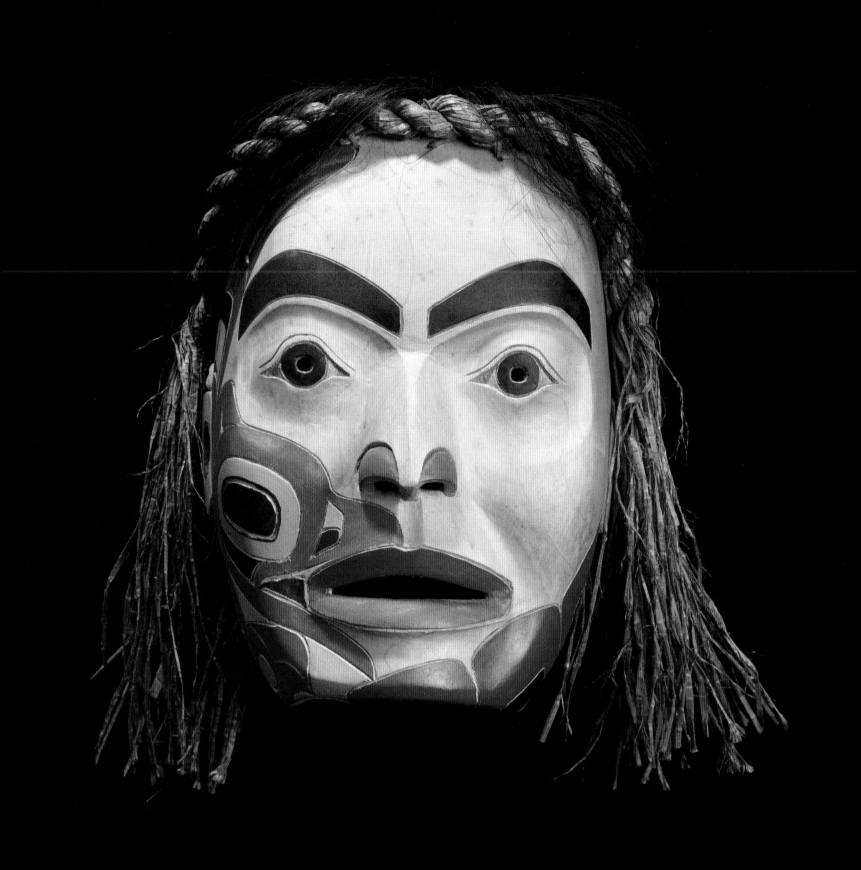

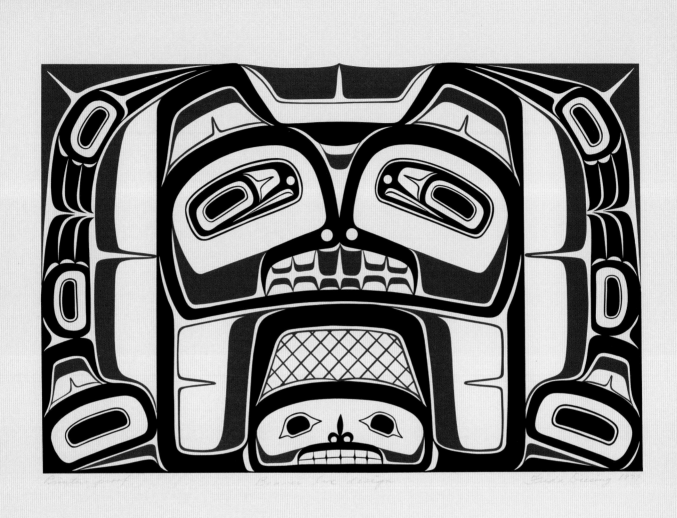

Beaver Box Design, 1979
Silkscreen; 17¼ × 22 in.
Printer's proof
Collection of George and Colleen Hoyt 439

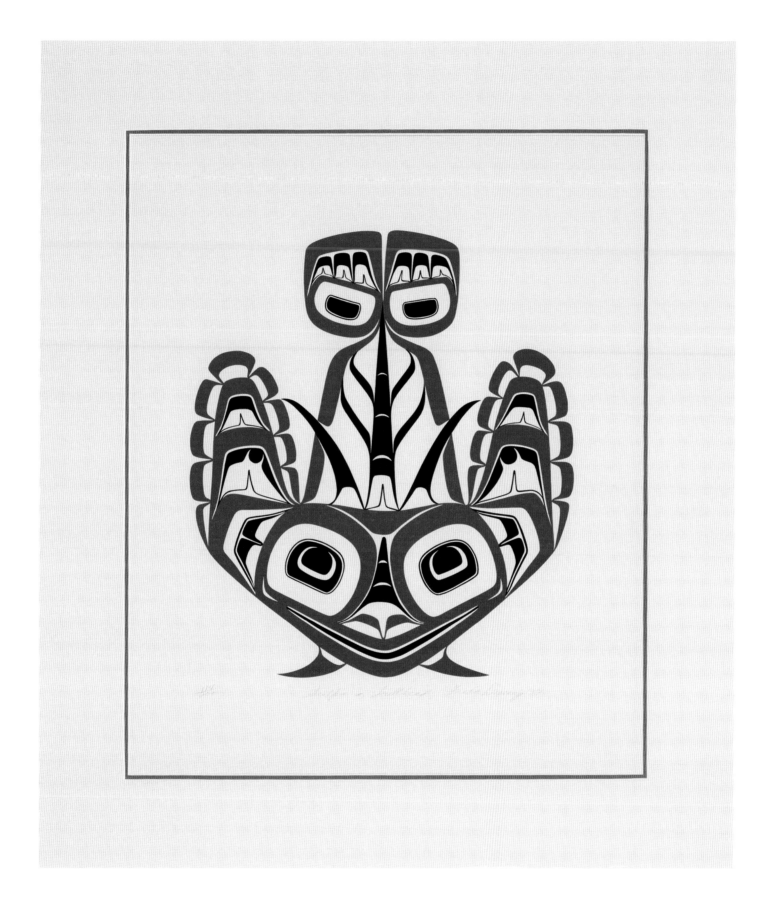

Sculpin & Bullhead, 1981
Silkscreen; 17½ × 14¼ in.
Ed. 114/200
Collection of George and Colleen Hoyt 125

Doug Cranmer

(Kwakwaka'wakw, 1927–2006)

Born in Alert Bay, British Columbia, Doug Cranmer began drawing and carving when he was young; he occasionally studied with his step-grandfather, Mungo Martin. In 1958, he was invited by Bill Reid to assist with creating Haida-style houses and totem poles at the University of British Columbia, and his career as a serious artist began. Cranmer incorporated materials, tools, and techniques (such as silkscreening) in new and innovative ways. His designs began to include abstract and fluid formlines, and Cranmer continued to experiment with conventions throughout his career. In 1967, the Vancouver Art Gallery recognized Cranmer in *Arts of the Raven*, their first exhibition of contemporary Northwest Coast art, and a major retrospective of his work was hosted by UBC's Museum of Anthropology in 2012. Cranmer taught other First Nations artists at Kitanmaax School near Hazelton, BC, as well as at various studios across British Columbia and at the Museum of Vancouver.

Hawkman Mask, 1979
Cedar, paint, horsehair, feathers, and leather;
11 × 8½ × 8 in.
Collection of the Hallie Ford Museum of Art, Salem, Oregon, 2016.009.002
The George and Colleen Hoyt Northwest Coast Indigenous Art Fund

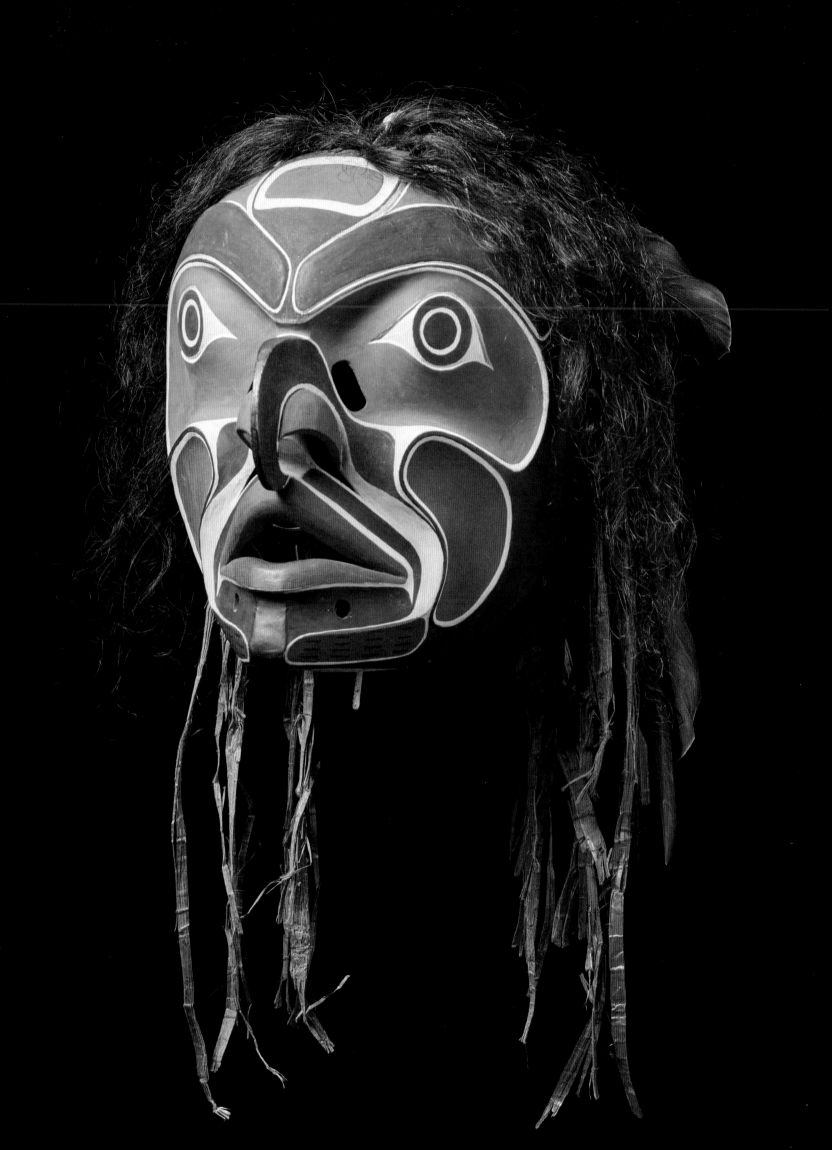

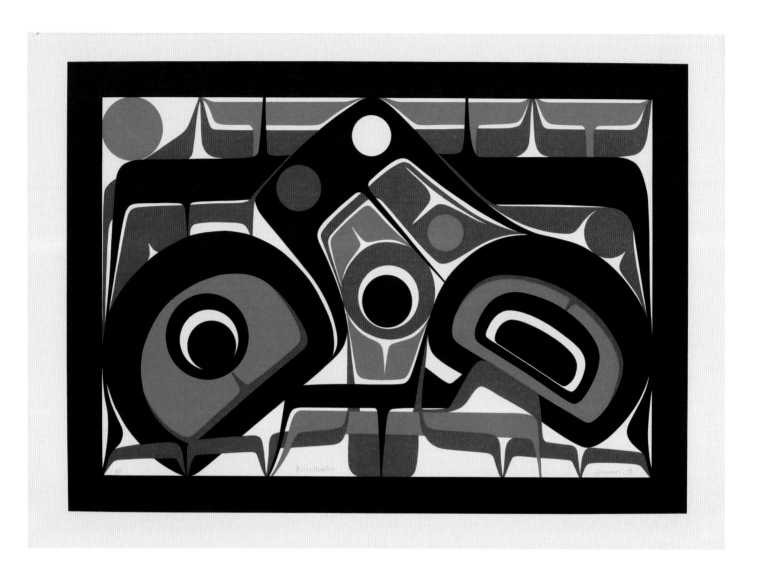

River Monster, 1992

Silkscreen; 21¾ × 30 in.

Artist's proof

Collection of George and Colleen Hoyt 204

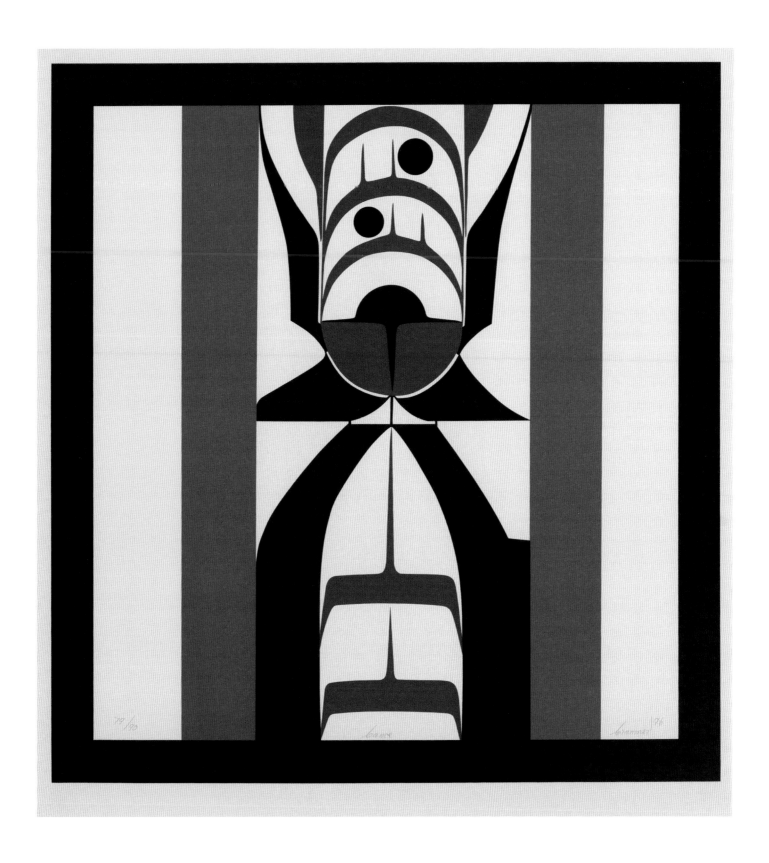

Canoe, 1996
Silkscreen; 23¾ × 22 in.
Ed. 79/90
Collection of George and Colleen Hoyt 107

This print is based on a 1978 painting of the same title. Part of his mid-1970s *Abstract Series* paintings that includes *Killer Whales, Ravens in Nest,* and *River Monster*, *Canoe* is considered one of Cranmer's most conceptually complex images, as it contains—or, really, conceals—multiple views of a single canoe while simultaneously being a highly successful abstraction.

Walter Harris

(Gitxsan, 1931–2009)

Walter Harris was born in Kispiox, British Columbia, and worked as a carpenter in the 1960s. He was involved in the reconstruction of an ancient Gitxsan village near 'Ksan and helped to build traditional plank houses and other structures. He then went on to attend the Kitanmax School of Northwest Coast Indian Art at 'Ksan and learned from renowned artists such as Doug Cranmer. Although he is often known first as a carver due to his carpentry background, Harris also became an accomplished printmaker, as did many other First Nations artists. Harris is associated with the 'Ksan style of Northwest Coast art, based on the Gitxsan clans (Fireweed, Killer Whale, and Eagle) and other cultural iconography. He also carved totem poles for various locations in Canada, France, and Japan.

Moon Portrait Mask, 1988
Birch, abalone, paint; 10¾ × 11 × 4½ in.
Collection of the Hallie Ford Museum of Art, Salem, Oregon, 2016.045
The George and Colleen Hoyt Northwest Coast Indigenous Art Fund

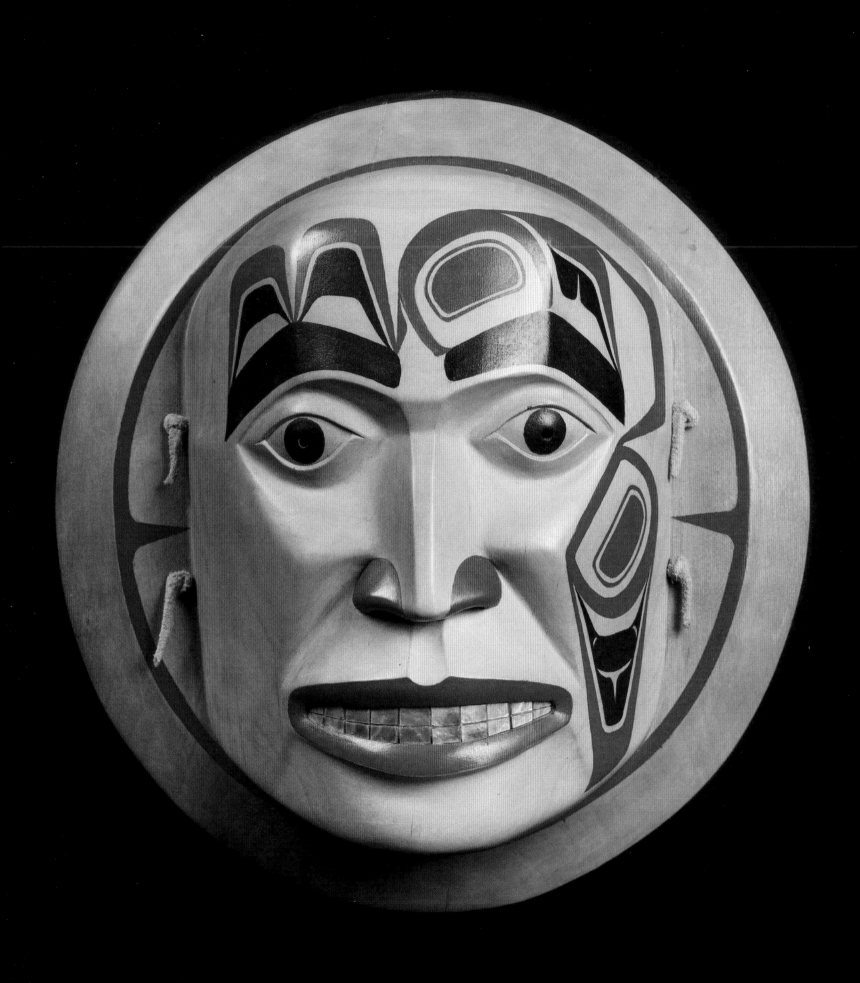

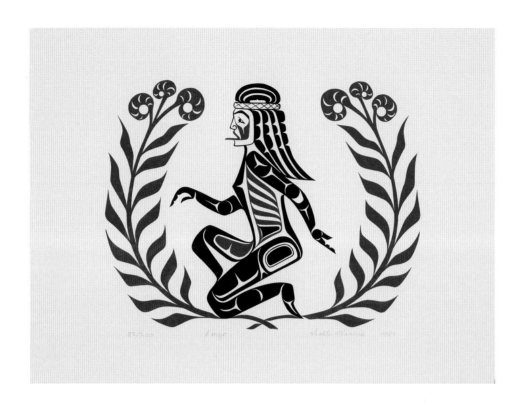

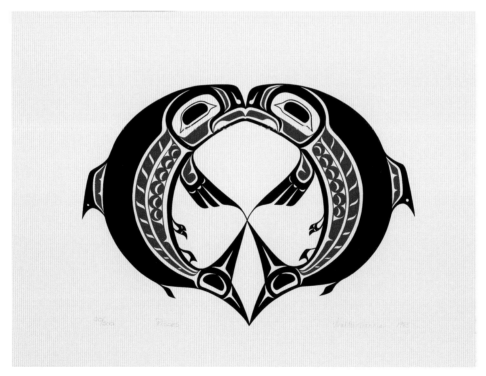

Virgo, 1983
Silkscreen; 11 × 15 in.
Ed. 82/200
Collection of George and Colleen Hoyt 100

Pisces, 1983
Silkscreen; 11 × 15 in.
Ed. 150/200
Collection of George and Colleen Hoyt 121

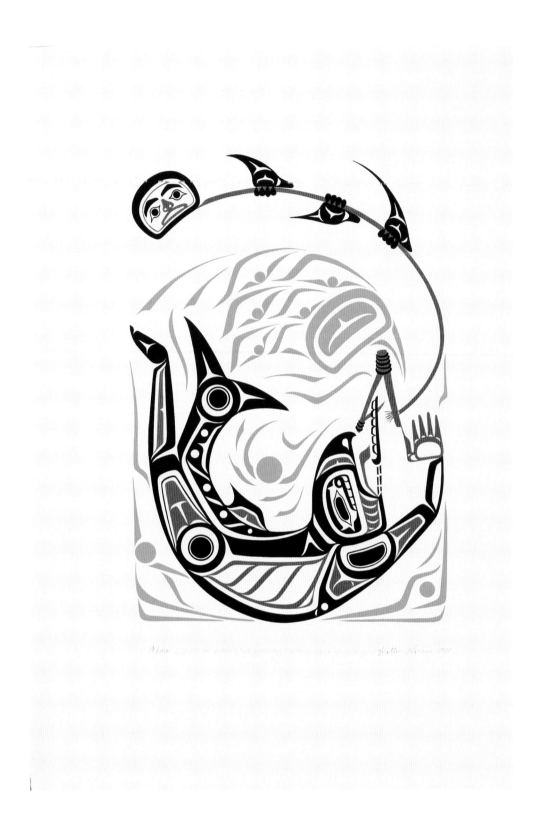

Pulling the Jaw off the Transformed Weget, 1981
Silkscreen; 22 × 15 in.
Ed. 18/100
Collection of George and Colleen Hoyt 250

Weget (sometimes Wee Gyet) is a cultural hero throughout Northwest Coast oral literature and is often depicted as Raven. In this print, the Transformer has morphed into Salmon in an attempt to steal bait from children who were fishing. When he became caught on the hook, the children then pulled so hard his jaw came off.

Don "Lelooska" Smith
(Cherokee descent, 1933-1996)

Born in Sonoma, California, Don Smith was
raised in Oregon. Smith described his mother
Mary as being of Cherokee background and
explained the name "Lelooska" derived from
an experience he had with Niimíipuu (Nez
Perce) elders as an adolescent. Eventually,
Smith became focused on learning about
Northwest Coast tribes; his explorations
led the adult Smith and his family to be
adopted into the James Sewid family of the
Kwakwaka'wakw. Beginning in 1963, Smith and
his family performed shows inspired by their
interpretations of Northwest Coast storytelling,
song and dance, drawing thousands of visitors—
especially families and school groups–to their
Ariel, Washington, family compound annually.
Smith's work was considered worthy of inclu-
sion in the 1967 *Arts of the Raven* exhibit at the
Vancouver Art Gallery.

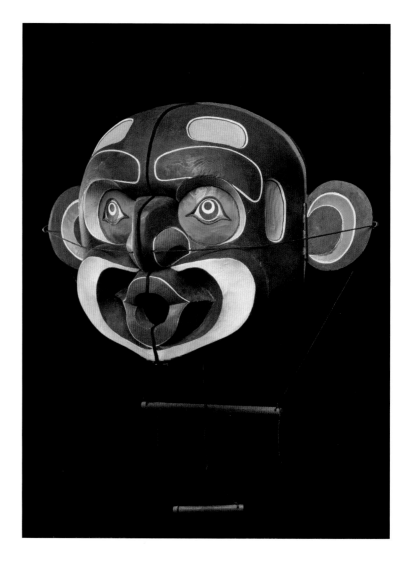

Bear Transforming to Man, 1977
Wood, paint; 23 × 17 × 6 in.
Collection of George and Colleen Hoyt 329

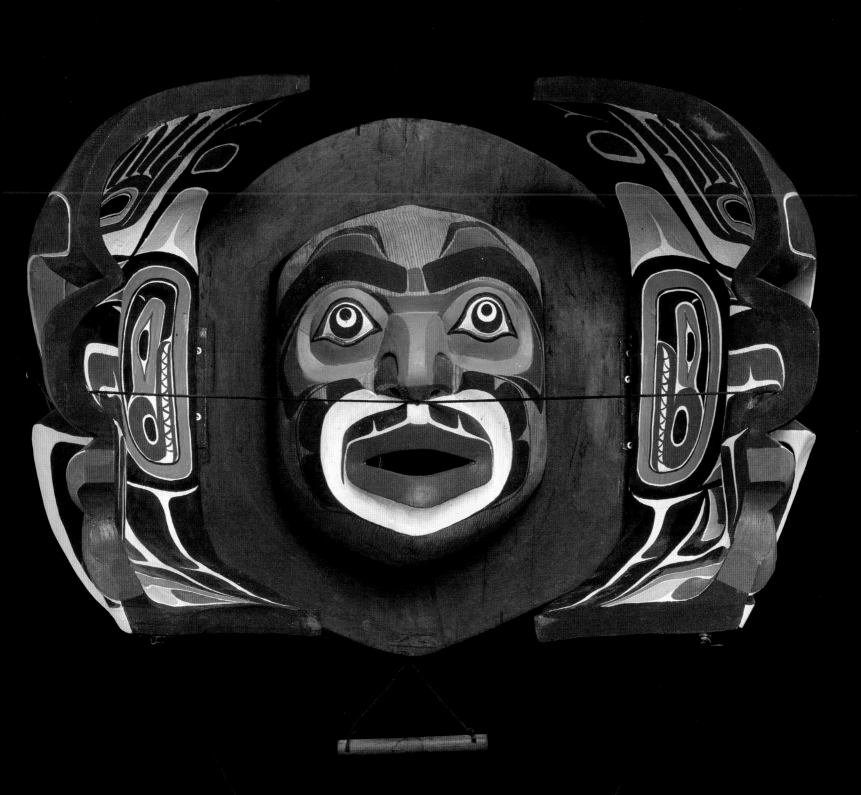

Earl Muldoe
(Gitxsan, 1936–2022)

Master carver Earl Muldoe was born in Kispiox, British Columbia. A survivor of residential school, he eventually went on to be one of the first graduates of the Kitanmax School of Northwest Coast Indian Art. Having experienced anti-Indigenous racism during his youth, Muldoe became a strong advocate for education about and for Native peoples and became involved in many public art commissions. He was one of the artists involved in carving the entry doors of the University of British Columbia's Museum of Anthropology. In 1997, Muldoe and Alfred Joseph (Wet'suwet'en) took part in the landmark case *Delgamuukw vs. British Columbia*, a lawsuit that had started in 1984. Their efforts helped to challenge Canada's legal system and change how Indigenous rights were recognized. In 2011, he received the prestigious Order of Canada from the federal government for his cultural contributions.

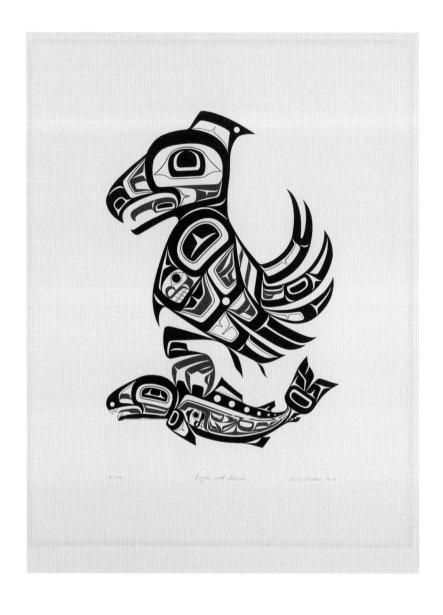

Eagle and Salmon, 1978
Silkscreen; 26 × 20 in.
Ed. 2/100
Collection of George and Colleen Hoyt 303

Bullhead, twentieth century
Silkscreen; 22½ × 30 in.
Ed. 1/100
Collection of George and Colleen Hoyt 187

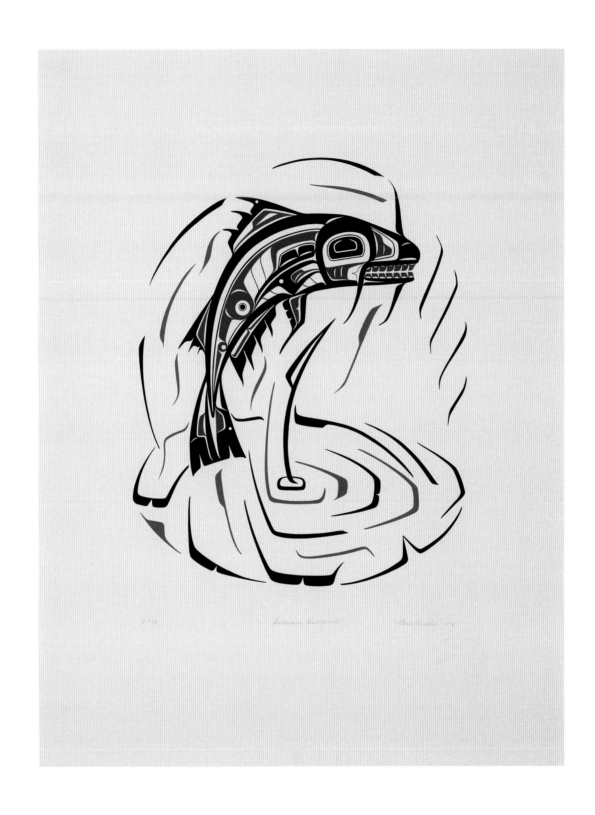

Pat Dixon
(Haida, 1938–2015)

Born in Skidegate, British Columbia, Pat Dixon was an internationally known artist who specialized in Haida-style carving in argillite, a black slate found only on Haida Gwaii. Dixon moved to Vancouver in 1966 and worked and learned alongside fellow Haida carver Pat McGuire. He also credited Bill Holm's book *Northwest Coast Indian Art: An Analysis of Form* for strengthening his understanding of flat formline designs. Dixon created many works over the years, including model poles, pendants, and sculptures, often utilizing abalone inlays for accents. He mentored and inspired many young artists with his dedication to argillite carving.

Bear Totem Pole, twentieth century
Argillite; 3½ × 1½ × 1 in.
Collection of George and Colleen Hoyt 434

Eagle Pole, twentieth century
Argillite; 4½ × 1½ × 1¾ in.
Collection of George and Colleen Hoyt 433

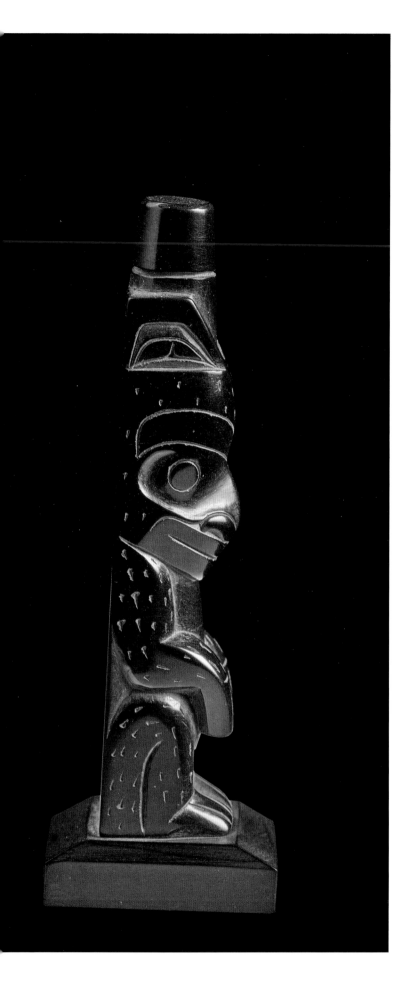
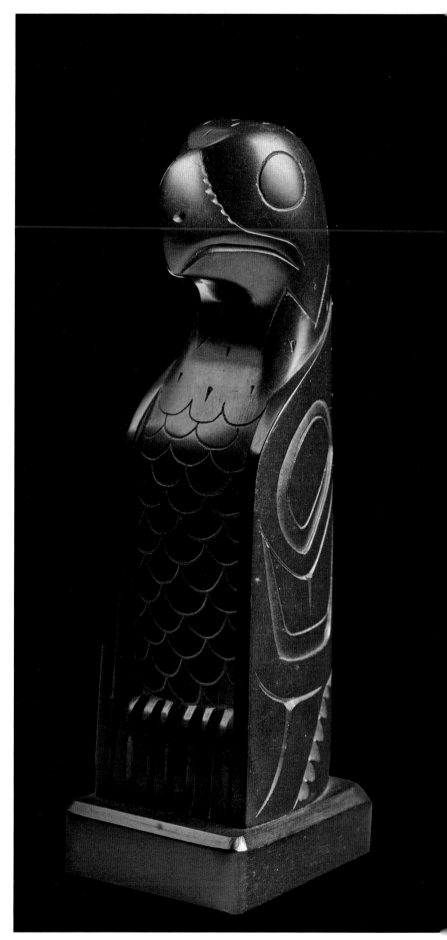

Norman Tait
(Nisga'a, 1941–2016)

Norman Tait was born in Kincolith, British Columbia. As a boy, Tait became fascinated by Nisga'a traditions and oral histories. He comes from a family of celebrated carvers, including his father, Josiah Tait, and brothers Alver and Robert. In 1973, he helped his father carve and raise the first Nisga totem pole in over fifty years. Like those of other First Nations, Nisga'a totem traditions were disrupted during the nineteenth century as Europeans either destroyed totems or sent them to be displayed in museums as artifacts. In 1977, the UBC Museum of Anthropology featured a solo exhibit of Tait's works, which was rare for a First Nations artist at the time. He was known for his realistic detailing and was a master in large- and small-scale works. Tait worked closely with his apprentice Lucinda Turner, who became his carving partner on numerous projects.

Chief's Helmet, 1973–2001
Wood, paint, horsehair, teeth; 26 × 20 × 17½ in.
Collection of George and Colleen Hoyt 420

This headpiece was originally started in 1973 and was a long-lasting project by Tait. He worked on it periodically throughout the years, perfecting the killer whale design, and completed it with his assistant Lucinda Turner in 2001. The dates are written inside the helmet by the artist.

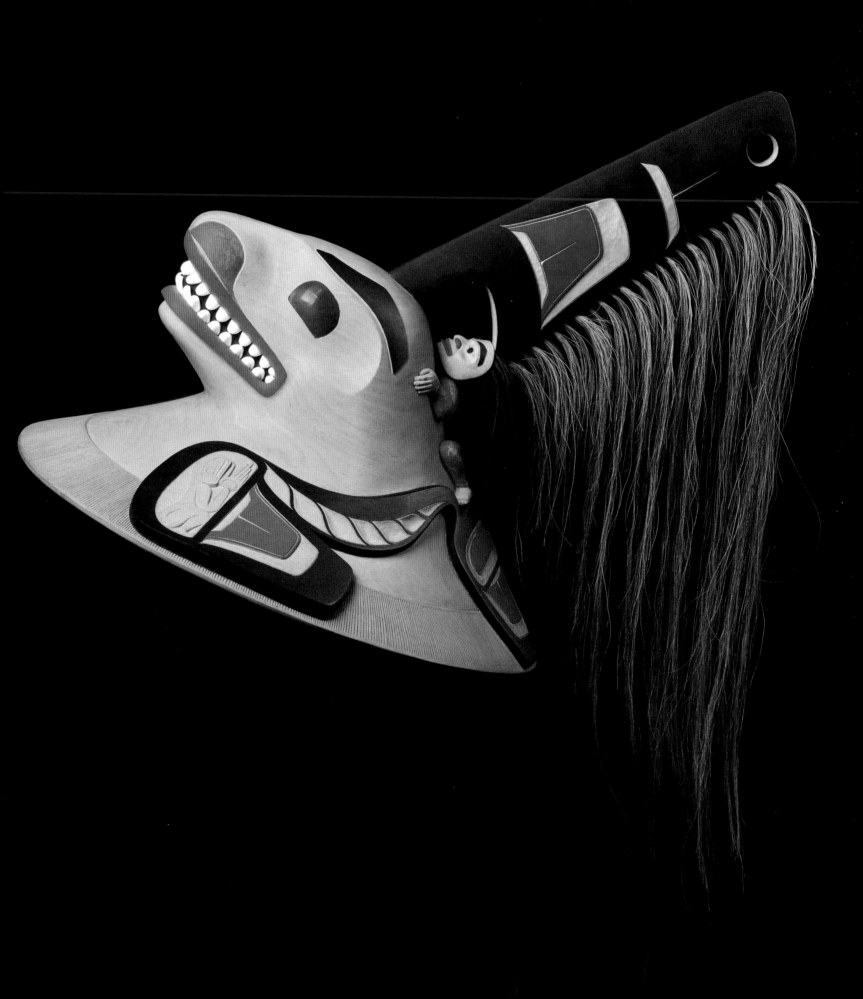

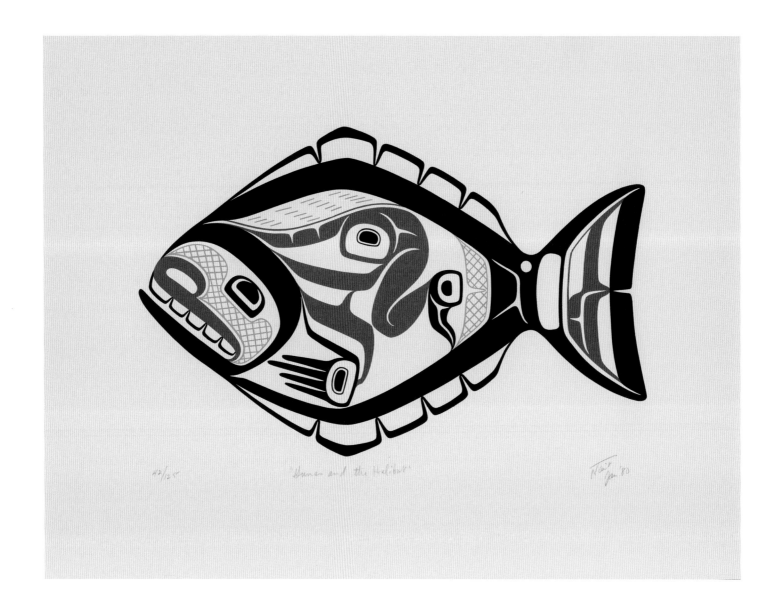

Gunas and the Halibut, 1980
Silkscreen; 11 × 14½ in.
Ed. 24/125
Collection of George and Colleen Hoyt 409

The story in this print is based on a genre of oral litera-
ture called a crest legend (the crest here being Gunas).
One day while traveling, Gunas went swimming and
was swallowed by a giant halibut. When his people
called upon an eagle to rescue him, they cut open the
halibut to find his body already decaying. His death
created a symbolic debt and the family earned the
right to fish the halibut.

Raven Rattle, 1971
Wood; 4½ × 14 × 4½ in.
Collection of George and Colleen Hoyt 485

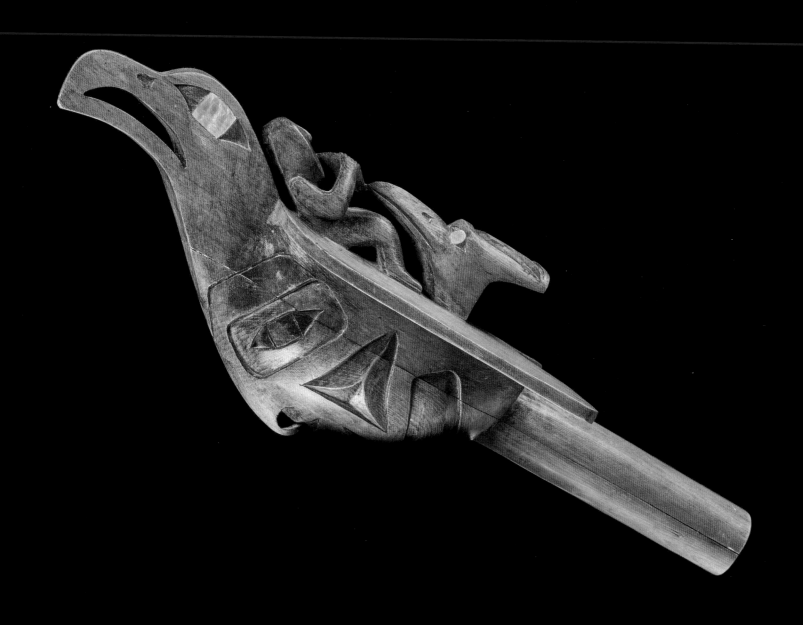

Tony Hunt Sr.
(Kwakwaka'wakw, 1942–2017)

Tony Hunt Sr. was born in Alert Bay, British Columbia. In 1952, his family moved to Victoria, where he learned carving from his maternal grandfather, Mungo Martin, and father, Henry Hunt. From 1962 to 1972, he worked as the assistant carver to his father at Thunderbird Park. After resigning from his position there, Hunt focused his attention on the Arts of the Raven Gallery that he co-founded with non-Indigenous artist John Livingston in Victoria in 1970. The gallery offered an apprenticeship program for young First Nations artists to gain skills in various art forms and other educational resources. Hunt had also mentored his son, the late Tony Hunt Jr., an accomplished artist as well. During his lifetime Hunt received numerous awards for his artwork, including the Commonwealth Medal of Honor and the Order of British Columbia.

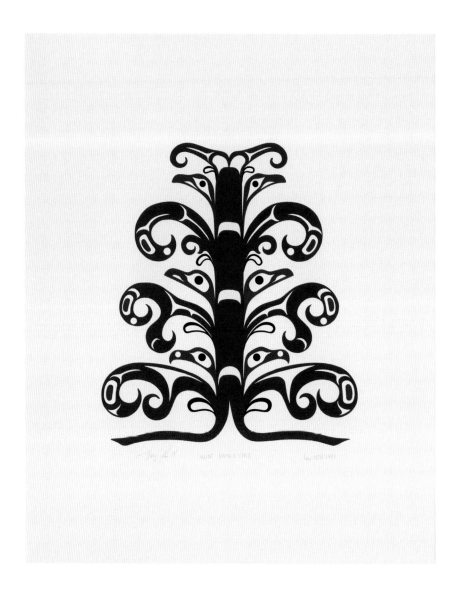

Hunt Family Tree, 1988
Silkscreen; 20 × 25 in.
Ed. 66/150
Collection of George and Colleen Hoyt 401

Kwa Giulth Thunderbird Design for Box Drum, 1974
Silkscreen; 23 × 15 in.
Ed. 39/400
Collection of George and Colleen Hoyt 118

Thunderbird is a supernatural being of power and strength. Its massive wings are said to create thunder and strong winds. This print was created as a box design and is similar to others leaving little room for negative spaces, utilizing the entire surface.

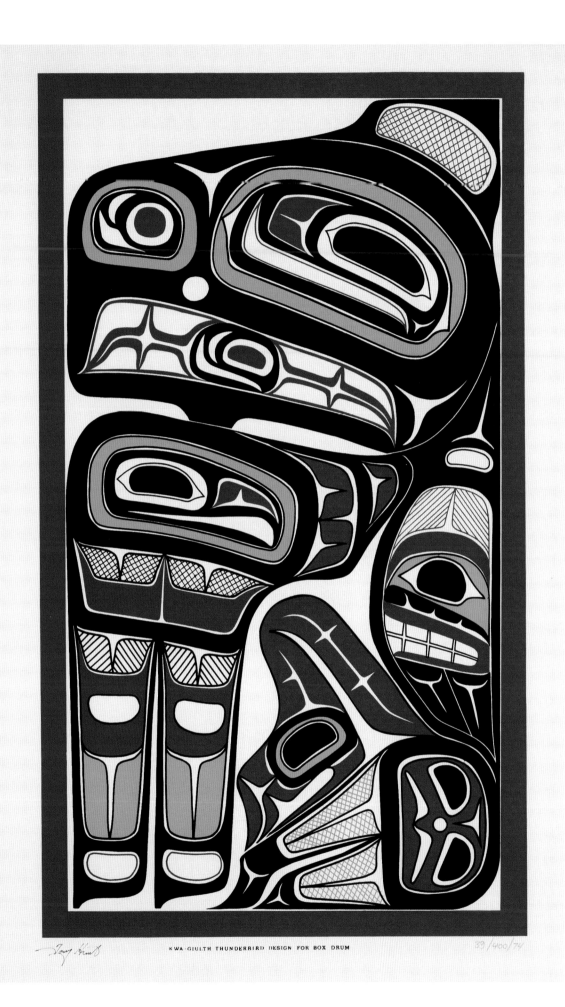

KWA-GIULTH THUNDERBIRD DESIGN FOR BOX DRUM

Larry Rosso

(Carrier, 1944–2006)

Born in Burns Lake, British Columbia, Larry Rosso was a versatile artist who began carving at an early age with his grandfather. He later studied under Doug Cranmer and then apprenticed with Robert Davidson for three years after the two worked together on a project in 1988. Rosso's style was greatly influenced by Carrier and Kwakwaka'wakw designs and traditions. He was well known for his bentwood technique on wooden bowls and boxes. However, his body of work included coffee tables, wall panels, masks, paintings, and serigraphs (silkscreen prints). When he first saw the value of the printmaking industry, Rosso started Northwest Coast Screencrafts and specialized in printing limited-edition serigraphs for First Nations artists like Robert Davidson and Roy Henry Vickers. His support and mentorship helped make screen printing more accessible to many local artists.

This box has a nearly invisible seam and highlights Rosso's skill and attention to detail. Bentwood boxes are used for both functional and ceremonial purposes. The technique requires one plank of wood to be steamed, scored, molded, and then joined together to create all four sides.

Bentwood Fishing Box, 1987
Cedar, paint, leather; 18 × 12 × 12 in.
Collection of George and Colleen Hoyt 10

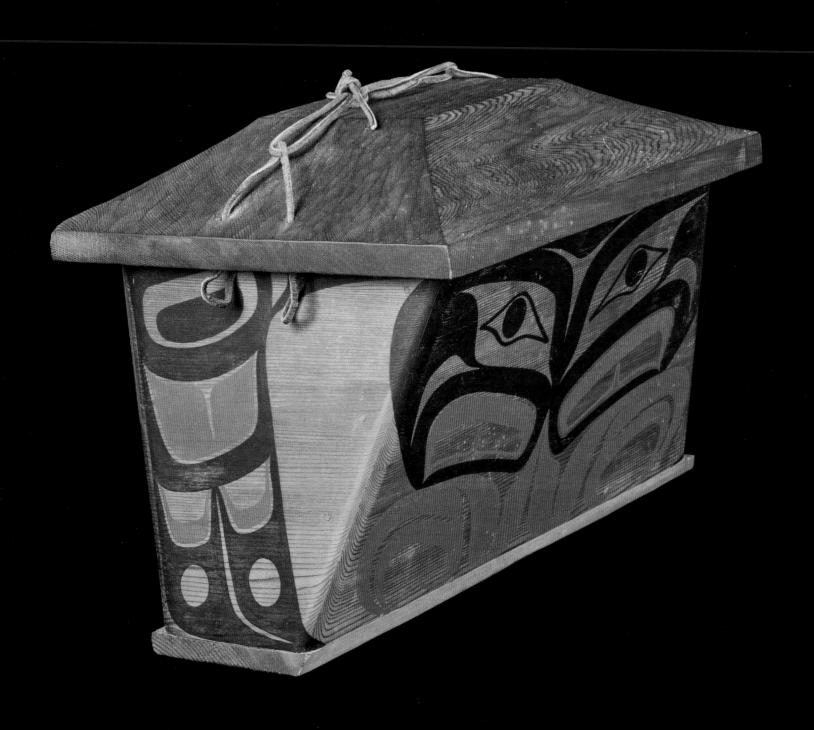

Joe David
(Nuu-chah-nulth, b. 1946)

Joe David was born in Opitsaht, British Columbia, to parents who raised him with a foundation in his cultural heritage. He studied art in San Marcos, Texas, and in Seattle took inspiration from the Northwest Coast art at the University of Washington's Burke Museum and the work of scholar Bill Holm. David later worked with and learned from many Northwest Coast artists, including his cousin Ḳi-ḳe-in (Ron Hamilton), Art Thompson, Bill Reid, and Robert Davidson, and non-Indigenous artist Duane Pasco. Through his studies and experiences with different artists around the world, he defined his own style working with wood, bronze, oils, and jewelry and became one of the key figures in the resurgence of Northwest Coast art. In 1977, he added silkscreen printing as another medium and released several significant limited-edition prints in a West Coast style, which tends to have more fluid formlines. David has taken on numerous commissions for large projects around the world, including two large welcome figure sculptures for Expo 86 in Vancouver that are now located at the Vancouver International Airport. In 2000, he had the honor of being the first artist chosen for the Aboriginal Artist in Residence Program at Pilchuck Glass School in Seattle.

Portrait Mask, 1973
Wood, paint, horsehair; 10 × 7 × 4 in.
Collection of George and Colleen Hoyt 457

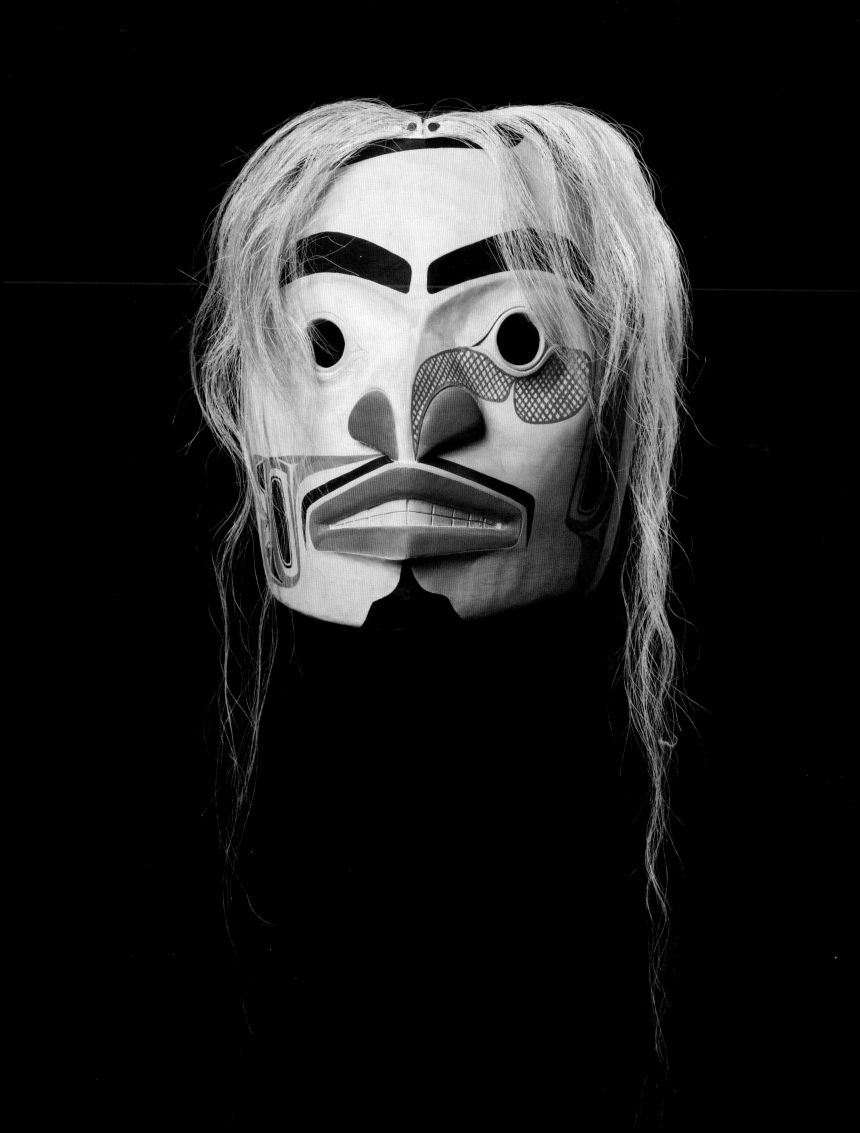

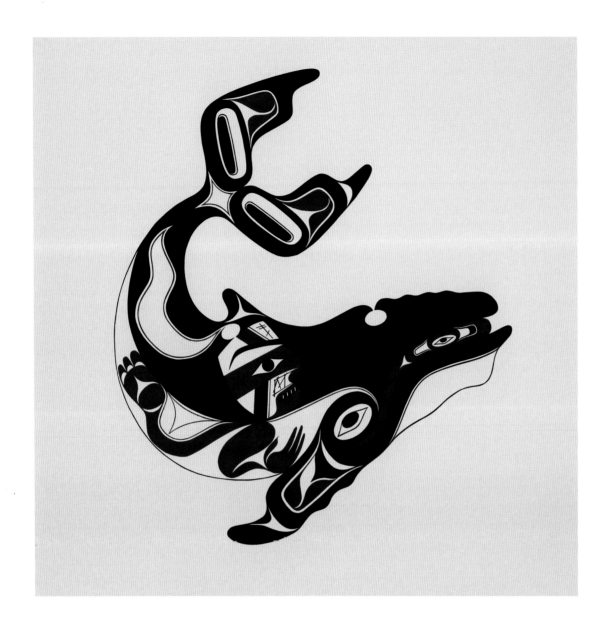

Whaler's Story, twentieth century
Silkscreen; 30 × 30 in.
Ed. 1/75
Collection of George and Colleen Hoyt 190

"Gunarh and the Whale" is a myth about a man who had warned his new wife to be cautious of the sea. One day, when she was washing a pelt, she was taken by the killer whale chief to live under the water. Gunarh cried and wandered the shoreline for many days until another killer whale arrived to help. Together the two searched the depths until they found a large copper house and rescued his wife from inside.

Ba̱k'wa̱s Wildman Mask, 1975
Wood, paint, horsehair; 15 × 7 × 5 in.
Collection of George and Colleen Hoyt 429

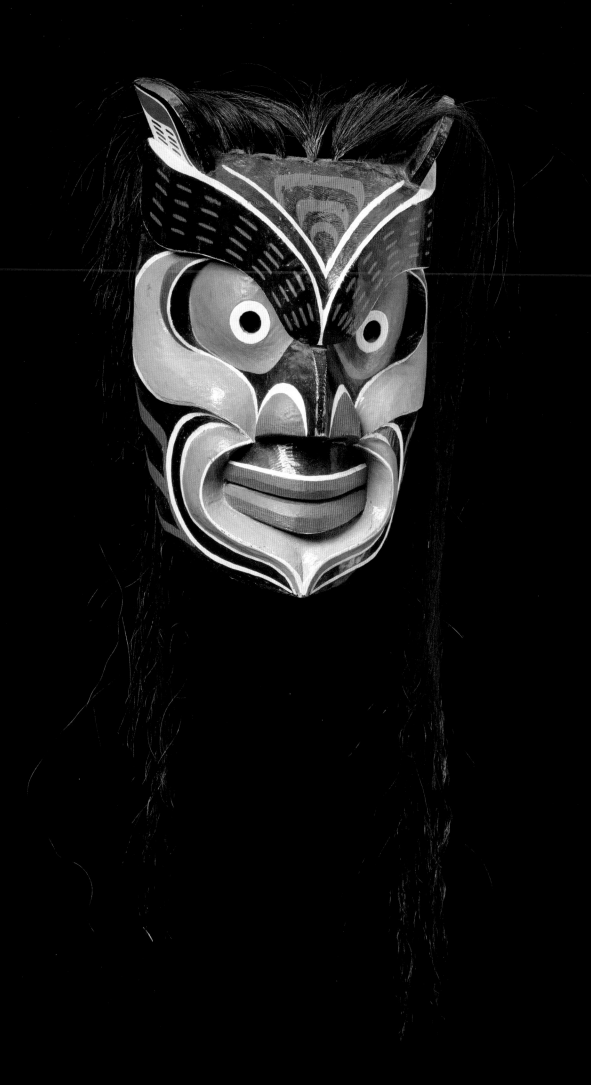

Robert Davidson
(Haida, b. 1946)

Robert Davidson Jr., or Guud Sans Glans, is an internationally acclaimed artist who was born in Hydaburg, Alaska, and later raised in Old Massett on Haida Gwaii. He began carving at age thirteen under the tutelage of his father, Claude Davidson, and his grandfather, Robert Davidson Sr. In 1965 he moved to Vancouver and began to learn more about Haida art and culture through the city's museum collections. He briefly worked with Bill Reid and through him met Bill Holm and UBC anthropologist Wilson Duff. In 1967, he enrolled at the Vancouver School of Art (now the Emily Carr University of Art + Design) to refine his skills. Then, at twenty-two, with the help of his father and brother, he carved and raised the first totem pole in Masset in nearly ninety years. In 1992, Davidson, along with Bill Reid, Christie Harris, and Margaret Blackman, published an illustrated children's book titled *Raven's Cry* that is a fictionalized retelling of the cultural erasure attempts in Haida Gwaii by the Canadian government. Davidson continues to be a leading figure in the upsurgence of Haida art and culture and has gone on to receive many honors for his accomplishments.

Watchman, 2011
Silkscreen; 40 × 30 in.
Ed. 6/74
Collection of George and Colleen Hoyt 205

Davidson is known for his brilliant, abstracted interpretations of Northwest formline design. This print is based on a 2009 acrylic painting of the same name and references the tradition of the watchman in Haida culture and art. Watchmen played important roles as sentinels watching for approaching danger; in Haida art, they are often represented in groups of three or more on the tops of poles. Here, Davidson presents a watchman in profile, looking out with intense gaze and perhaps calling out, indicated by the open mouth and protruding tongue.

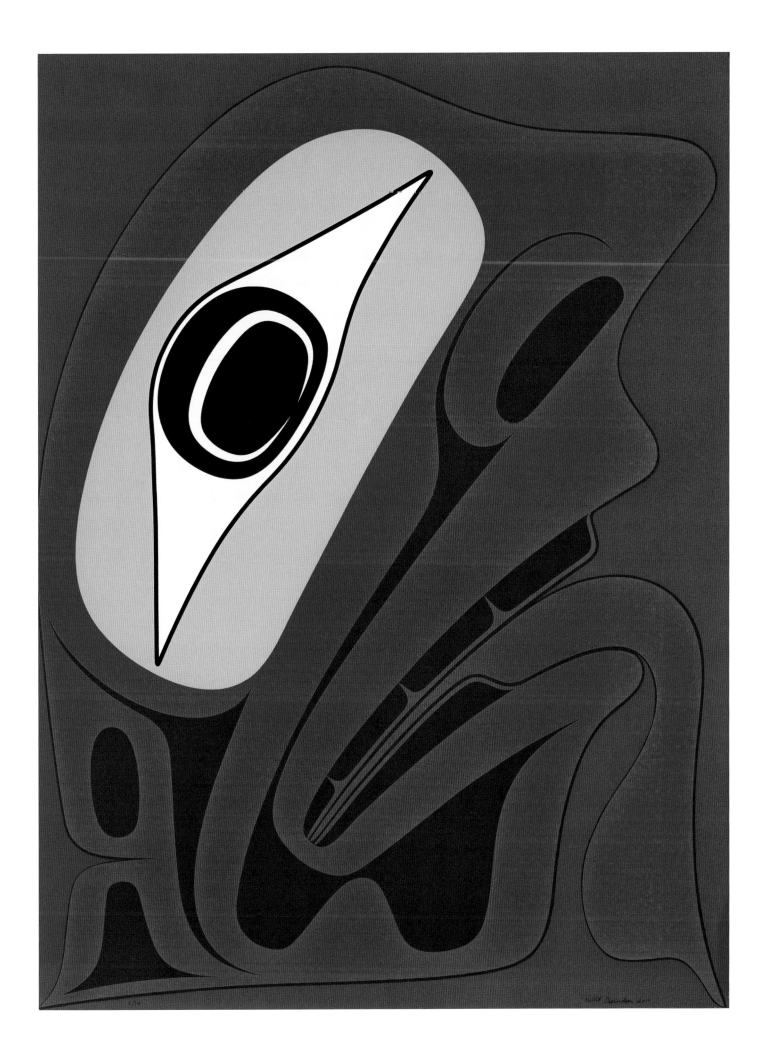

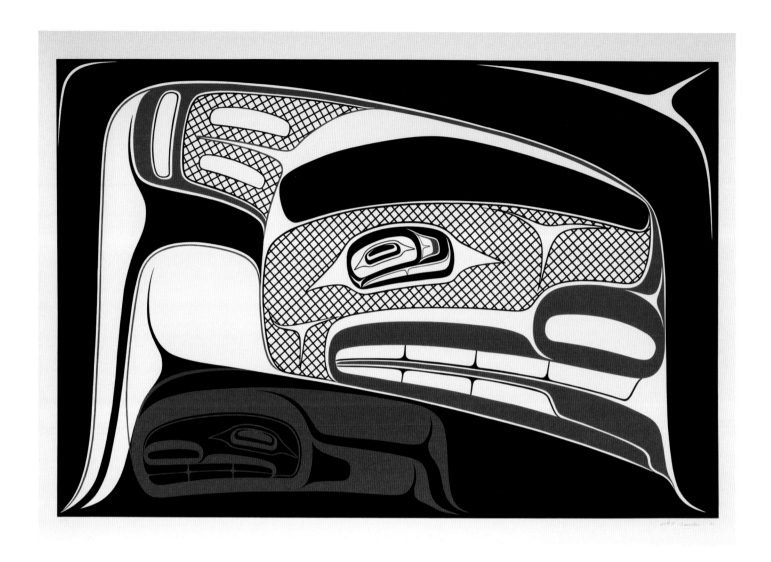

Wolf inside Its Own Foot, 1983
Silkscreen; 30 × 41 in.
Ed. 19/99
Collection of George and Colleen Hoyt 259

There Is Darkness in Light, 2012
Silkscreen; 60 × 30 in.
Ed. 77/100
Collection of George and Colleen Hoyt 272

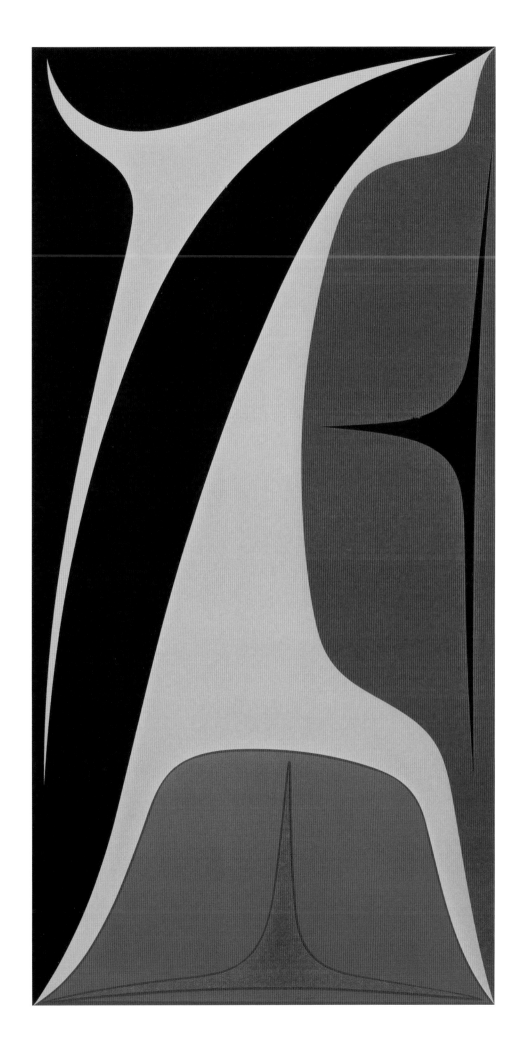

Roy Henry Vickers
(Tsimshian, b. 1946)

Born in Greenville, British Columbia, Roy Vickers is known for his use of bold, primary colors and emphasis on animals, nature, and spiritual symbols. He comes from Tsimshian, Haida, Heiltsuk, Scottish, and Irish lineages, diverse heritages that he blends together in his art. He became a professional artist after finishing his studies at the Kitanmax School of Northwest Coast Indian Art in 1974. When he began his career, he focused on blacks, reds, and whites due to his color blindness, but has since developed a system by which he can use a wider range of colors. In 1980 he made the decision to incorporate new stylistic choices that he felt represented his mixed heritage better and helped his art become more accessible. In addition to printmaking, Vickers is an accomplished painter and carver who has created more than twenty-five totem poles, including the Salmon Totem for the 1994 Commonwealth Games near Victoria. In 1986 he opened Roy Henry Vickers Gallery in Tofino, BC, in a longhouse-style building he built with family and fellow artists.

Spring Salmon, 1980
Silkscreen; 19½ × 25 in.
Ed. 107/150
Collection of George and Colleen Hoyt 57

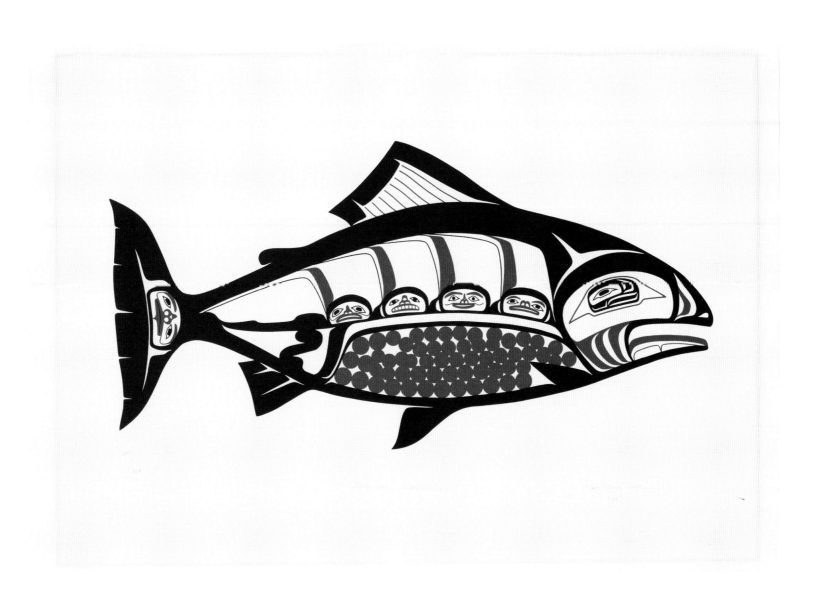

Dempsey Bob
(Tahltan-Tlingit, b. 1948)

Dempsey Bob was born in Telegraph Creek, British Columbia, and began carving in 1968. He attended the Kitanmax School of Northwest Coast Indian Art from 1972 to 1974 and learned from mentor and teacher Freda Diesing, who he credits as a major influence on his work. Determined to create his own style, Bob began to travel around the world so that he could also study older Tlingit pieces that were located primarily in museums and private collections at the time. Today, Bob's preferred medium is wood, but he also enjoys creating bronze sculptures and prints that are strongly influenced by Tlingit designs. Bob is a highly celebrated artist and educator known for being a major innovator of the Tahltan-Tlingit style.

Young Killer Whale Mask, 1997
Alder, leather; 12½ × 7 × 6 in.
Collection of the Hallie Ford Museum of Art, Salem, Oregon, 2016.036
The George and Colleen Hoyt Northwest Coast Indigenous Art Fund

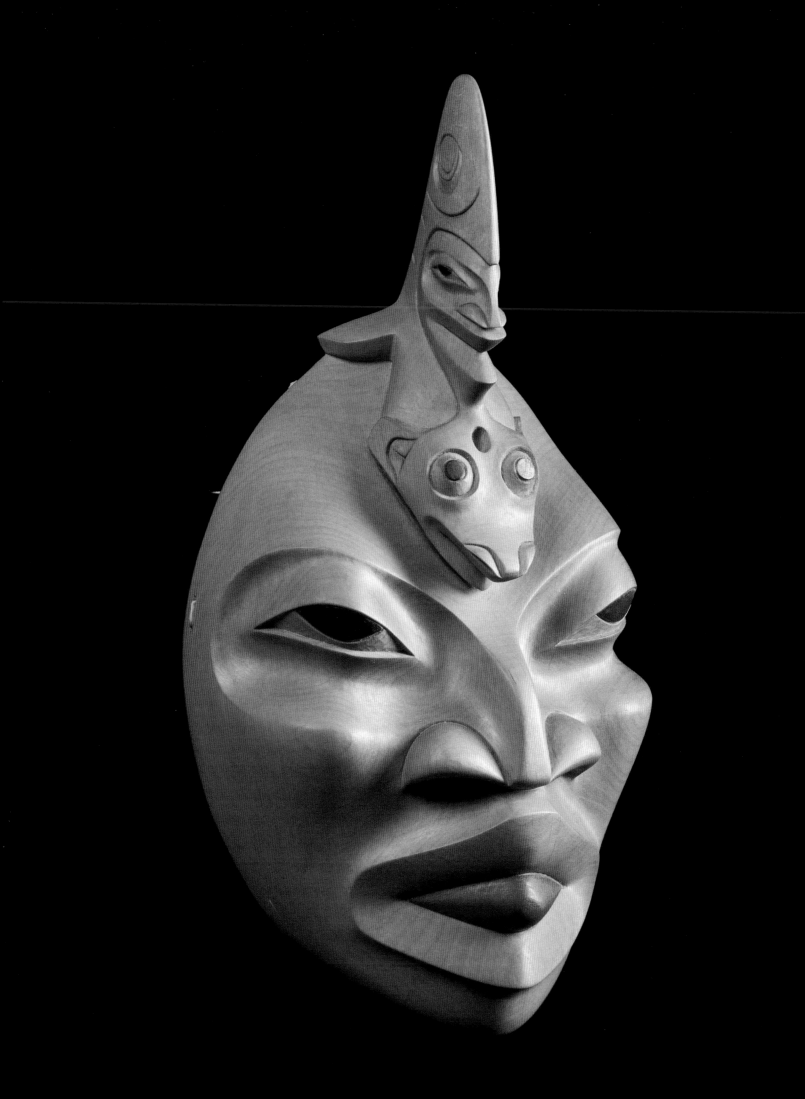

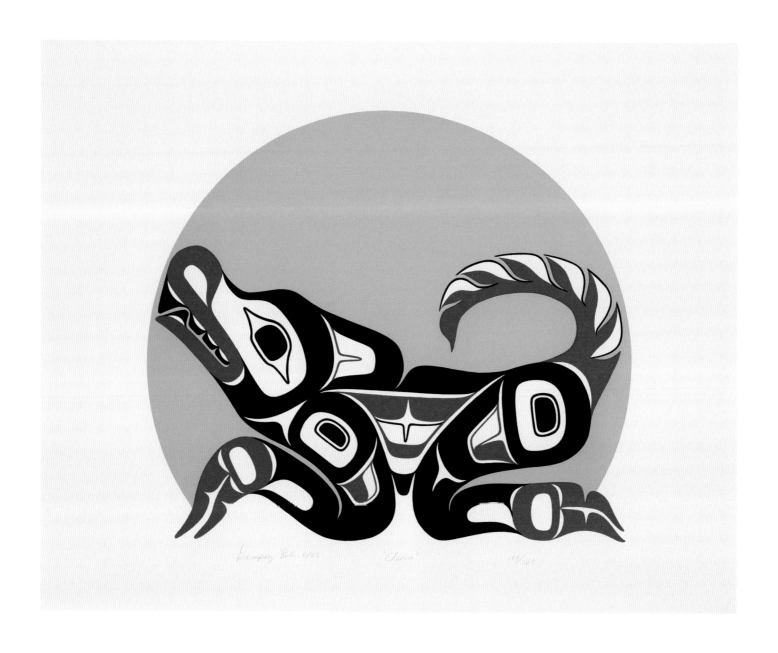

Cheona, 1983
Silkscreen; 16 × 19 in.
Ed. 120/160
Collection of George and Colleen Hoyt 151

Bear Bowl, 1988
Alder, paint; 5 × 17 × 8 in.
Collection of George and Colleen Hoyt 397

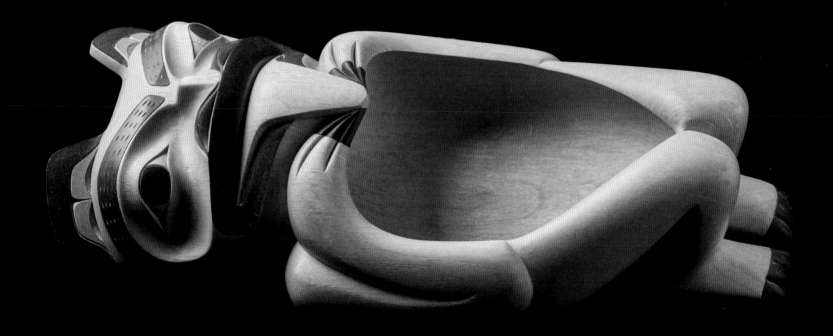

Greg Colfax

(Makah, b. 1948)

Greg Colfax was born in Neah Bay, Washington, and is an educator, creative writer, and artist. He obtained degrees from both Western Washington University and the University of Washington and has taught in the Native American Studies Program at The Evergreen State College in Olympia, Washington. In 1974 he began studying under artists Art Thompson, George David, Steve Brown, and Loren White. Since then, he has taught and worked with many artists including Andy Wilbur-Peterson, who in 1984 helped him carve the *Welcome Woman* that stands at the entrance of the Evergreen College campus. The *Welcome Woman* was restored by Colfax and Wilbur-Peterson's daughter Bunni Peterson-Haitwas (Skokomish) in 2019.

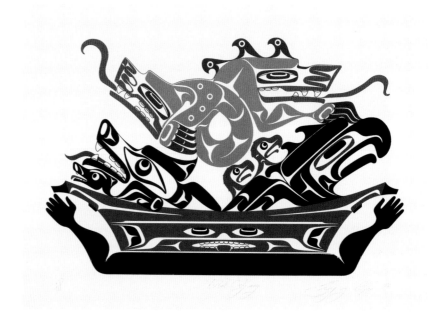

Tribal Odyssey, 1996
Silkscreen; 21½ × 29½ in.
Artist's proof
Collection of George and Colleen Hoyt 202

Pooq-oobs Mask, twentieth century
Wood, paint, cedar bark; 25 × 13 × 8 in.
Collection of George and Colleen Hoyt 288

Greg Colfax, in an artist statement included in George Hoyt's 2016 notes regarding this print, explained: "The figure at the top is a Lightning Serpent which is ruler of the realm of man's imagination. He contains and yet transcends all the colors of the design. The canoe has two bows because it is a canoe of 'modern times' and is going in all directions at once. The black band on the water below represents the ancestors who (at one time at least) prayed for us (thus the upraised arms.) The figures in the canoe represent the Makah people (some Thunderbird clan and other Wolf clan)."

Pooq-oobs (sometimes Pookmis), Wild Man of the Sea, is the transformed spirit of a whale hunter who was lost at sea and appears in many Kwakwa̠ka̠'wakw myths. Pooq-oobs masks have distinctive features, including pursed lips and hair tied in a topknot, and are often painted white to symbolize the effects of drowning. He is the counterpart to the Wild Man of the Woods.

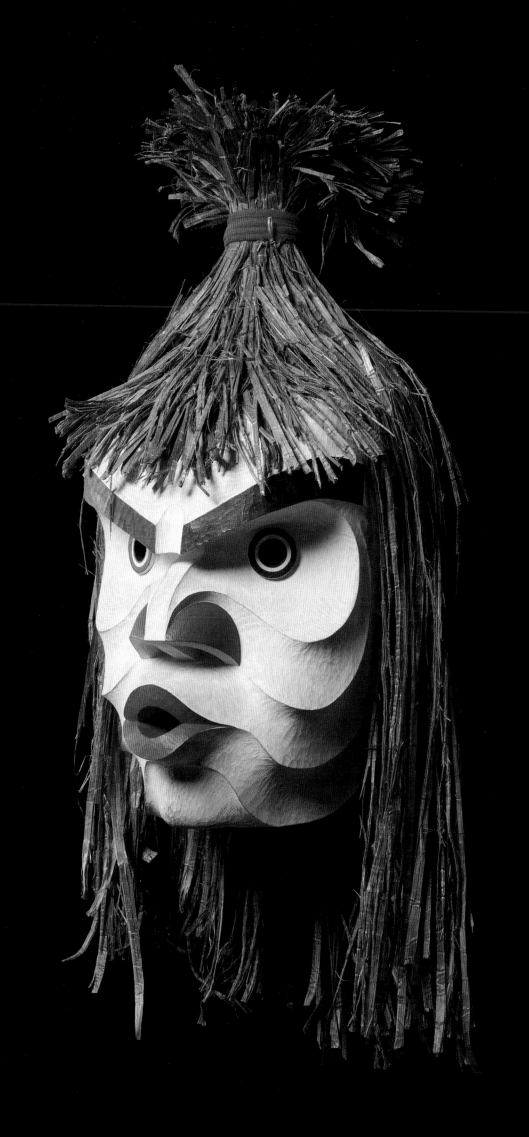

Ḳi-ḳe-in
(a.k.a. Ron Hamilton)
(Nuu-chah-nulth, b. 1948)

Ḳi-ḳe-in, also known as Hupquatchew and
Ron Hamilton, is a member of the Hupacasath
(Opetchesaht) First Nation under the Nuu-chah-
nulth Tribal Council. He was born at Ahaswinis,
British Columbia, and while still a teenager, in
1965, found his passion in designing art. He
spent time around different family members
who taught him how to carve and paint from
an early age. Ḳi-ḳe-in remembers growing up
around his uncle George Cultesi feeling con-
flicted about how his uncle's carvings and paint-
ings were being prized as trophies by some
non-Indigenous people. In 1971, he apprenticed
with Henry Hunt and worked as a carver at the
Royal British Columbia Museum until 1974. He
then returned home to learn more about Nuu-
chah-nulth ceremonial and social life. Ḳi-ḳe-in
has made the conscious choice to limit his
commercial work to screenprints and prefers to
carve masks, rattles, and drums exclusively for
other First Nations peoples. He has created his
own variation on West Coast style that he shares
with his cousin, Joe David.

Tukuk, 1981
Silkscreen; 14¾ × 16½ in.
Ed. 50/80
Collection of George and Colleen Hoyt 128

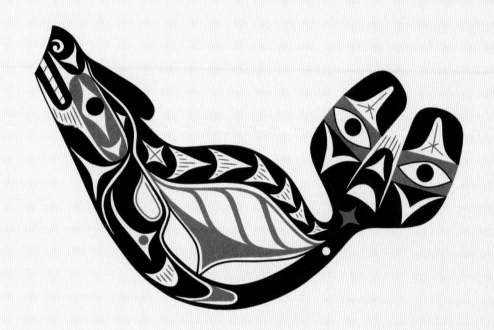

 Opetcheemutit Tiila
Tukik 39/60
Pei kumgutagutin

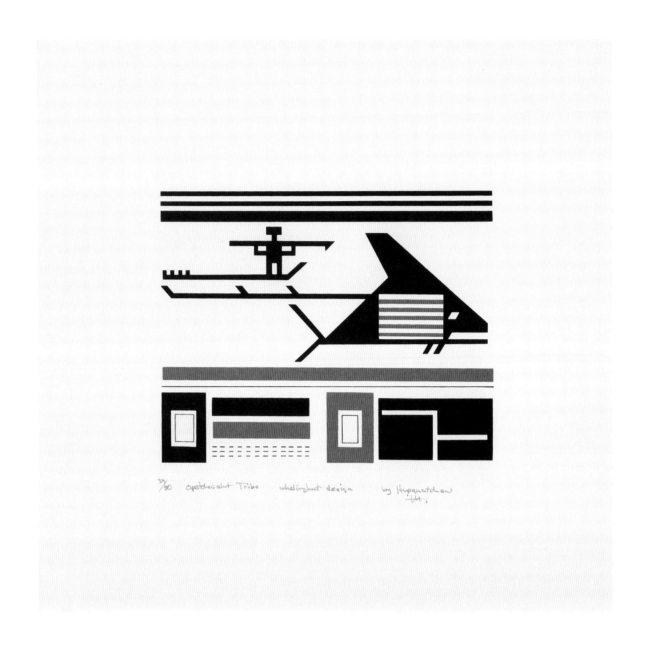

Whaling Hat Design, twentieth century

Silkscreen; 12 × 12 in.

Ed. 39/90

Collection of George and Colleen Hoyt 367

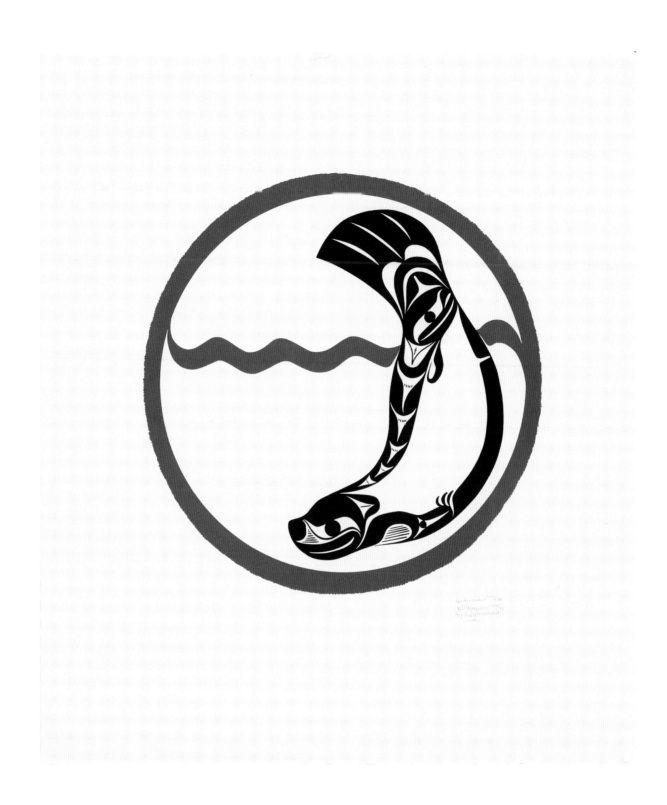

Killtianoos, 1994
Silkscreen; 22 × 19½ in.
Ed. 65/77
Collection of George and Colleen Hoyt 166

Robert Jackson

(Gitxsan, b. 1948)

Robert Jackson was born in Port Edward, British Columbia. He grew up in a small community where he met fellow future artist Dempsey Bob; the two would carve their own toys together. In the 1960s, Jackson refined his skills by studying and replicating older Gitxsan art. Jackson went on to attend the Kitanmax School of Northwest Coast Indian Art, where he practiced wood carving, jewelry making, and serigraph printing from 1973 to 1976. From 1979 to 1984, Jackson owned and operated the Skyclan Art Shop in Prince Rupert, BC, which specialized in Northwest Coast art. He has been credited as a leading innovator and technician for his work with Gitxsan portrait mask design.

Portrait Mask, 1989
Wood, paint, cedar bark; 10½ × 10 × 2¾ in.
Collection of George and Colleen Hoyt 550

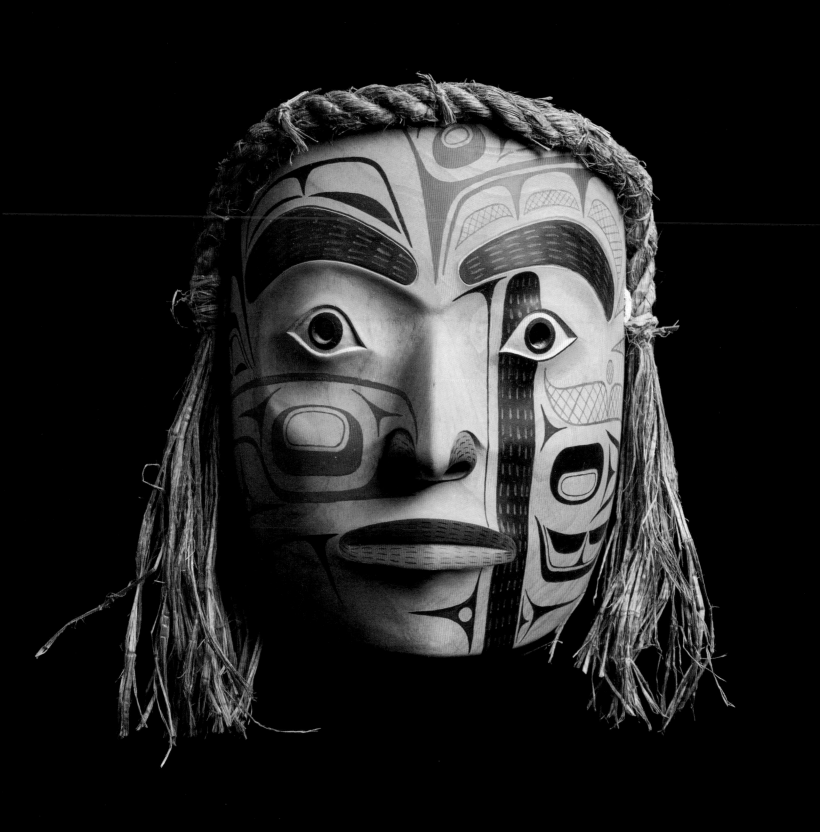

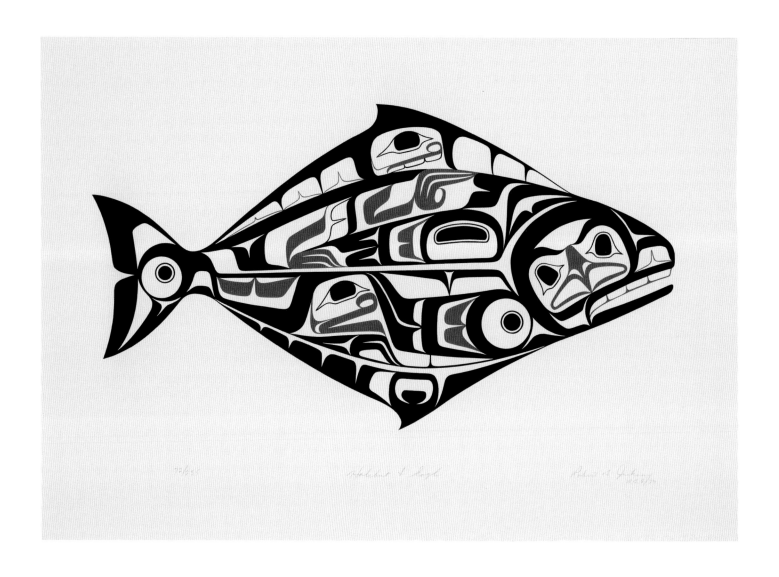

Halibut and Eagle, 1979
Silkscreen; 14 × 20 in.
Ed. 72/235
Collection of George and Colleen Hoyt 116

Raven and Frog Canoe Bowl, twentieth century
Wood, paint; 6 × 10 × 6½ in.
Collection of George and Colleen Hoyt 394

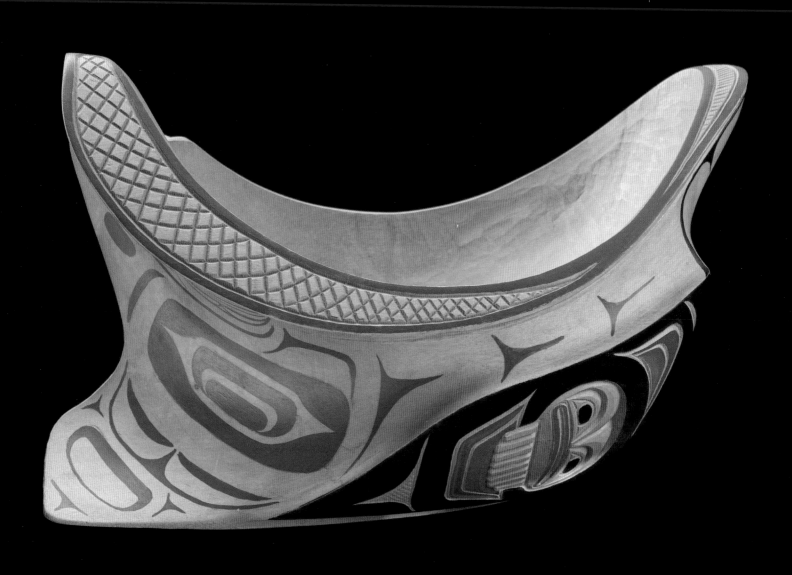

Art Thompson

(Ditidaht/Nuu-chah-nulth, 1948–2003)

Art Thompson was born in Whyac, British Columbia. He is widely known for his approach to the silkscreen medium in terms of colors and subject matter. In 1964, Thompson graduated from residential school; later, he became a powerful spokesperson about child abuse in the system. As an adult, he attended Camosun College, where he studied fine arts, and then Vancouver School of Art (now the Emily Carr University of Art + Design), where he focused on two- and three-dimensional forms. In 1973, Thompson began to produce print images for serigraphs and drums. He was also known for his work with wood sculptures, masks, and silver engraving. Thompson's work continues to inspire many Northwest Coast artists.

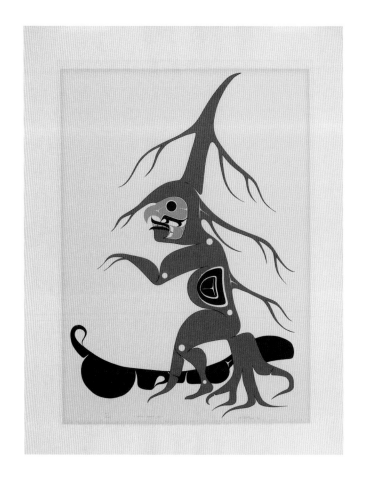

This image honors the spirit of the cedar tree, which is core to Northwest Coast cultures, as it provides material for housing, clothing, tools, canoes, baskets, and carvings and masks. Thompson was drawing attention to how the spirit of the cedar is thanked before any part is harvested for use.

Uthl-muc-ko (Yellow-Cedar-Man), 1977
Silkscreen; 29½ × 23½ in.
Ed. 57/100
Collection of George and Colleen Hoyt 274

Tribute to My Grandfather, 1998
Wood, fiber, paint; 36 × 36 × 10 in.
Collection of George and Colleen Hoyt 511

This mask represents the transition of Thompson's grandfather, Tooq-beek, from life to death. Tooq-beek had once witnessed the Wild Man of the Woods, who then became a part of his spiritual identity. When the operator opens the mask with one of the handles it reveals the transformation from human to Wild Man.

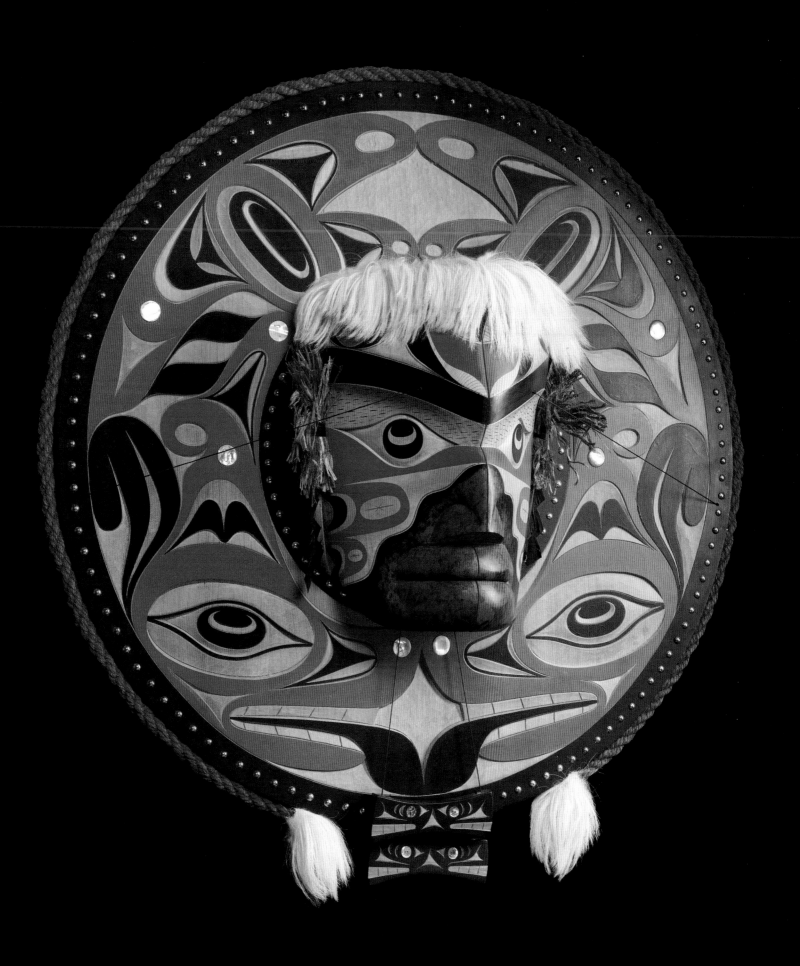

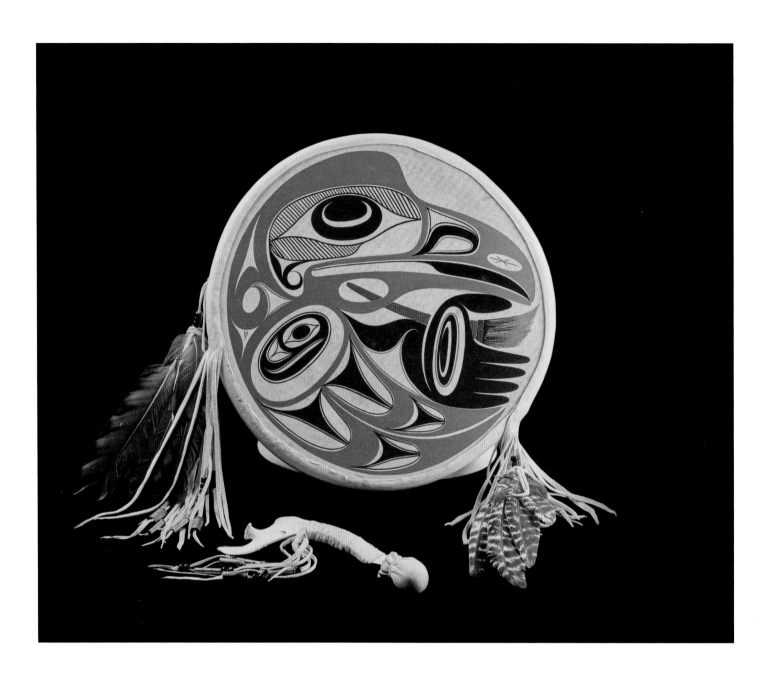

Raven Painting Itself, twentieth century
Silkscreen on hide drum; 19 × 12 × 7 in.
Collection of George and Colleen Hoyt 452

Wolf Mask, 1991
Wood, copper, paint; 14 × 9 × 18 in.
Collection of George and Colleen Hoyt 455

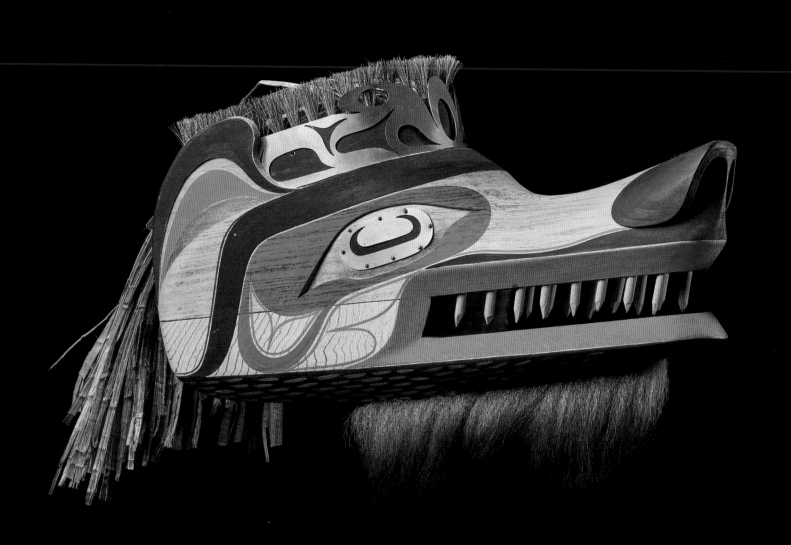

Gerry Marks
(Haida, 1949–2020)

Gerry Marks was born in Vancouver, British Columbia, and grew up without much knowledge about Haida art. When he was twenty, he discovered the metalwork of his grandfather John Marks, and began to gain an interest in learning about his heritage. In 1971, he apprenticed under Freda Diesing, who taught him about Northwest Coast design. He later attended the Kitanmax School of Northwest Coast Indian Art, where he met teacher Alfred Joseph. In 1984, he was assigned as the lead carver for a pole at the Royal British Columbia Museum that he created with the help of Richard Hunt and Tim Paul. Marks was known for his attention to detail in both his carvings and screen prints.

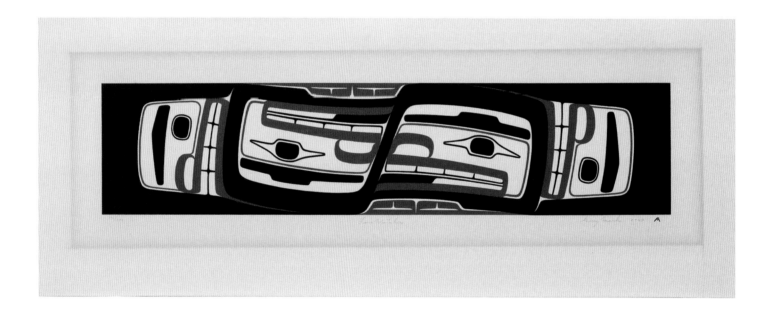

Four Watchers, 1980
Silkscreen; 5 × 18 in.
Ed. 116/119
Collection of George and Colleen Hoyt 450

Beaver, 1977
Silkscreen; 22 × 30 in.
Ed. 26/75
Collection of George and Colleen Hoyt 219

Each head faces in a different direction as a way to provide protection. In the past, Haida watchmen would help to guard their villages from danger. Today, Haida employees work for the Haida Gwaii Watchmen Program to protect and interpret Haida heritage on the islands of Haida Gwaii.

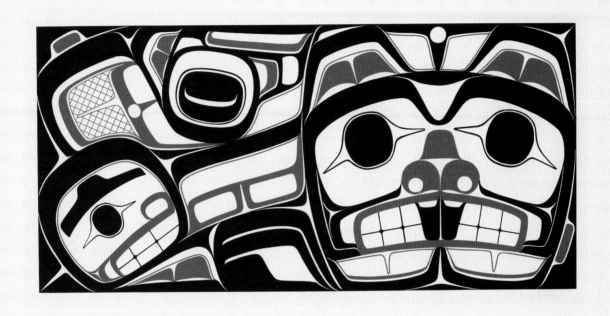

Vernon Stephens
(Gitxsan, b. 1949)

Vernon Stephens was born in Hazelton, British Columbia, and was an instructor at the Kitanmax School of Northwest Coast Art during the 1970s. As a result, he has been a mentor to many artists active today. Stephens is known for his highly stylized interpretations of Northwest Coast art. In his screenprints, he uses a minimalistic approach to formline designs and transforms them into scenes featuring realistic silhouettes of humans and animals. Stephens is also known for his carving and was one of the artists working alongside Earl Muldoe on the entry doors for the University of British Columbia's Museum of Anthropology. He also has several pieces in permanent collections in museums around the province.

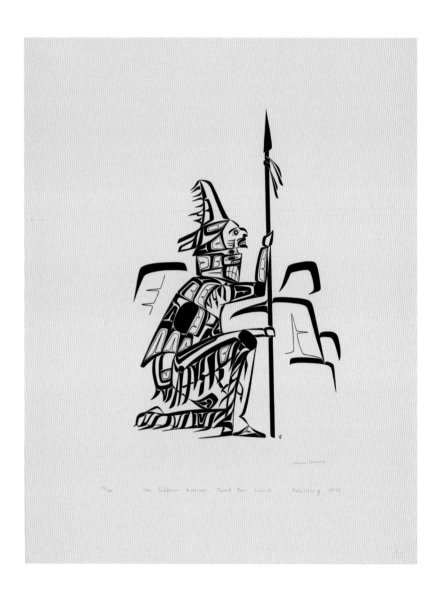

Gitxsan Warrior, Quest for Land, 1975
Silkscreen; 20 × 16 in.
Ed. 14/130
Collection of George and Colleen Hoyt 361

Frog Man Mask, twentieth century
Wood, paint, horsehair, ermine; 8¾ × 8½ × 2¾ in.
Collection of George and Colleen Hoyt 521

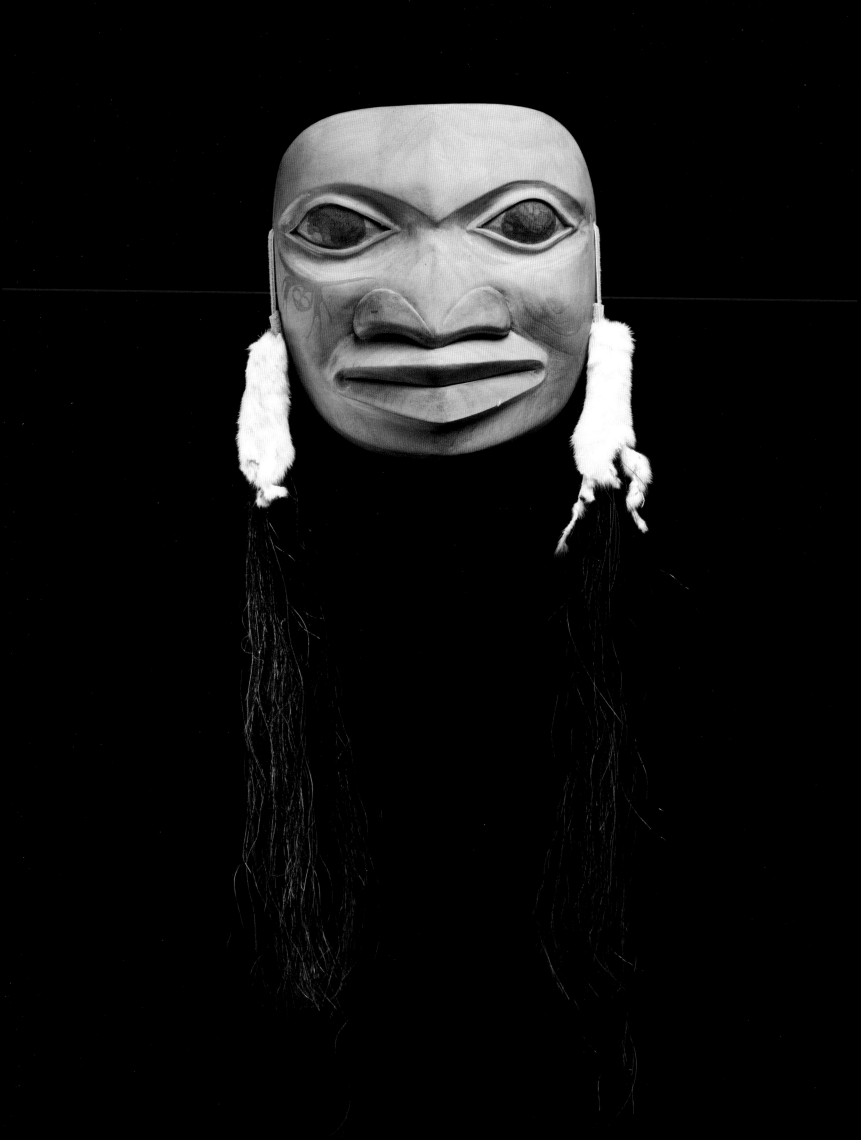

Bruce Alfred

(Kwakwaka'wakw, b. 1950)

Bruce Alfred was born in Alert Bay, British Columbia. He is the son of Clarence Alfred Sr. and Lilac Matilpi and grew up immersed in Kwakwaka'wakw culture. Alfred began his professional career in Northwest Coast art in 1978 and worked under artist Doug Cranmer, who instructed him on flat design, engraving, and bentwood box making. In addition to Cranmer, he has worked with many prominent artists over the years, including Beau Dick, Bill Reid, and his cousins Wayne Alfred and Richard Hunt. Alfred has also worked on several projects through the Arts of the Raven Gallery in Victoria and is best known for his striking masks, rattles, plaques, and bentwood boxes. He also worked on projects to rebuild the Alert Bay Big House and create a Northwest Coast village in the Netherlands.

Bentwood Fishing Box, 2016
Wood, paint; 7 × 12 × 8 in.
Collection of George and Colleen Hoyt 104

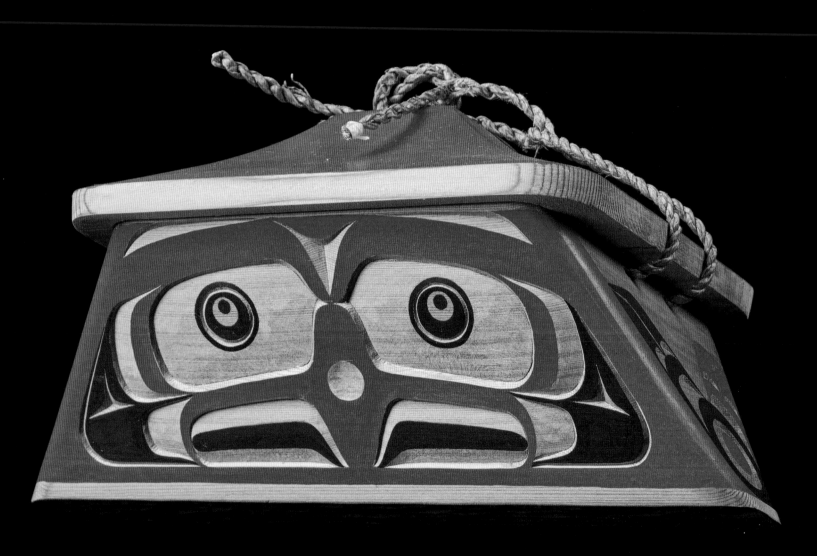

Phil Janzé

(Gitxsan, 1950–2016)

Phil Janzé was born in Hazelton, British Columbia, in 1950. His interest in art started when he would come to work with his grandmother, a curator at the Skeena Treasure House in Hazelton. Janzé did not grow up with any carvers in his immediate family and was primarily self-taught. He began engraving metal at thirteen and learned from studying others' work; however, he never took on a formal apprenticeship. Over the years, Janzé received guidance from many experienced artists, including Walter Harris, Vernon Stephens, Norman Tait, and Gerry Marks. From 1982 to 1984, Janzé was recognized by Canadian Jeweller's Challenge for creating some of the finest pieces in Canada. In addition to jewelry making, Janzé also adapted his intricate designs for wood carvings and silkscreen prints.

Bear Mask, twentieth century
Wood, paint, leather, human hair; 11½ × 8 × 7½ in.
Collection of the Hallie Ford Museum of Art, Salem, Oregon, 2016.004
The George and Colleen Hoyt Northwest Coast Indigenous Art Fund

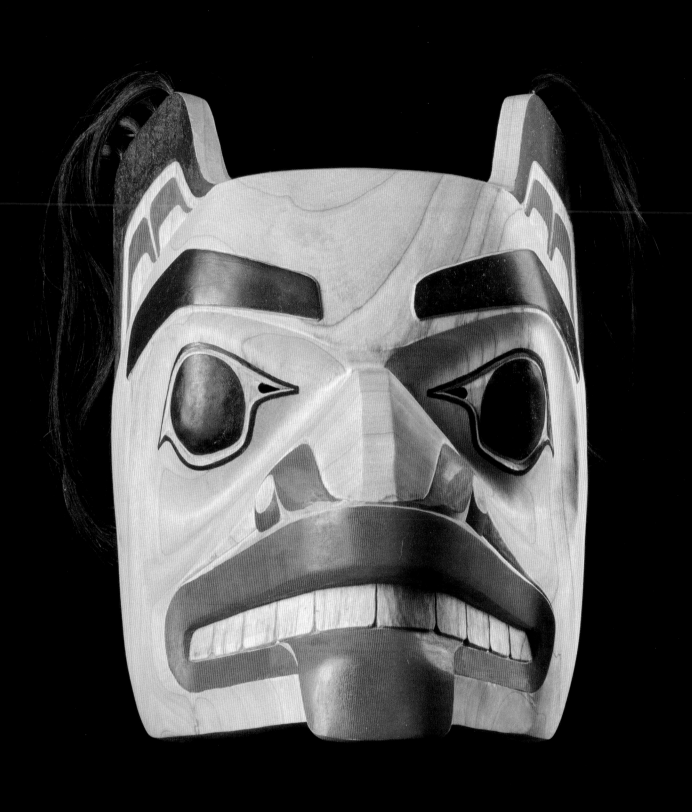

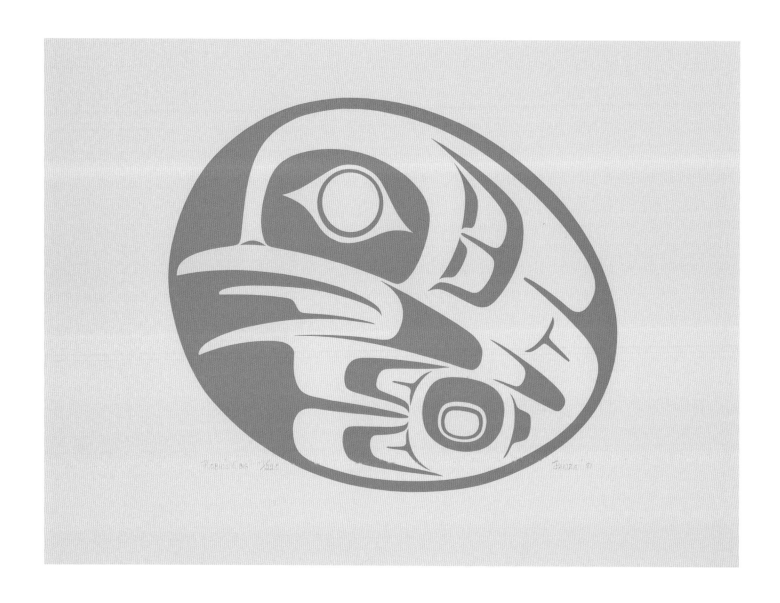

Robin's Egg, 1981
Silkscreen; 11½ × 15½ in.
Ed. 117/225
Collection of George and Colleen Hoyt 322

Robins are very uncommon in Northwest Coast
art compared to Raven, Eagle, Kingfisher, and
Thunderbird. In addition to the species choice, Janzé's
choice of light blue color was unusual in Northwest
Coast prints at that time.

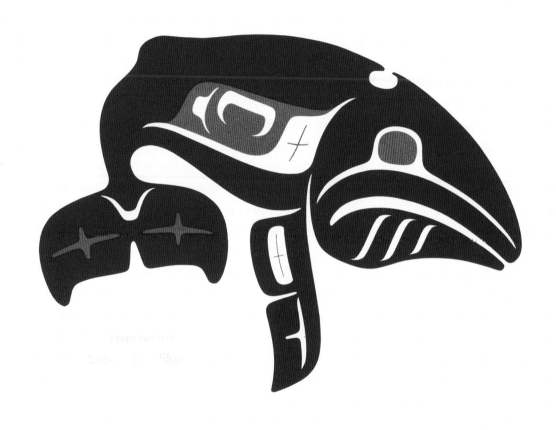

Humpback Whale, 1981
Silkscreen; 11 × 15 in.
Ed. 187/225
Collection of George and Colleen Hoyt 168

Tim Paul

(Hesquiaht/Nuu-chah-nulth, b. 1950)

Tim Paul was born in Zeballos, British Columbia, in 1950. He was raised by his grandparents and heavily immersed in family and tribal histories. At nineteen, Paul visited Thunderbird Park in Victoria and witnessed the carving program then led by artist Henry Hunt. In the 1970s, he began working for the program under the tutelage of Richard Hunt, eventually becoming senior carver himself. In 1992, he decided to leave his position at the museum to help the Port Alberni school board with an education program for First Nations children. Paul continues to practice his interpretations of West Coast sculpture and two-dimensional design. His knowledge of First Nations culture and history greatly influences his work as an artist, environmentalist, and teacher.

Earthquake Mask, 1989
Wood, paint, eagle feather, leather, hemp rope;
12 × 9½ × 6 in.
Collection of George and Colleen Hoyt 16

Earthquake, or Nininigaml, is a supernatural being associated with the natural event of the same name. The wrinkled-up forehead and wavy white lines help illustrate the story of an earthquake. The Hoyts purchased this mask shortly after experiencing the 1989 Loma Prieta earthquake in San Francisco.

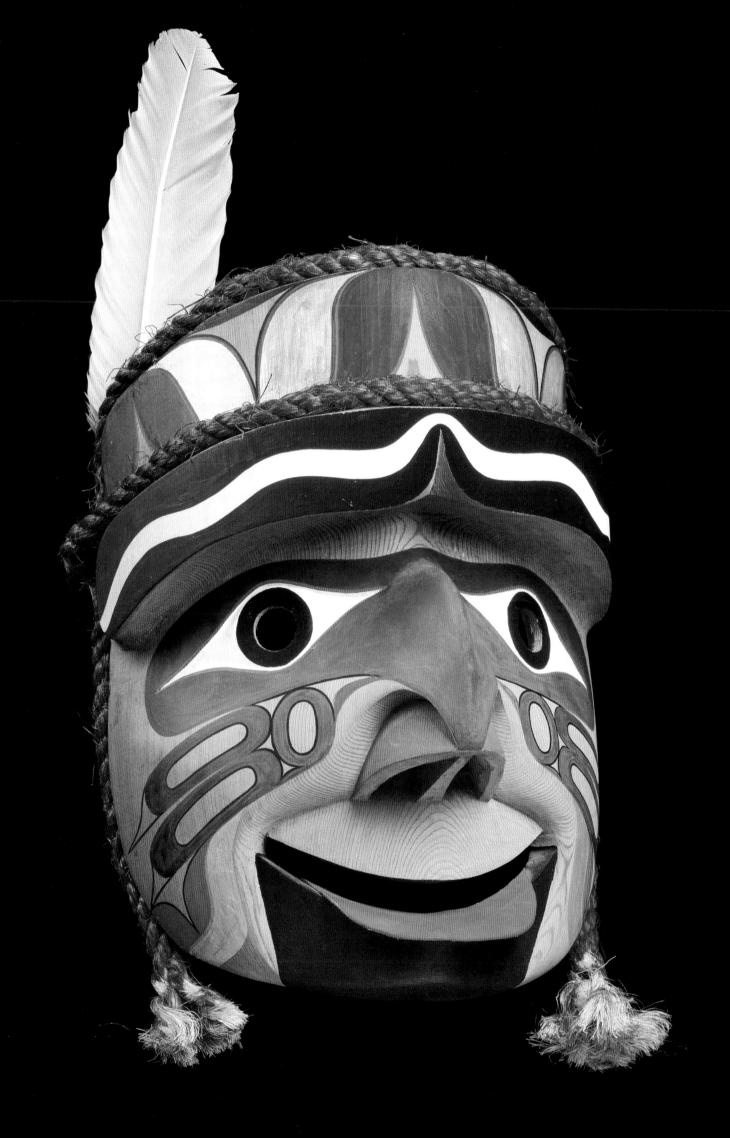

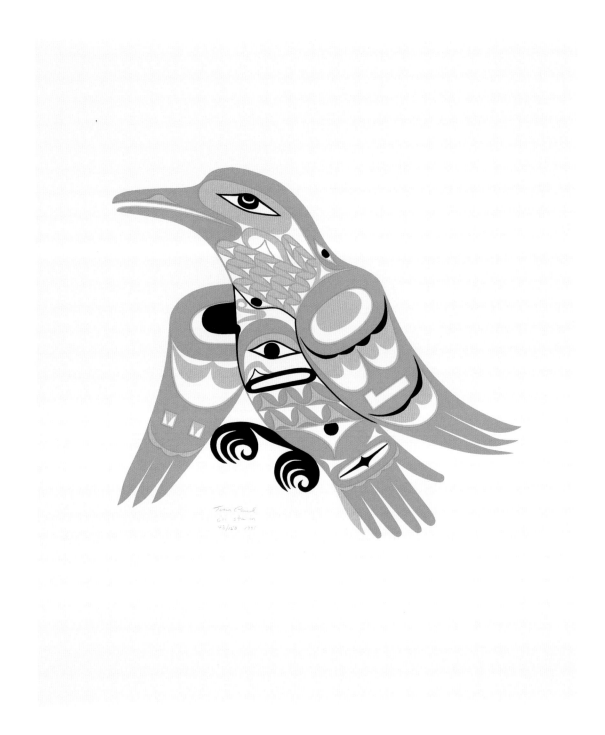

Cii-sta-in, 1991
Silkscreen; 18 × 15 in.
Ed. 43/150
Collection of George and Colleen Hoyt 249

Eclipse, 2017
Red cedar, paint; 20 × 19 × 3½ in.
Collection of George and Colleen Hoyt 331

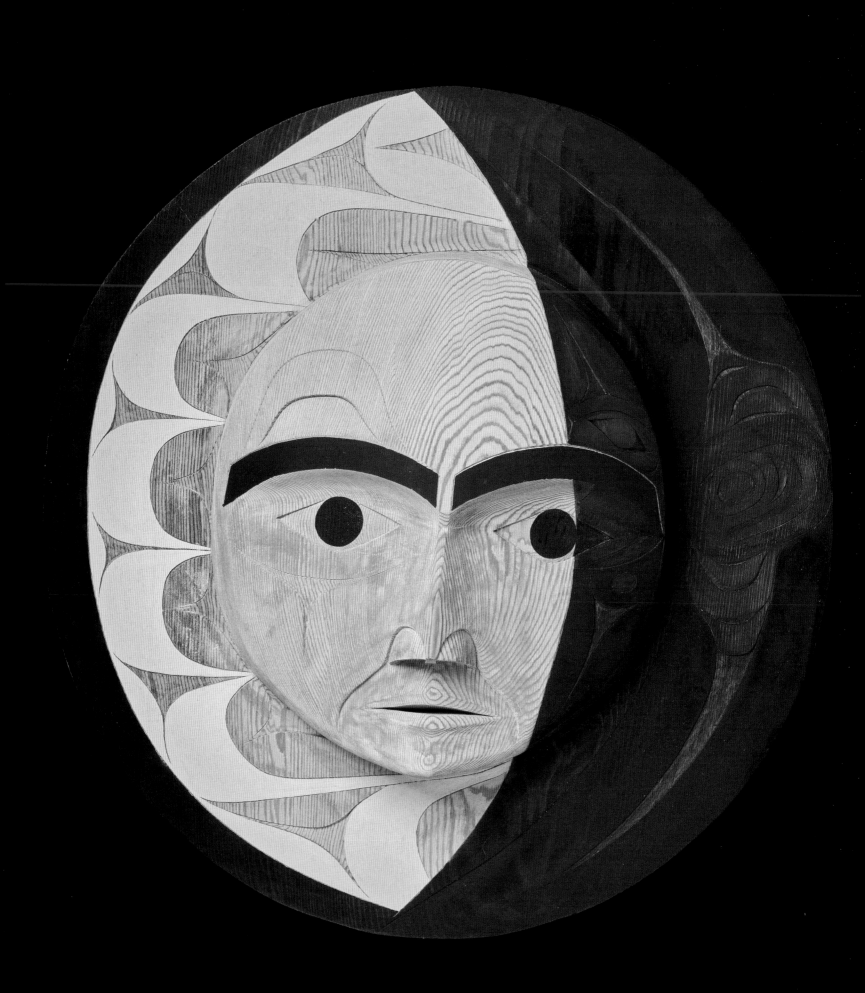

Russell Smith

(Kwakwaka'wakw, 1950–2011)

Russell Smith was born at Alert Bay, British Columbia. Smith grew up learning about Kwakwaka'wakw culture and his family's oral histories from his mother. He was inspired by the works of the late artists Charlie James Sr. and Arthur Shaughnessy. At eighteen, Smith began to take up wood carving, and a year later, in 1969, he was invited by Bill Holm to assist in the restoration of the south Kwakiutl Longhouse in Seattle, Washington. Smith later went on to study wood sculpture with Doug Cranmer and Larry Rosso. In addition to carving, he also learned from jewelry and metalwork artists Bill Reid, Gerry Marks, and Phil Janzé. Russell was known for working exclusively in ancient and traditional Kwakwaka'wakw designs as a way to honor his heritage.

Eagle Mask, 1988
Red cedar, cedar bark, feathers, paint; 10½ × 8 × 6 in.
Collection of George and Colleen Hoyt 13

This fully painted, high-contrast work was the first mask of dozens acquired by George and Colleen Hoyt for their collection in the decades since the 1980s. It was purchased in 1988, from the Marion Scott Gallery in Vancouver, B.C.

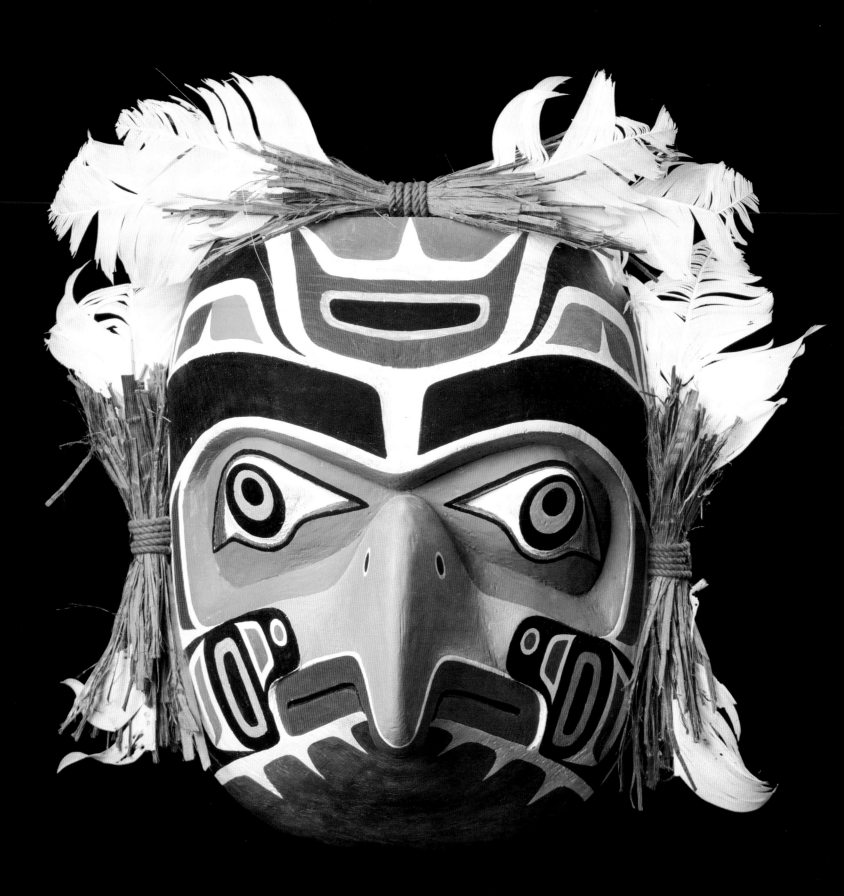

Simon Dick
(Kwakw̱aḵa'wakw, b. 1951)

Simon Dick, also known as Tanis, was born in Alert Bay, British Columbia, and raised in Kingcome Inlet. Dick learned about Kwakw̱aḵa'wakw traditions from his family growing up and spent time with a number of different artists. In his early twenties, he worked as an apprentice for four years under carver Tony Hunt Sr. in Victoria and then went on to study language and music with Sam Henderson. Dick's work has also been significantly influenced by James Sewid, Henry Speck, Charlie George, and Benjamin "Blackie" Dick. He has become a master canoe carver over time and has worked on many large-scale projects around the world. In addition to his woodworking, Dick began creating limited-edition prints in 1995.

Simon Dick wore this mask at the historic 1989 protests in the Brazilian Amazon, supporting the efforts of Indigenous peoples of the region to call international attention to the environmental destruction of their homelands and waterways. It is one of the only masks in the Hoyt collection to have been used ceremonially prior to being acquired.

Grouse Mask, 1988
Red cedar, cedar bark, feathers, paint; 12 × 9 × 7¾ in.
Collection of George and Colleen Hoyt 25

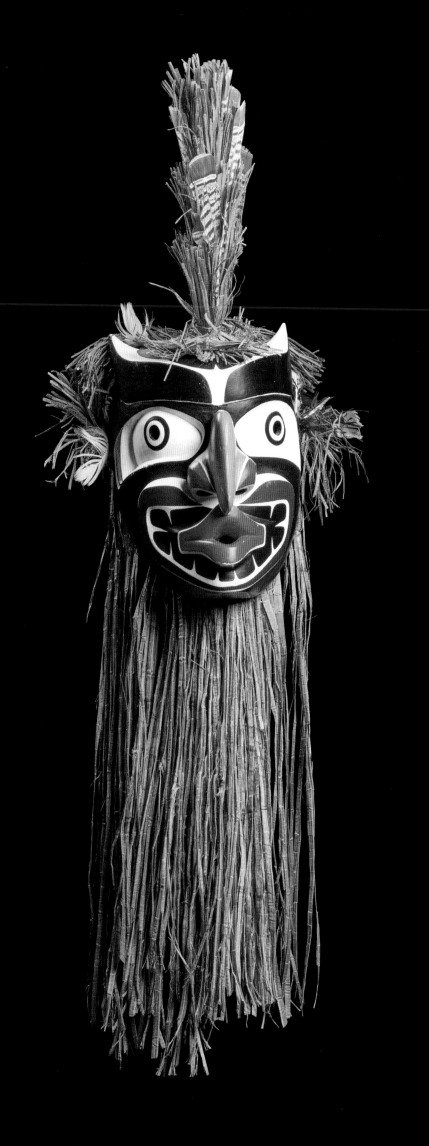

Richard Hunt

(Kwakwaka'wakw, b. 1951)

Richard Hunt was born in Alert Bay, British Columbia. He is the son of master carver Henry Hunt and brother to Tony Hunt Sr. and Stan Hunt. He began apprenticing under his father in Thunderbird Park in 1973. He then served as master carver there from 1974 until 1986, when he was succeeded by artist Tim Paul. Hunt is well known for both his carving and printmaking skills. In both mediums, Hunt enjoys creating pieces that have a touch of levity in them, which he accomplishes by adding smiles and other small details when possible. Aside from his role as artist, Hunt believes in being an educator and has done projects and demonstrations all over the world.

Eagle Transforming into Sisiutl, 2007
Red cedar, cloth, paint; 15 × 16 × 32 in.
Collection of George and Colleen Hoyt 15

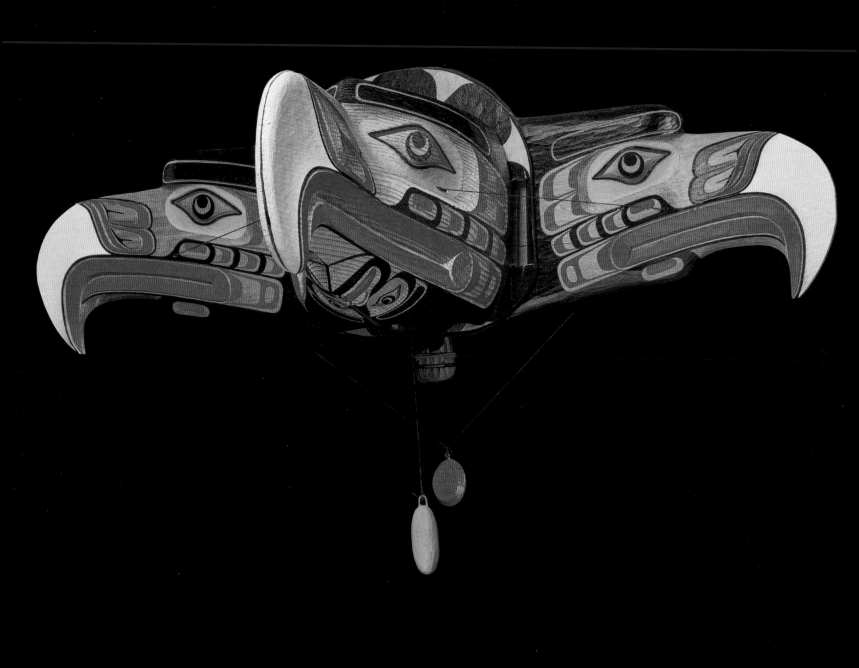

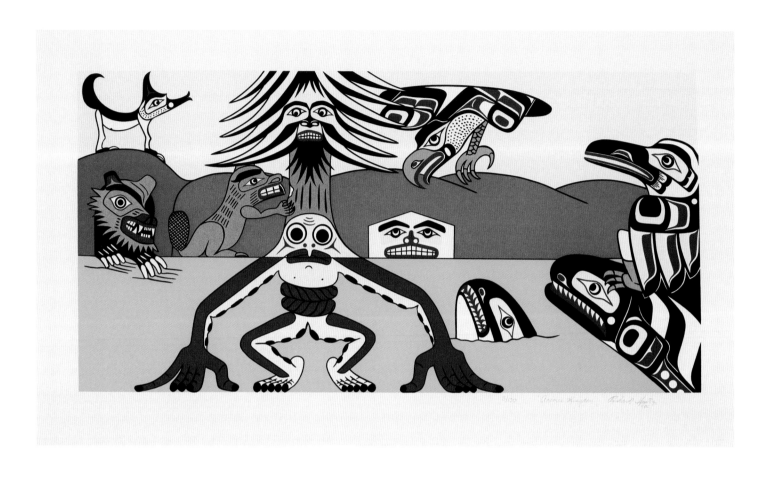

Animal Kingdom, 1992
Silkscreen; 15¾ × 27 in.
Ed. 3/150
Collection of George and Colleen Hoyt 230

Illustrated in this print are animals from the land, sea, and sky as well as the supernatural realm. The tree, Cedar Man, begins to transform his roots under the water, turning into an octopus. The animals, according to the artist, are headed to the longhouse to dance.

Salmon Mask, 1999
Wood, paint; 21½ × 18 × 7 in.
Collection of George and Colleen Hoyt 395

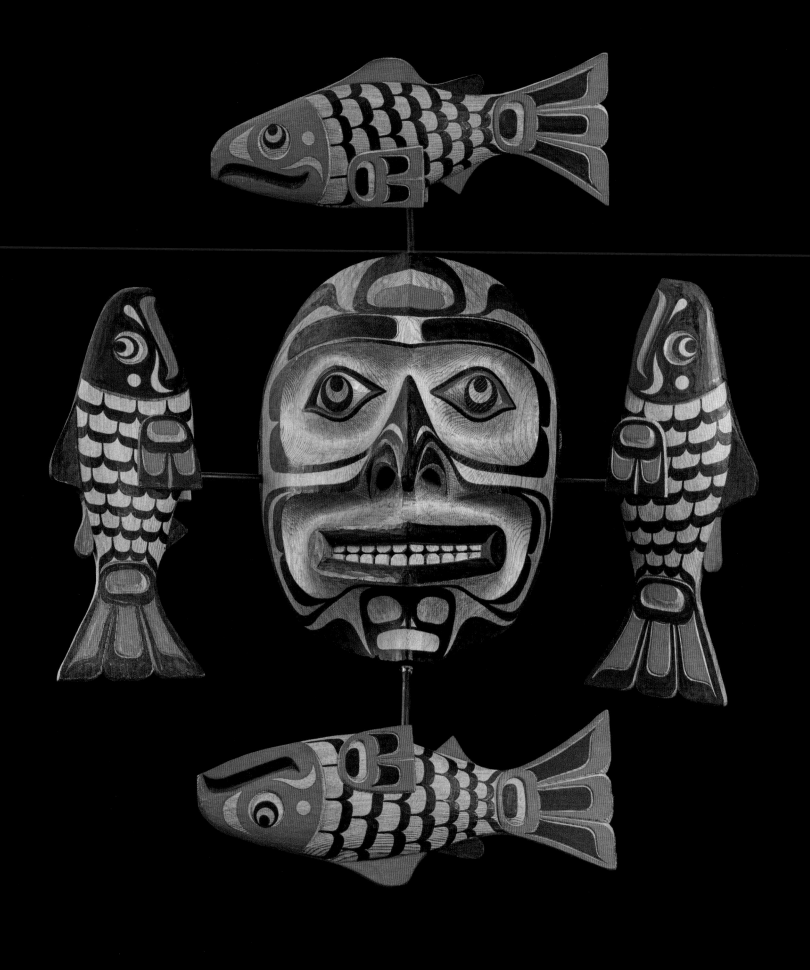

David A. Boxley
(Tsimshian, b. 1952)

David A. Boxley was born in Metlakatla, Alaska. His grandparents, who raised him, taught him about Tsimshian culture and the Sm'algyax language. He graduated from Seattle Pacific University in 1974 and became a high school teacher. In 1980, he began studying older Tsimshian carvings from museum collections and ethnographic materials. By 1986, he had left his teaching position to pursue his art career. He has produced countless bentwood boxes, masks, drums, and prints, and carved more than seventy totem poles. With his family, including son David R. Boxley, also an artist, he formed the Git Hoan Dancers, who bring Tsimshian dance to wide audiences.

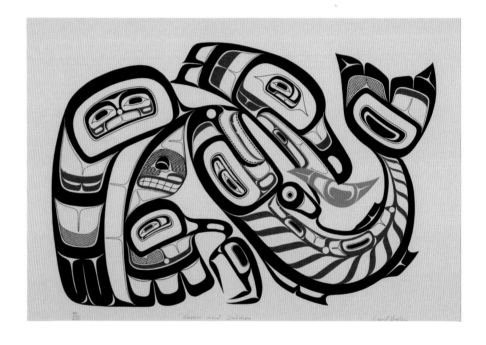

Legend Adaox, 1988
Ash, alder, paint; 26½ × 25 × 6 in.
Collection of George and Colleen Hoyt 1

Raven and Salmon, 1991
Silkscreen; 24 × 32½ in.
Ed. 94/200
Collection of George and Colleen Hoyt 43

Encircling the storyteller in the center of this plaque are images associated with the Tsimshian Eagle Clan. This is one of Boxley's early significant works and has been used as a signature image by the artist.

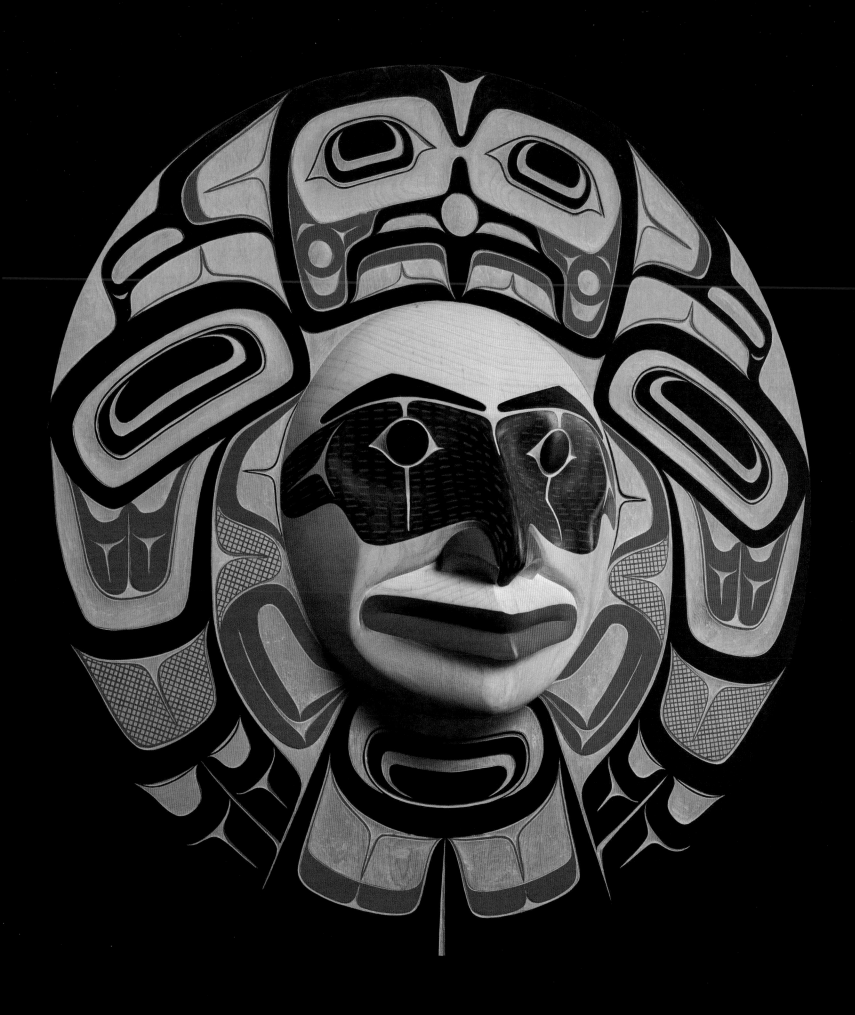

Susan Point
(Coast Salish/Musqueam, b. 1952)

Susan Point was raised on the Musqueam Indian Reserve near Vancouver, British Columbia, where she still lives. She is known for helping to bring attention to the once-underrepresented Coast Salish style, especially through her public art installations. As a child, Point was not exposed directly to art within her community. In the early 1980s, she sought to learn more about Coast Salish art, studying collections at the University of British Columbia Museum of Anthropology and the Royal British Columbia Museum, and seeking guidance from artists and scholars. As she learned about her culture, she became fascinated by the spindle whorl, a carved wooden disk used for spinning wool. Point's art has been strongly influenced by these circular designs, which can be seen on her silkscreen prints and etched-glass work. In addition to her fine art, Point is highly regarded for her countless public works, including *Flight (Spindle Whorl)*, which was installed at the Vancouver International Airport in 1995. The piece is recognized as the largest spindle whorl in the world, measuring 16 feet (4.8 meters) in diameter. Point's work has been a source of inspiration for many artists past and present, including her own children, well-established artists Thomas Cannell and Kelly Cannell.

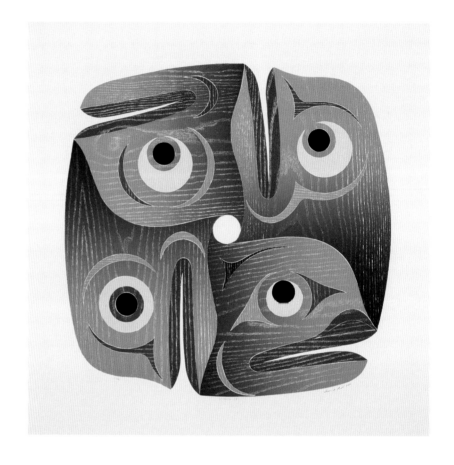

Nowhere Left, 2000
Woodblock; 30 × 30 in.
Ed. 10/44
Collection of George and Colleen Hoyt 539

Into the Light, 2008
Silkscreen; 48 × 17½ in.
Ed. 41/100
Collection of George and Colleen Hoyt 240

Susan Point, like many Northwest Coast artists, is profoundly concerned with the environmental conditions of the planet. The shape of this woodblock print is, like much of Point's work, patterned after a spindle whorl; the placement of the frog's faces in four directions is evocative of the four directions, the four seasons, and the four corners of the earth. Frogs in Northwest Coast worldview are harbingers of the changing seasons and of growth and renewal; their return in spring is welcomed with joy. But in recent decades near Point's home on the Musqueam reserve, the frogs' song has quieted as development puts pressure on their habitat. Soon, as the title suggests, they will have nowhere left to go.

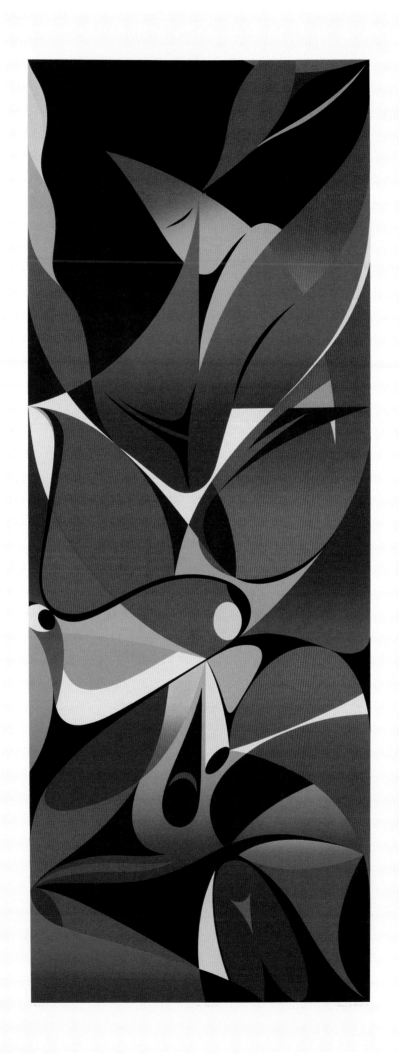

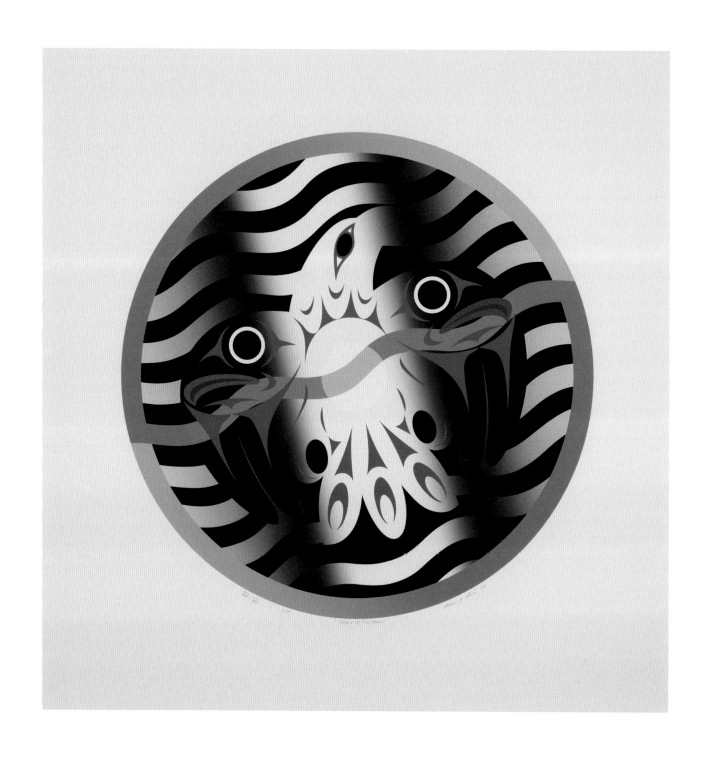

Spirit of the Taku, 2004
Silkscreen; 22 × 22 in.
Artist's proof 8/8
Collection of George and Colleen Hoyt 378

Flight Spindle Whorl, 1994
Glass; 15 × 2 in.
Collection of George and Colleen Hoyt 547

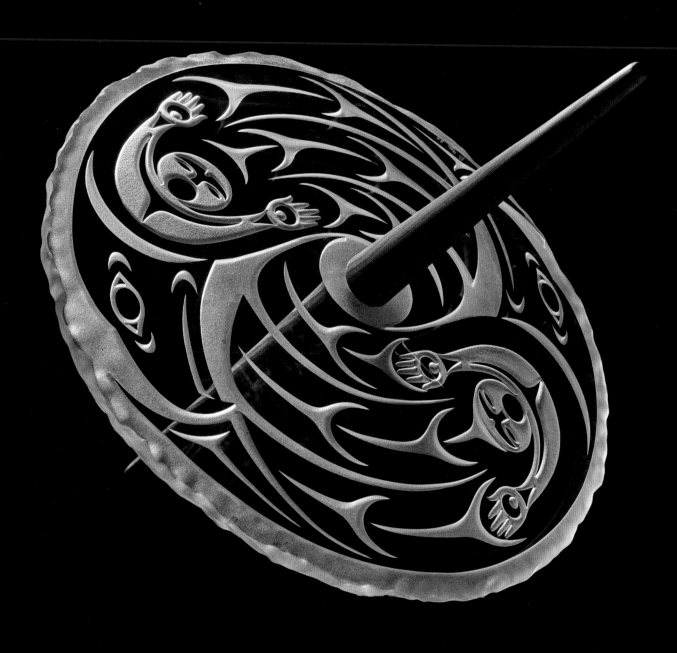

Floyd Joseph
(Coast Salish/Squamish,
b. 1953)

Floyd "Tyee" Joseph was born in Homulticison
(Capilano), British Columbia. Growing up he
was surrounded by Salish art and learned
from his father, carver Larry Joseph. After
graduating high school, Joseph went on to
attend Capilano College, where he majored
in art, learning sculpture, pottery, drawing,
and design. He also began to travel in Europe
around this time, visiting museums and absorb-
ing different art styles and cultures. In 1995,
he was commissioned by the University of
Victoria to create the *Welcome Figure*. The
large red cedar sculpture stands in front of the
engineering department. Joseph has gained
international success for his art and is known
for his bold color choices and unusual designs.
Today, he continues to work as a master carver,
painter, printmaker, and silversmith.

Loon Bowl, 1989
Red cedar, elk horn, paint; 10 × 8 × 20 in.
Collection of George and Colleen Hoyt 32

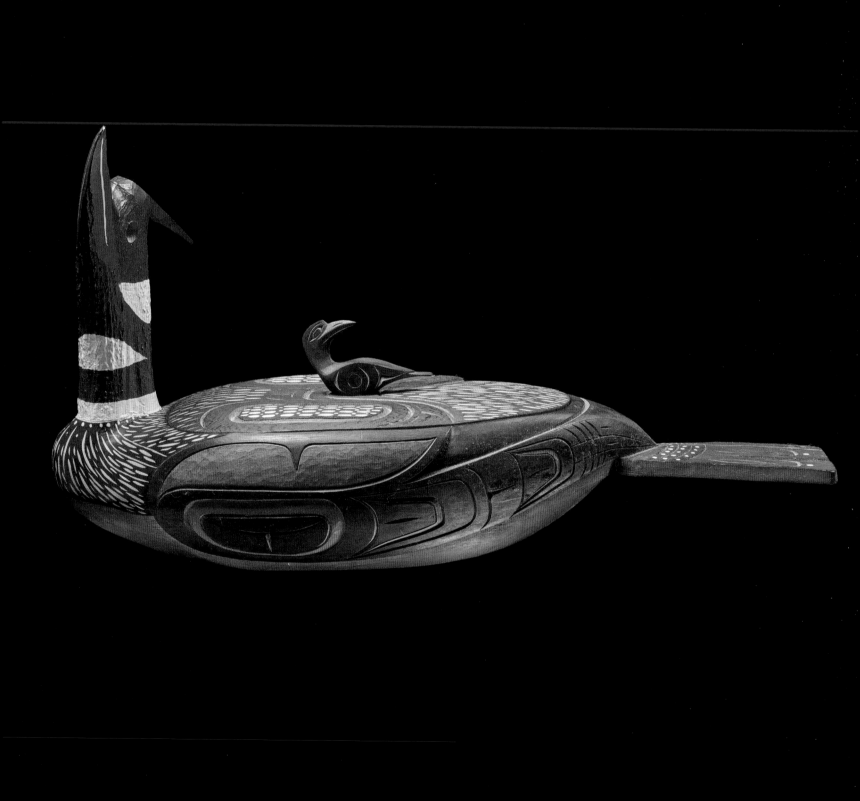

Doug LaFortune

(Coast Salish/Lummi/Tsawout, b. 1953)

Doug LaFortune Sr. was born in Bellingham, Washington in 1953 and raised in the Cowichan Valley in British Columbia. LaFortune attended his first fine-arts class at Camosun College in 1970; however, he was unsure of his path and went into the logging industry until 1972. He then met the Cowichan elder carver Simon Charlie and began working as his apprentice. With the encouragement of his mentor, LaFortune was able to develop his own signature style. Like many other artists, he has a diverse skill set in working with wood, paintings, and two-dimensional design. He is perhaps most well known for his project the *City of Totems*, which consists of five twelve-foot totems located in Duncan, and a *Salish Welcome Figure* that was presented to Queen Elizabeth at the Opening Ceremonies of the XV Commonwealth Games in Victoria.

Heron and Frog Feast Ladle, 1998
Red cedar; 11 × 42 × 9 in.
Collection of George and Colleen Hoyt 12

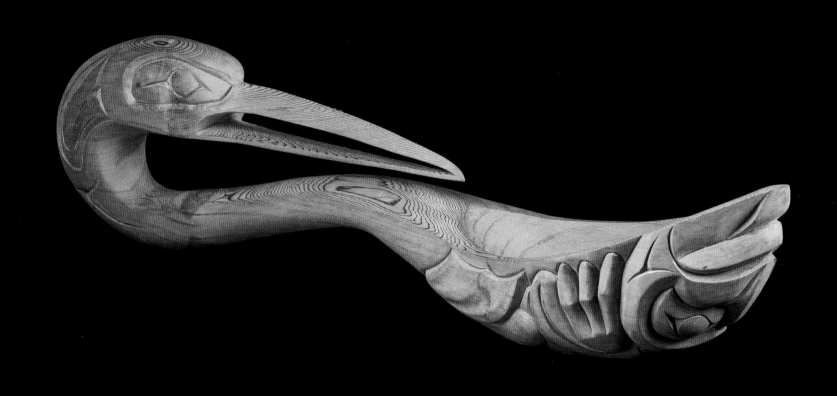

Reg Davidson
(Haida, b. 1954)

Born in Masset, British Columbia, Reg Davidson is the son of Claude Davidson and brother to Robert Davidson. He is an internationally celebrated artist with a wide variety of skills including carving, painting, weaving, and jewelry making. He began carving argillite in 1972 by studying with his father and studying historical publications. In the late 1970s, he worked with his brother, Robert, and many other artists on the Charles Edenshaw Memorial Longhouse in Masset. During this time, he sought to establish his own style and created some of his first designs for carvings and prints. In 1980, Reg and his brother, Robert, formed the Haida Rainbow Creek Dancers, a group for which he has designed and created many masks, drums, and capes. Davidson is also a singer and dancer for the group.

Volcano Woman Mask, 1982
Cedar, horsehair, leather, paint; 9½ × 7 × 5 in.
Collection of the Hallie Ford Museum of Art, Salem, Oregon, 2016.009.001
The George and Colleen Hoyt Northwest Coast Indigenous Art Fund

The Volcano Woman, also known as Dzalarhons, is a Haida mountain spirit. She watches over the creatures of the earth and retaliates against any abusers. She is often depicted with frogs coming out of her eyes and mouth.

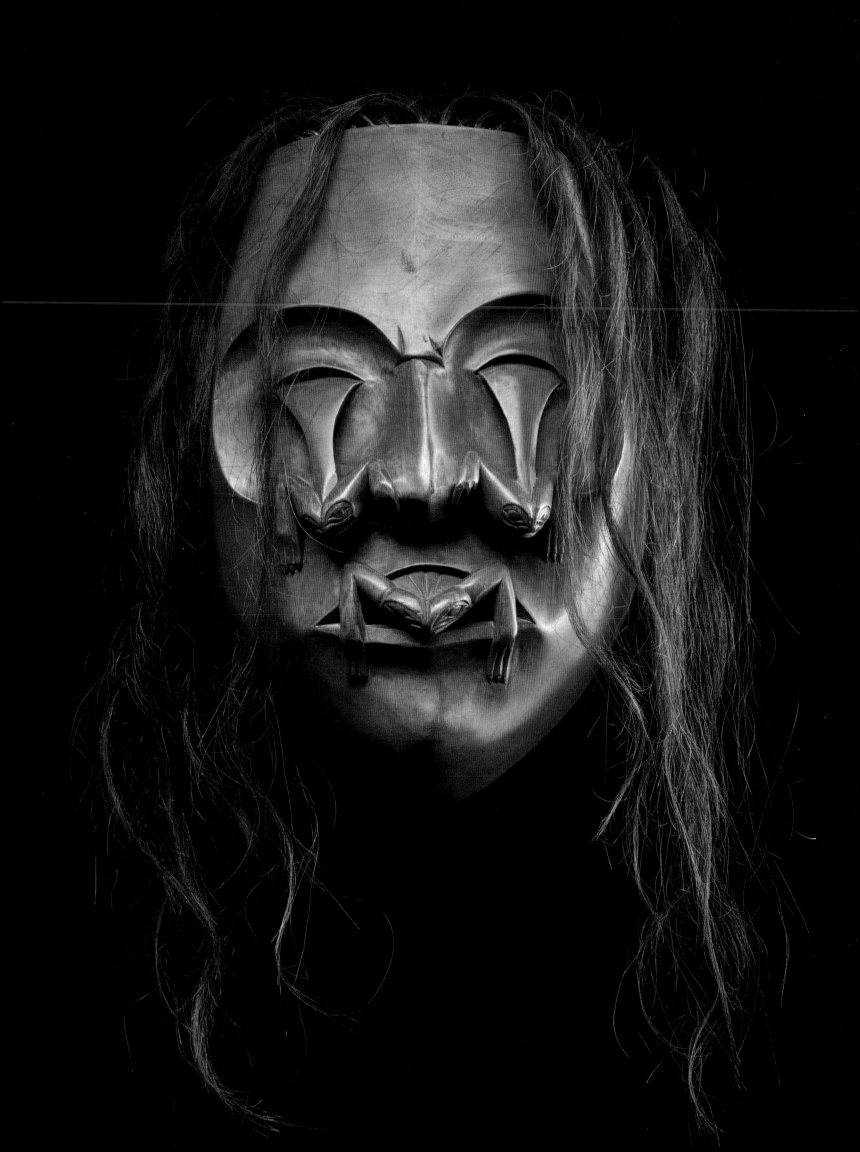

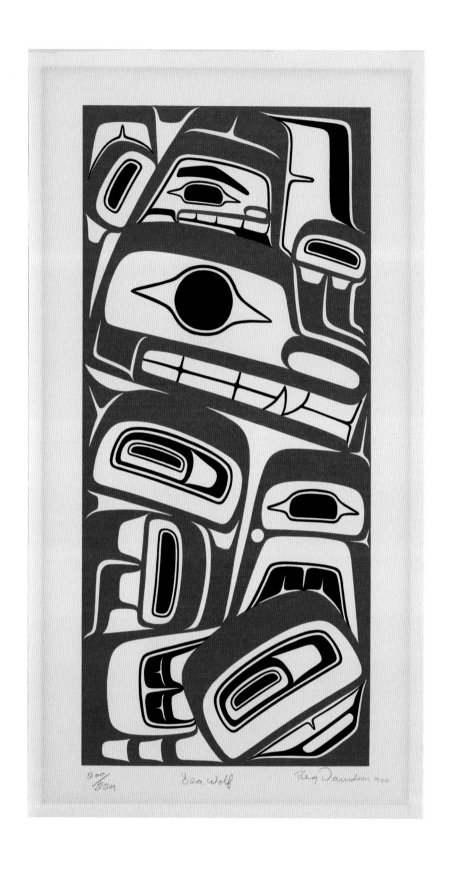

Sea Wolf, 1980
Silkscreen; 14½ × 7½ in.
Ed. 200/229
Collection of George and Colleen Hoyt 441

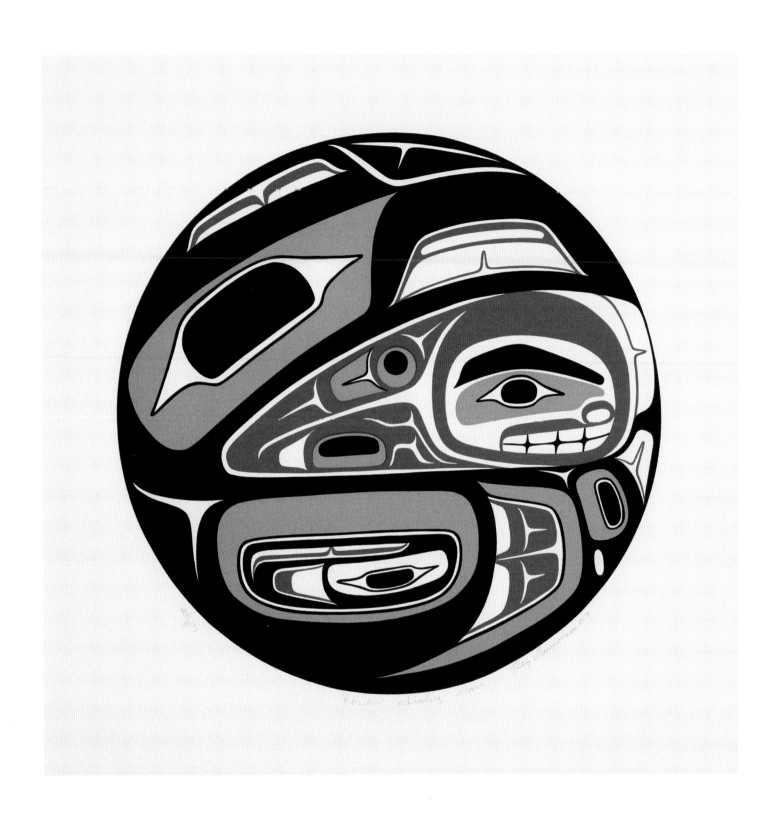

Raven Stealing Moon, 1987
Silkscreen; 16 × 15¾ in.
Ed. 46/193
Collection of George and Colleen Hoyt 124

Jim Hart
(Haida, b. 1954)

Jim Hart was born in Masset, British Columbia. As a child he was able to grow up with his grandparents and avoid residential school since his father was of European descent. He is the great-grandson of renowned Haida artist Charles Edenshaw (c. 1839-1920) on his mother's side. In 1978, he was asked to join the team working on totem poles for the Charles Edenshaw Memorial Longhouse, which was led by Robert Davidson. In 1980, Hart moved to Vancouver and worked under Bill Reid on many projects. Two years later, he created the first bronze pole by a Northwest Coast artist with the help of caster Jack Harman. Hart is known for his experimentation with Haida design and for incorporating new elements. For example, his re-creation of an old wooden Haida bowl was masterfully executed with designs similar to the original's, but crafted in silver. Hart's work is part of many museum collections and he has won numerous awards and honors.

Whale Killer 3 Fin, 1995
Silkscreen; 31¾ × 10 in.
Artist's proof 1/2
Collection of George and Colleen Hoyt 101

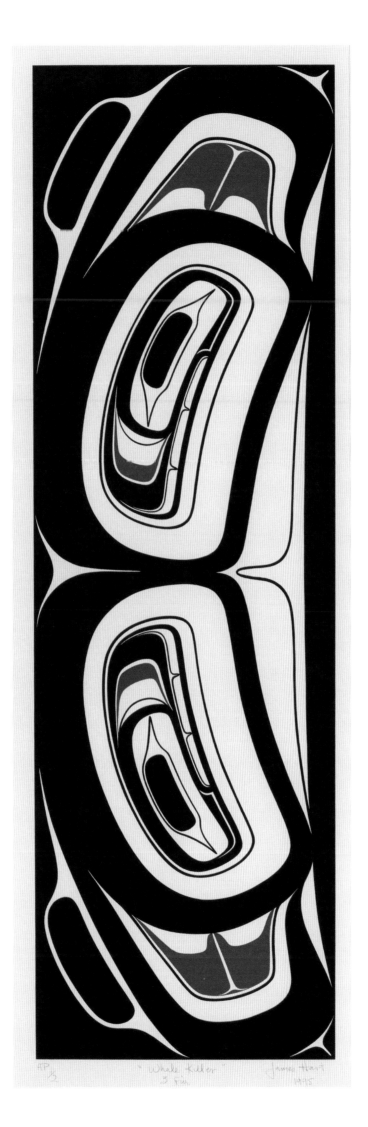

Stanley Hunt
(Kwakwa̲ka̲'wakw, b. 1954)

Born in Victoria, British Columbia, Stan Hunt is an accomplished artist who comes from a long line of master carvers, including his father Henry Hunt and grandfather Mungo Martin. Hunt learned with and alongside his two older brothers, Tony Sr. and Richard. In turn, Stan Hunt's sons, Trevor and Jason, are artists in their own right, and have worked alongside their father. One of his best-known works is a pole carved for the Canada Pavilion in Buenos Aires, Argentina, dedicated in 2012 to replace one originally carved by Henry Hunt and Mungo Martin in 1962. In addition, Stan Hunt has restored several other poles in California and Canada originally carved by his father.

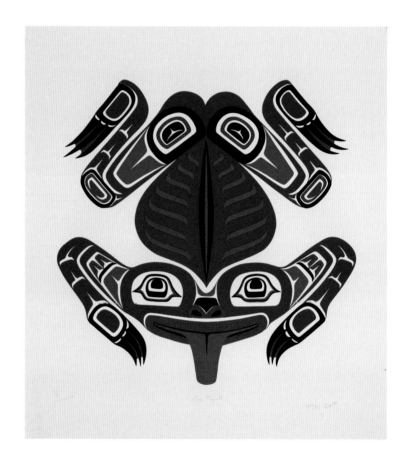

Frog and Mosquito, 1992
Silkscreen; 29 × 26 in.
Printer's proof 2/2
Collection of George and Colleen Hoyt 471

Hawkman Mask, 1991
Wood, paint, abalone; 12 × 9 × 8 in.
Collection of George and Colleen Hoyt 70

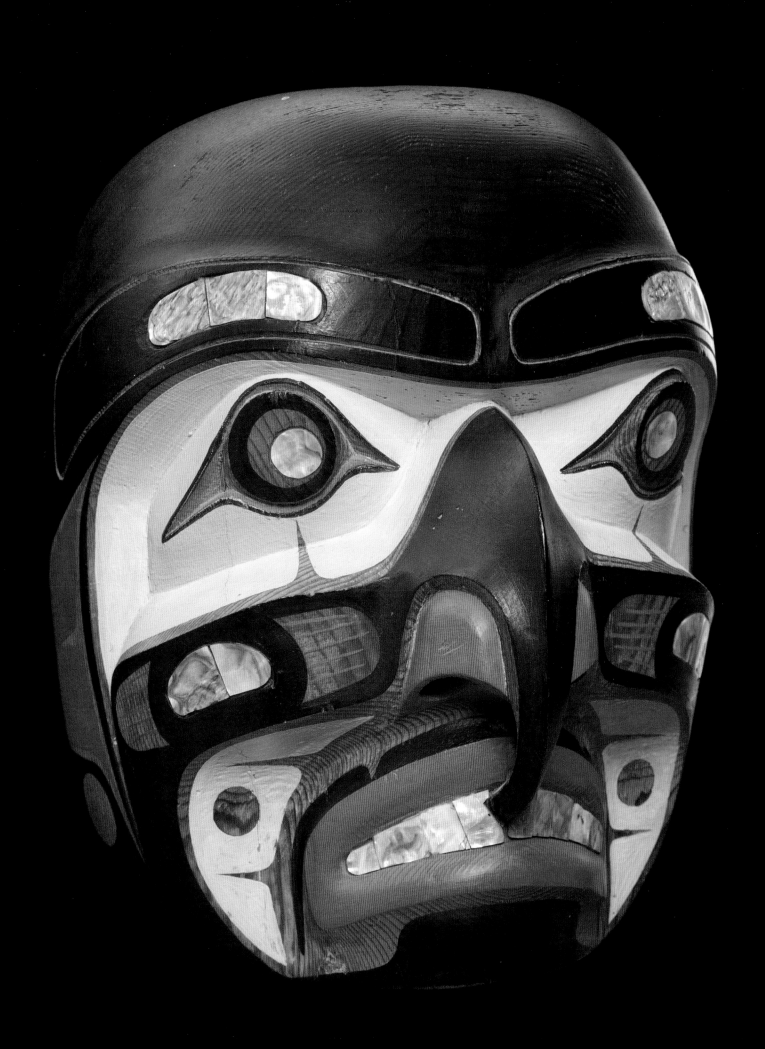

Beau Dick
(Kwakwa̱ka'wakw, 1955–2017)

Benjamin Kerry "Beau" Dick, also known as
Walas Gwa'yam, was born in Alert Bay, British
Columbia, and became one of the Northwest
Coast's most vital artist-activists. He began
carving at an early age under the guidance of
his father, Benjamin "Blackie" Dick, and later
apprenticed with his grandfather James Dick.
He also worked with a number of other artists,
including his uncle Jimmy Dawson, Henry
Speck, Doug Cranmer, Joe David, Tony Hunt
Sr., Bill Reid, and Robert Davidson. Dick's work
is grounded in Kwakwa̱ka'wakw culture and
epistemology and his art practice has included
deploying his creations to support Indigenous
rights and to critique global consumerism. He
is well known for masks, rattles, drums, paint-
ings, and limited-edition prints. Dick was the
subject of the 2017 documentary film *Maker of
Monsters*, which follows his career as an artist,
community leader, and political activist.

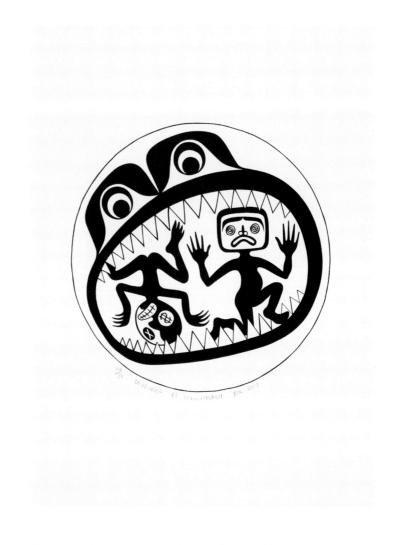

Devoured by Consumerism, 2017
Silkscreen; 30 × 22 in.
Ed. 40/88
Collection of George and Colleen Hoyt 320

Pooq-oobs Mask, twentieth century
Red cedar, cedar bark, horsehair, feathers, paint;
31 × 27 × 23 in.
Collection of the Hallie Ford Museum of Art,
Salem, Oregon, 2016.041
The George and Colleen Hoyt Northwest Coast
Indigenous Art Fund

This print, a drum design, was the logo for an exhibi-
tion of the same name of Beau Dick's work curated
in the last year of his life. The design features a large,
sharp-toothed mouth—that of the monster of capitalist
consumption—eating two figures. The upside-down
figure is blinded by a dollar sign and an X; the figure at
right may be Indigenous and is trapped but is taking
one tiny step outside the mouth. In this exhibition and
in his career more generally, Dick was speaking from a
place of deep immersion in his Kwakwa̱ka'wakw culture,
one in which material wealth is accumulated in order
to be shared. He relentlessly critiqued the destructive
forces of consumerism through his art, his actions, and
his commitment to the ceremonial life of his community,
and sought to reveal the dangers of consumerism on
both an individual and a planetary level.

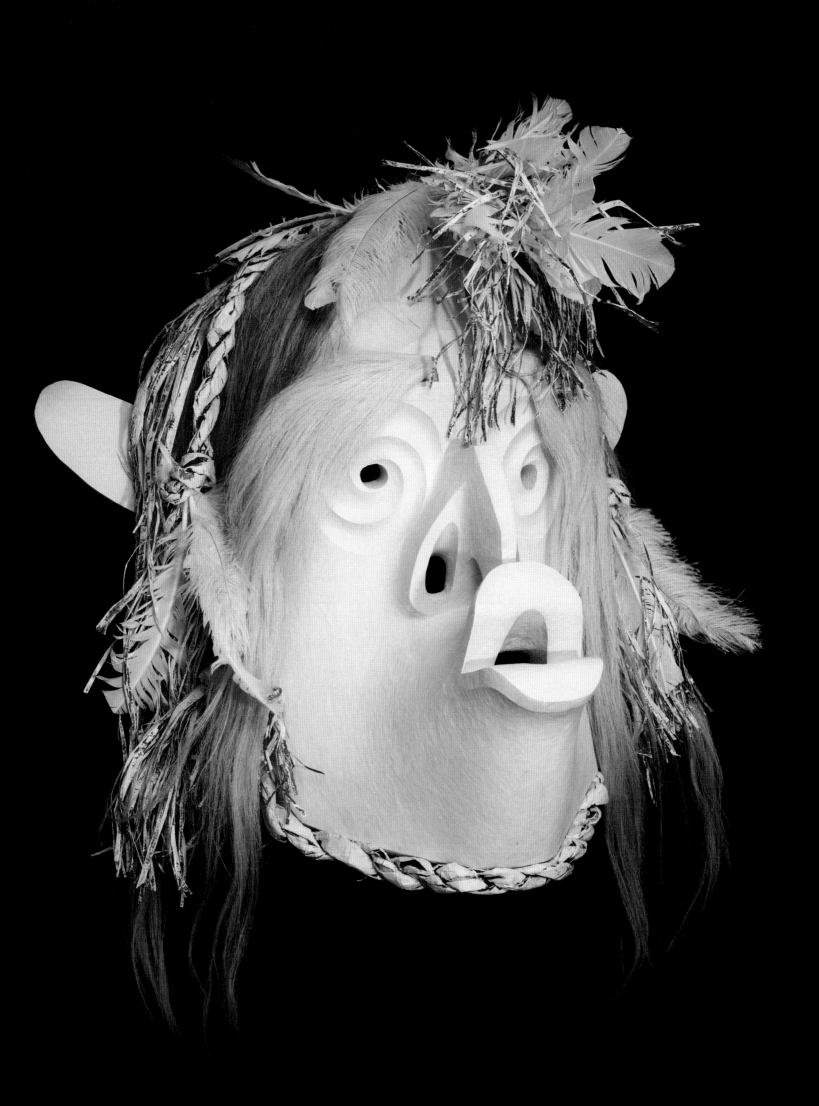

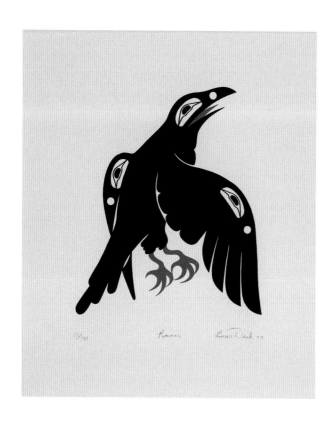

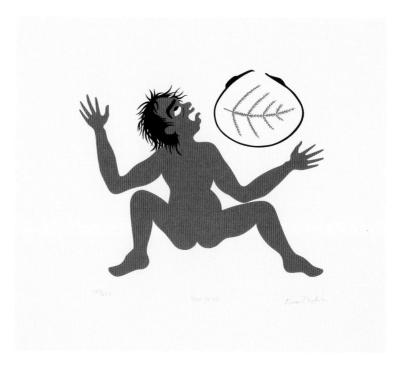

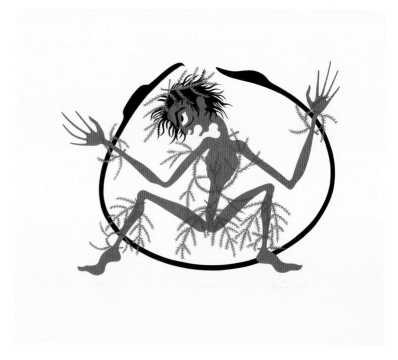

Raven, 1977
Silkscreen; 17¾ × 14¾ in.
Ed. 61/190
Collection of George and Colleen Hoyt 338

Tani Gee, 1981
Silkscreen; 14½ × 16½ in.
Ed. 198/225
Collection of George and Colleen Hoyt 174

Tan-is, 1981
Silkscreen; 14½ × 16½ in.
Ed. 62/225
Collection of George and Colleen Hoyt 175

Fish Trap Rattle, 1994
Cedar, cedar bark, paint; 16 × 13 × 17 in.
Collection of George and Colleen Hoyt 18

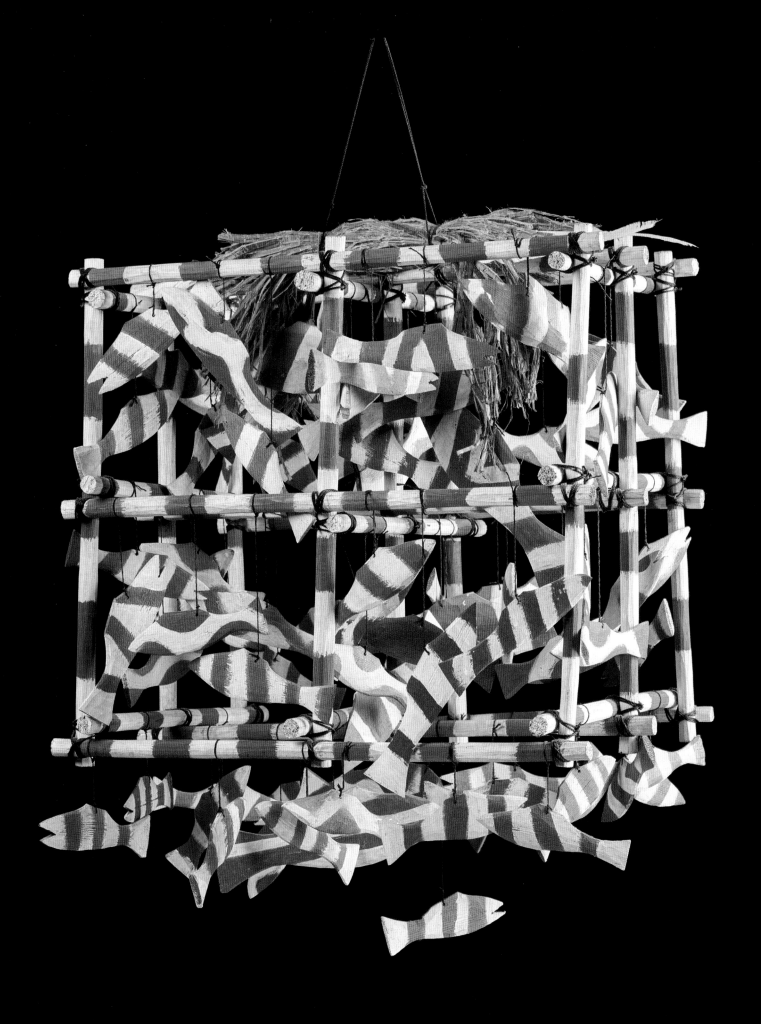

Andy Wilbur-Peterson

(Coast Salish/Skokomish, b. 1955)

Andy Wilbur-Peterson, sometimes known as Andy Peterson, was born in Shelton, Washington, and is a member of the Skokomish Nation. He first thought about pursuing art as a career after visiting a museum exhibition on Northwest Coast art. By age eighteen, Wilbur-Peterson had become a self-taught carver and painter working mainly in Haida, Tlingit, and Tsimshian formline styles. Later on, he began to study works made by his great-grandfather, Henry Allen, and Coast Salish collections owned by the University of Washington and the University of British Columbia. In 1987, Andy studied under Greg Colfax at Evergreen State College. There they worked on several projects together, including the twelve-foot *Welcome Woman* figure that underwent restoration work by Colfax and Wilbur's youngest daughter Bunni in 2019. Wilbur-Peterson has mentored many aspiring artists in his community, including his three daughters, Andrea, Malynn, and Bunni.

Wolf Speaks the Mysteries of Thunderbird, 1998
Wood, paint; 60 × 16 in.
Collection of George and Colleen Hoyt 66

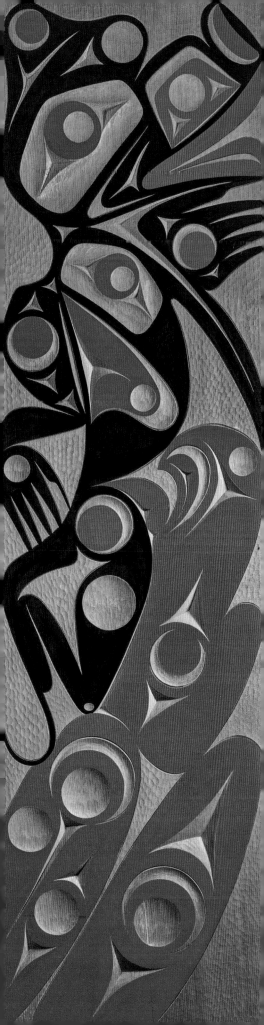

Calvin Hunt

(Kwakwaka'wakw, b. 1956)

Calvin Hunt was born in Fort Rupert in British Columbia and comes from a family immersed in Kwakwaka'wakw art and culture. He began carving as a young child under the guidance of his uncle Henry Hunt and cousin Tony Hunt Sr. Then, in 1972, he formally apprenticed with his cousin at the Arts of the Raven Gallery in Victoria for the next nine years. In the early 1980s, Calvin and his wife, Marie, returned to his ancestral home and opened up a carving workshop called the Copper Maker, and later they added a retail art gallery space. Hunt works in a variety of mediums including wood, gold, silver, stone, and silkscreen printing. In 2004, he was inducted into the Royal Canadian Academy of Arts, and he received the BC Creative Achievement Award for Aboriginal Art in 2009.

Numas Man and Butterfly Mask, 1986
Cedar, horsehair, wire, paint; 19 × 18 × 14 in.
Collection of George and Colleen Hoyt 458

This piece depicts the legend of Numas, a man who fled to the mountains as the world was flooding. When he reached the top, a butterfly came to comfort him and began to flap its wings. As it did so, the waters began to recede and Numas was able to return back home.

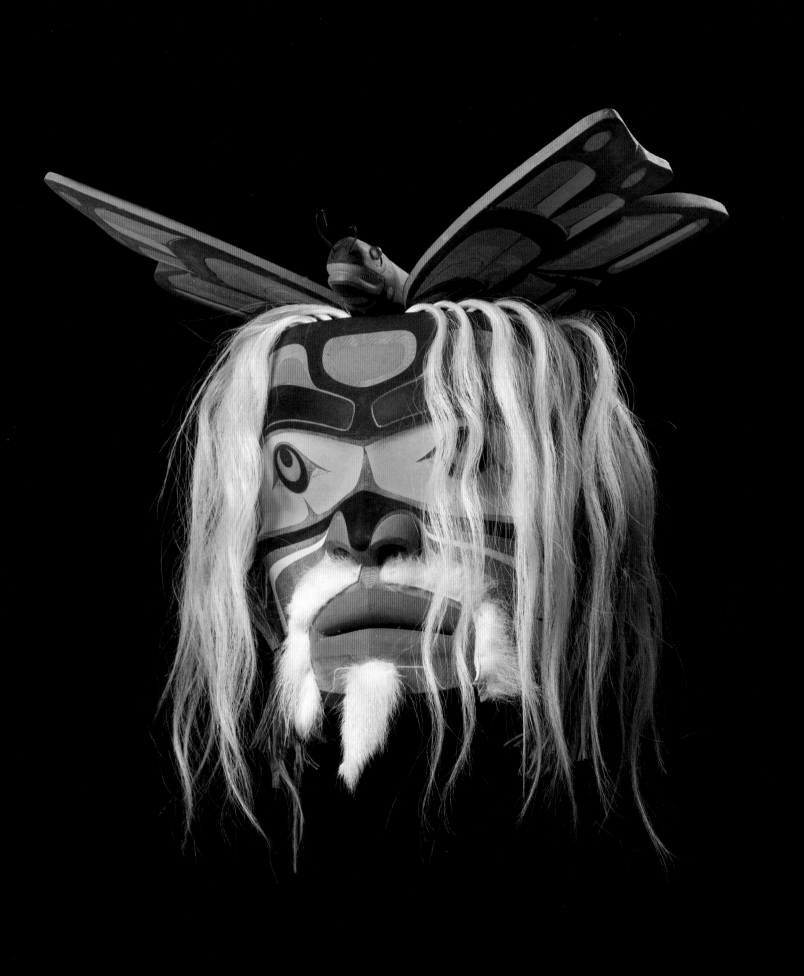

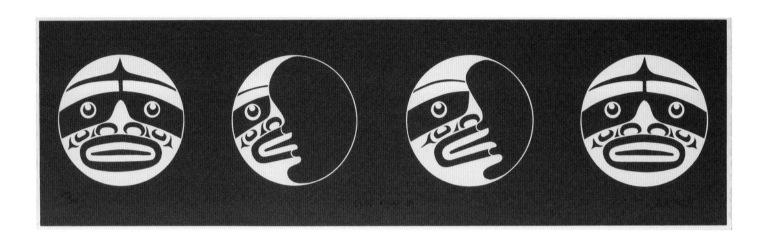

Komokwa Mask, 2018
Red cedar, copper, horsehair, paint; 24 × 12 × 5 in.
Collection of George and Colleen Hoyt 418

Komokwa is often referred to as the Chief of
the Undersea World or the Copper Maker in
Kwakwa̱ka̱'wakw and Haida myths. He is said to live
at the bottom of the sea in a large copper house and
is often associated with different sea creatures. In this
mask he is accompanied by a blue loon that rests on
top of his head.

Blue Moon, 2004
Silkscreen; 6½ × 22 in.
Ed. 297/300
Collection of the Hallie Ford Museum of Art, Salem,
Oregon, 2015.023.044
The George and Colleen Hoyt Northwest Coast
Indigenous Art Fund

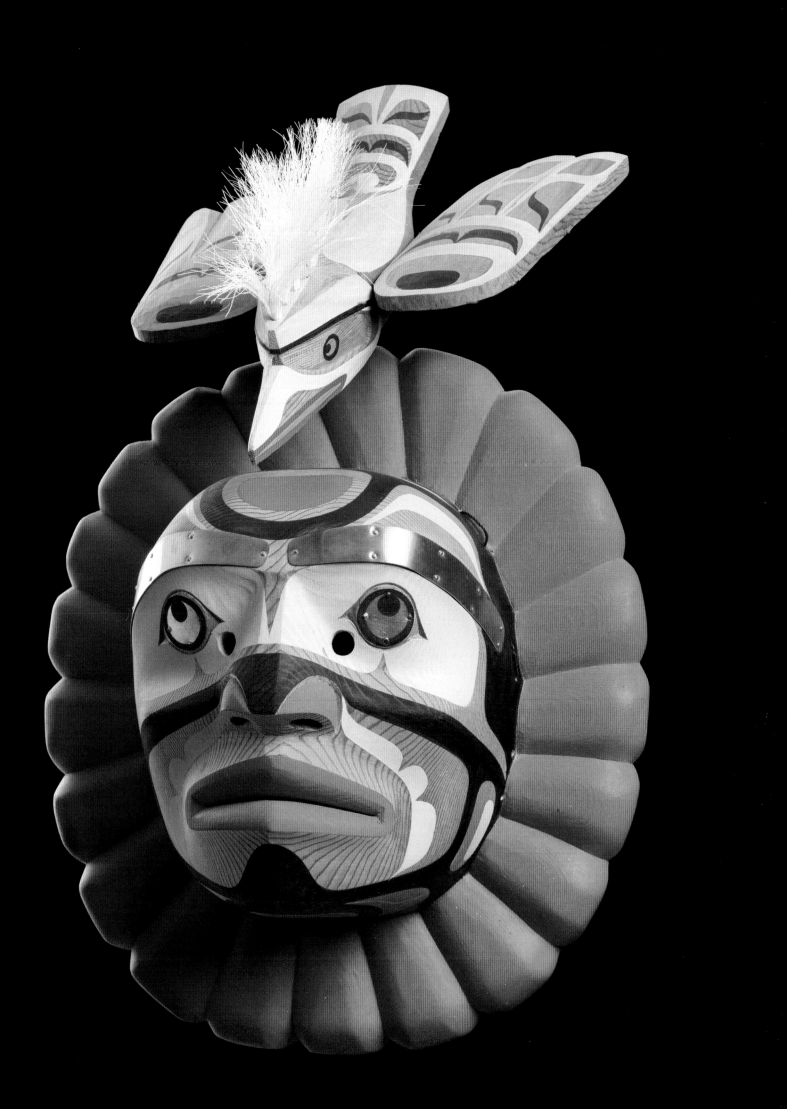

Wayne Alfred

(Kwakwa̱ka̱'wakw, b. 1958)

Wayne Alfred was born in Alert Bay, British
Columbia, and is the son of renowned carver
Pat Alfred. His identity was shaped early
on by the stories, songs, and masks that he
encountered frequently when he visited his
grandmother's home. Alfred was inspired by
the achievements of his uncle, Henry Hunt, and
began to pursue a career in Northwest Coast
art at the age of nineteen. He went on to study
with his uncles Henry Hunt and Charlie George
as well as artists Doug Cranmer, Benjamin
"Blackie" Dick, and Beau Dick. Many of Alfred's
works draw on inspiration from the styles
that originated in Blunden Harbour, Smith
Inlet, and Alert Bay. However, it is important
to him not to simply copy older masks or
designs, but instead to build upon them with
his own experiences as well as incorporating
contemporary social issues.

Noohmal Mask, 1992
Red cedar, cedar bark, paint; 19½ × 8 × 12½ in.
Collection of George and Colleen Hoyt 38

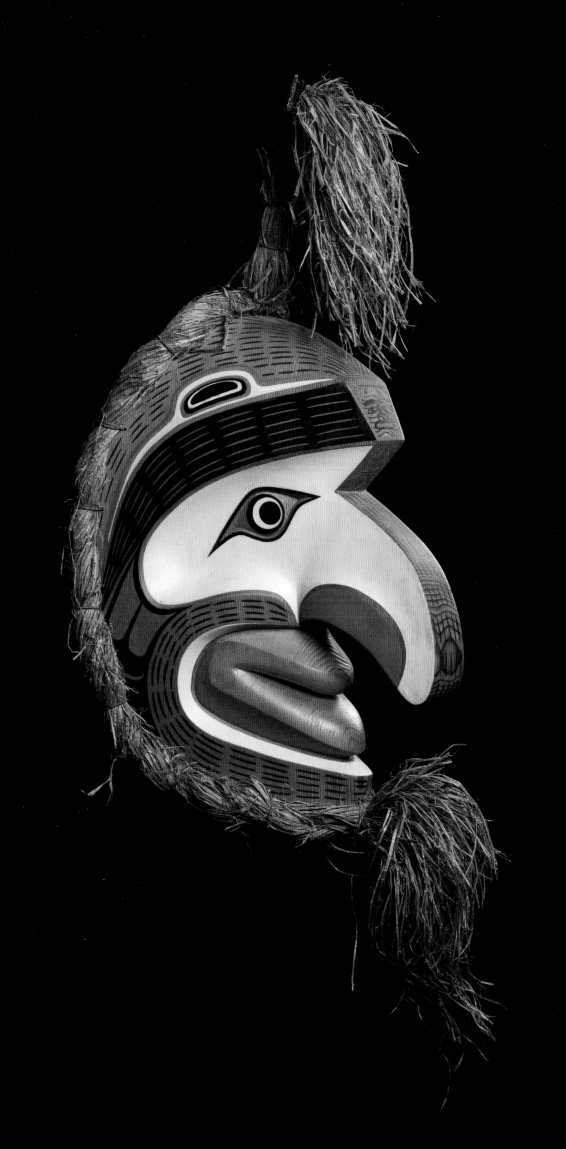

George Hunt Jr.
(Kwakwaka'wakw, b. 1958)

George Hunt Jr., also known as Nas-u-niz, was born in Campbell River, British Columbia, and comes from a long line of master carvers including his great-uncle Henry Hunt and uncles Tony Hunt Sr. and Calvin Hunt. At the age of fourteen, he apprenticed under his father, George Hunt Sr., and maternal grandfather, Sam Henderson, who both taught him about knife techniques and Kwakwaka'wakw forms. He has been professionally carving since 1972 and has spent many years refining his style and learning about his culture. Hunt's work is highly sought-after around the world due to his attention to detail and extremely intricate designs.

Mosquito Mask, 1993
Red cedar, ermine, copper, feathers, abalone, paint.
13 × 9 × 20 in.
Collection of George and Colleen Hoyt 36

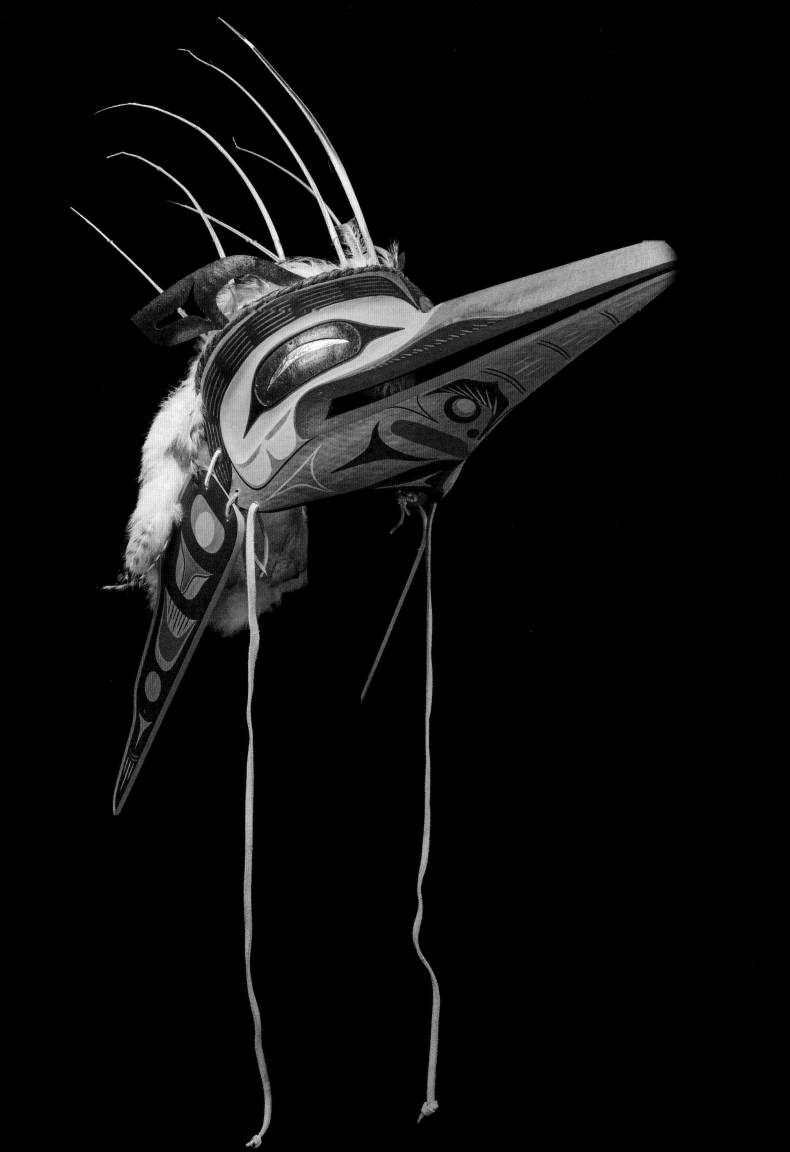

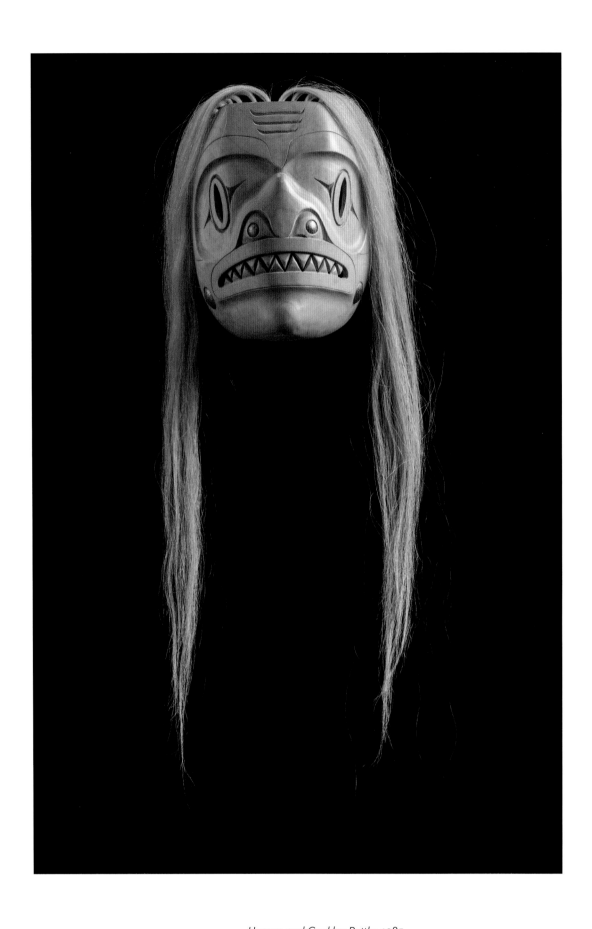

Human and Cockles Rattle, 1985
Wood, leather, abalone, copper, horsehair, paint;
10 × 4 × 4 in.
Collection of George and Colleen Hoyt 460

Shark Mask, 1988
Alder, copper, horsehair; 9 × 7½ × 5½ in.
Collection of George and Colleen Hoyt 53

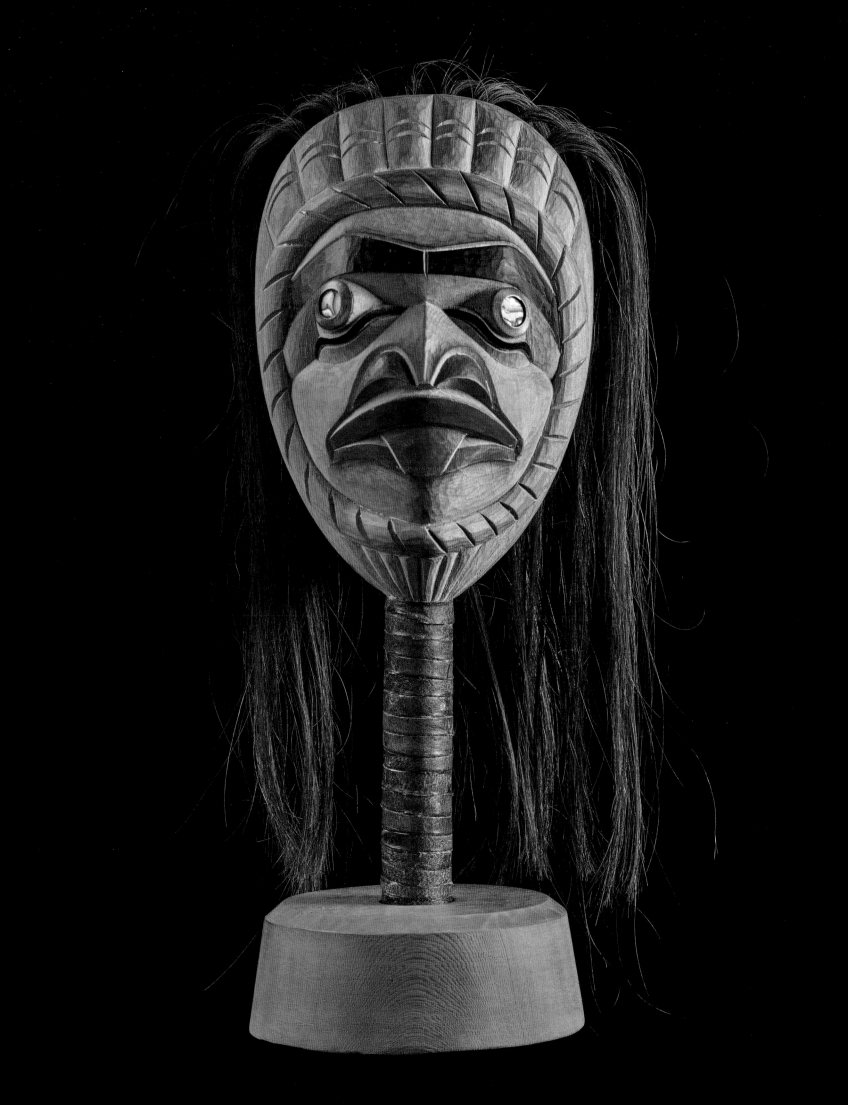

Don Yeomans
(Haida/Haisla, b. 1958)

Artist Don Yeomans was born in Prince Rupert, British Columbia. At the age of ten, he worked with his aunt Freda Diesing, who quickly encouraged him to create his own designs after witnessing his talent. Under the guidance of his mentor, he began to study other artists' work through books including Bill Holm's *Northwest Coast Indian Art: An Analysis of Form* and Marius Barbeau's *Totem Poles*. While still very young, Yeomans was invited in 1978 by Robert Davidson to assist with the ongoing construction of the Charles Edenshaw Memorial Longhouse on Haida Gwaii. Then, a year later, he met artists Gerry Marks and Phil Janzé, with whom he studied jewelry making and repoussé (a metalworking technique involving hammering to create a relief surface for carving). Yeomans is known as both a carver and printmaker and for his colorful, confident innovations in both media. He incorporates the use of negative formlines into some of his prints, which adds a striking layer of depth.

Raven in the 20th Century, 1979
Silkscreen; 14 × 15 in.
Ed. 28/150
Collection of George and Colleen Hoyt 344

In this print, Don Yeomans uses humor as he draws on his own observations about modern conveniences and depicts Raven resting on top of a car. Raven is commonly known as a trickster who uses creativity to get ahead. However, Raven can also represent a complex reflection of one's self.

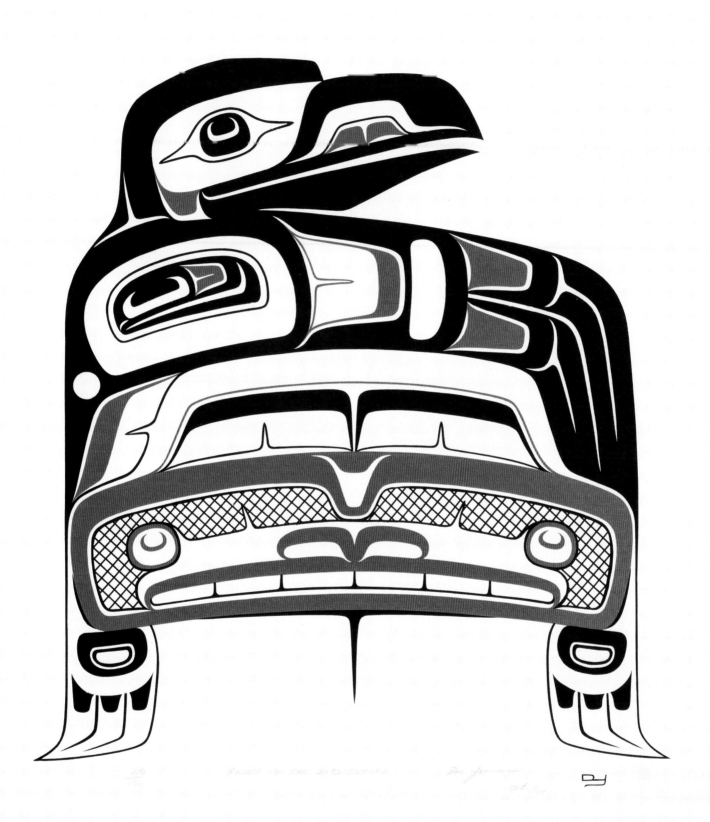

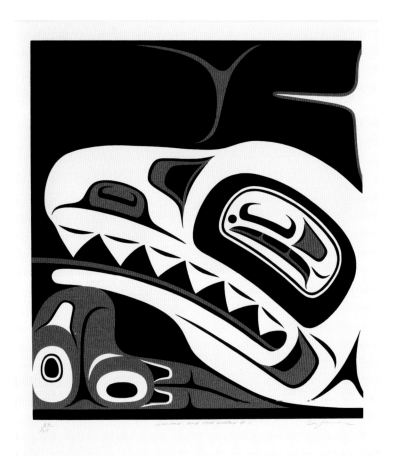
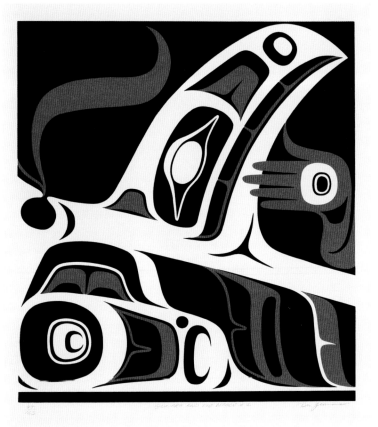

Gunarh and the Whale, 1994
Silkscreen; 14¾ × 52 in.
Ed. 44/165
Collection of George and Colleen Hoyt 26

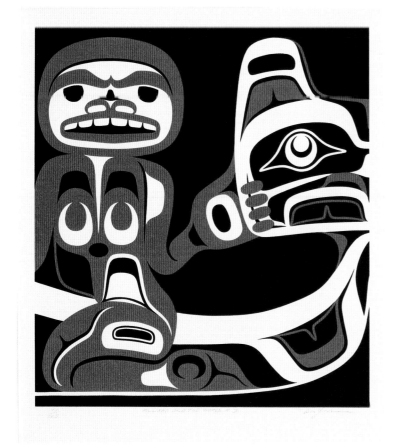

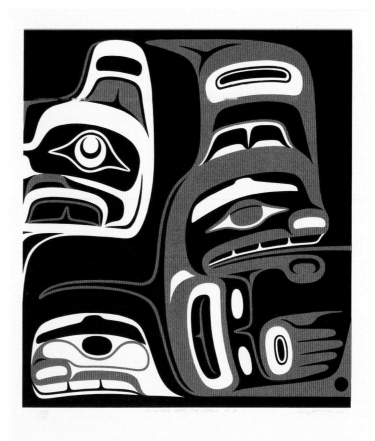

Francis Dick
(Kwakw̲ak̲a'wakw, b. 1959)

Francis Dick is a well-respected artist from the Musgamagw Dzawada'enux̲w band of the Kwakw̲ak̲a'wakw Nation. She was born in Kingcome Inlet, British Columbia, and attended residential school as a child. Dick is primarily self-taught but has been greatly influenced by other artists like her grandmother Anitsa, brother Beau Dick, and artists Bruce Alfred and Fah Ambers (Kwakw̲ak̲a'wakw). In 1991, she earned her bachelor's degree in social work from the University of Victoria in British Columbia, but soon realized she wished to make art her life's work. In addition to working in printmaking and carving, Dick is known for her performance art.

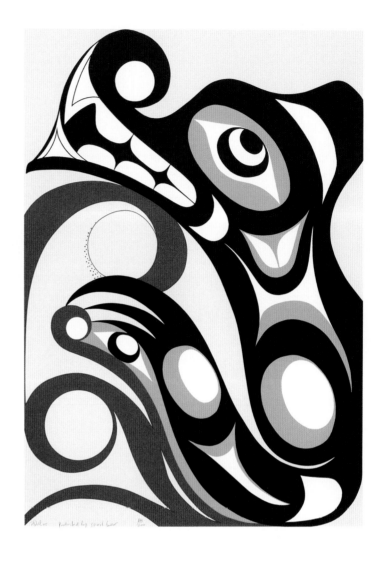

Protected by Spirit Bear, 2005
Silkscreen; 24 × 16½ in.
Ed. 171/200
Collection of George and Colleen Hoyt 223

Raelene, 1999
Silkscreen; 24 × 17¾ in.
Ed. 72/100
Collection of George and Colleen Hoyt 86

Francis Dick explained this image in a 1999 artist statement now in the University of Victoria Art Collections: "The image in this print is symbolic of beauty, quiet strength and unpraised endurance. Also symbolized by the eagle, the hummingbird and the flower is the ability to be in relationship with all creatures of the world. Hence they are depicted closely to and in balance with the woman. The wolf is symbolic of K̲awadelek̲ala, from whom I am descended, and it is wrapped around the image of quiet strength. In the top corner is the full moon and the crescent moon existing in simultaneous balance."

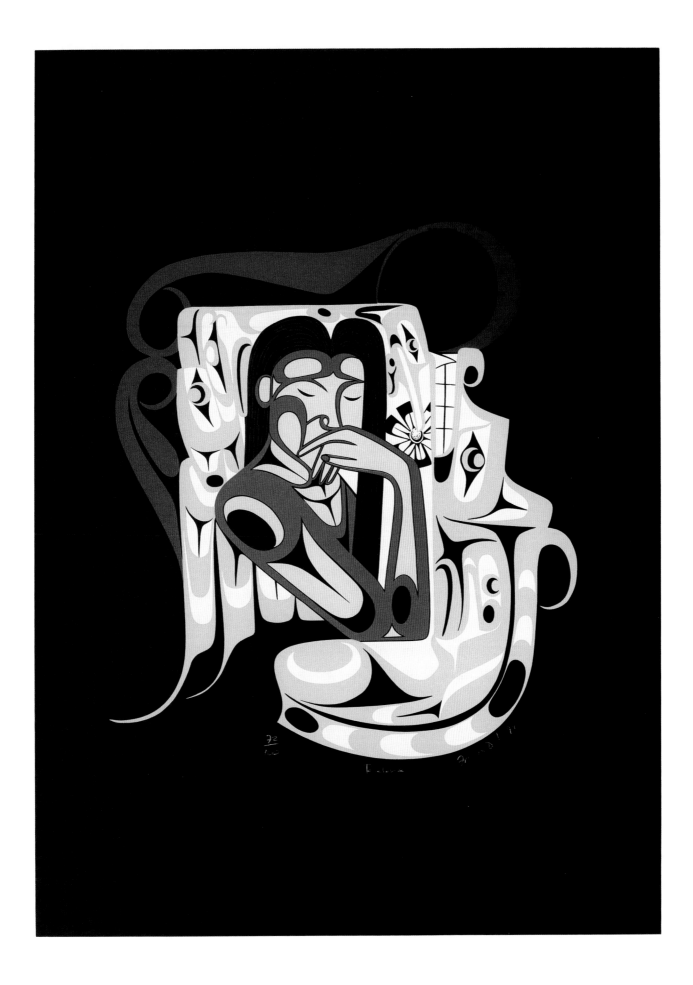

Tony Hunt Jr.
(Kwakwa̱ka̱'wakw, 1961–2017)

Tony Hunt Jr. was the son of Tony Hunt Sr and was born in Victoria, British Columbia, into the renowned Hunt family of artists. He began learning how to carve from his father while still a young teenager; he was able to spend his high school years studying both academics and carving at Arts of the Raven Gallery in Victoria. He assisted on large-scale projects alongside his father, his grandfather Henry Hunt, his uncle Calvin Hunt, and non-Indigenous artist John Livingston. He was known for his masks and carvings, many of which have been included in major museum exhibitions, and for his work with many other family members building the longhouse at Fort Rupert, the ancestral home of the Hunt family.

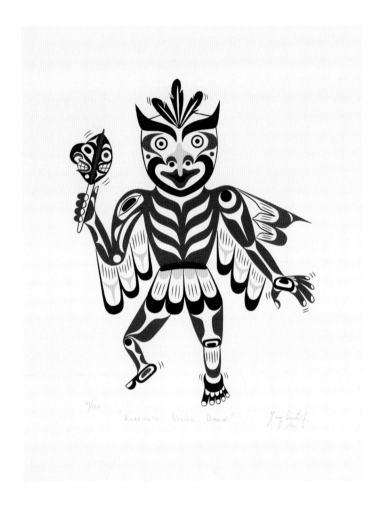

Kwagiulth Grouse Dancer, 1994
Silkscreen; 18 × 14 in.
Ed. 81/150
Collection of George and Colleen Hoyt 346

Whale Drum, 1993
Silkscreen on hide drum with drumstick; 16 × 4 in.
Collection of George and Colleen Hoyt 62

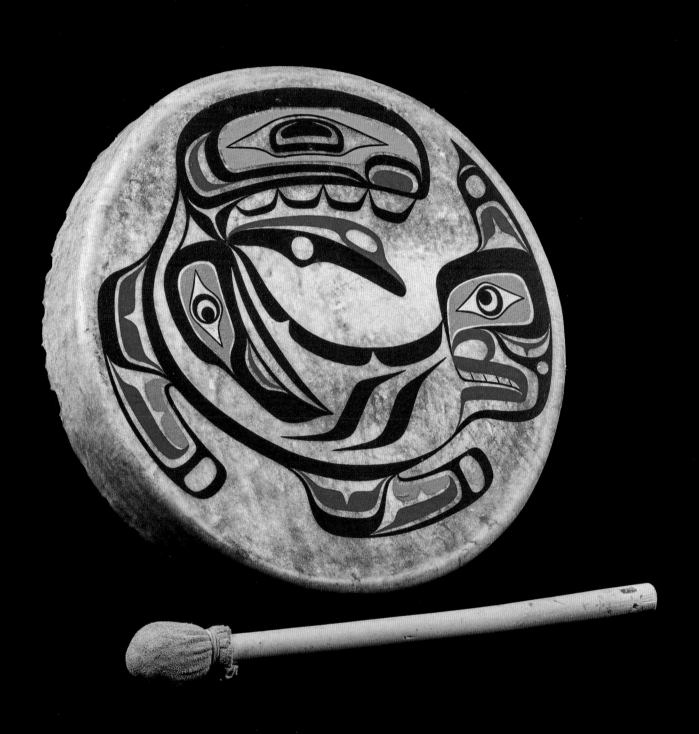

Ron Telek

(Nisga'a, 1962–2017)

Ron Joseph Telek was born in Kincolith, British Columbia, and was a member of the Nisga'a Tait family. He first studied carving in 1962 under the direction of his uncle Norman Tait and assisted him on several pole commissions. After a near-death experience, Telek was inspired to incorporate themes of spirituality, shamanism, and transformation into his works. He later enrolled at Langara College, where he studied sculpting techniques from Africa, Japan, and Italy. Telek's carvings are often left unpainted to highlight sinuous lines and fluid shapes, which create the illusion of motion.

Hummingbird Transformation Mask, twenty-first century
Wood, cedar bark, abalone; 18 × 7 × 12 in.
Collection of George and Colleen Hoyt 332

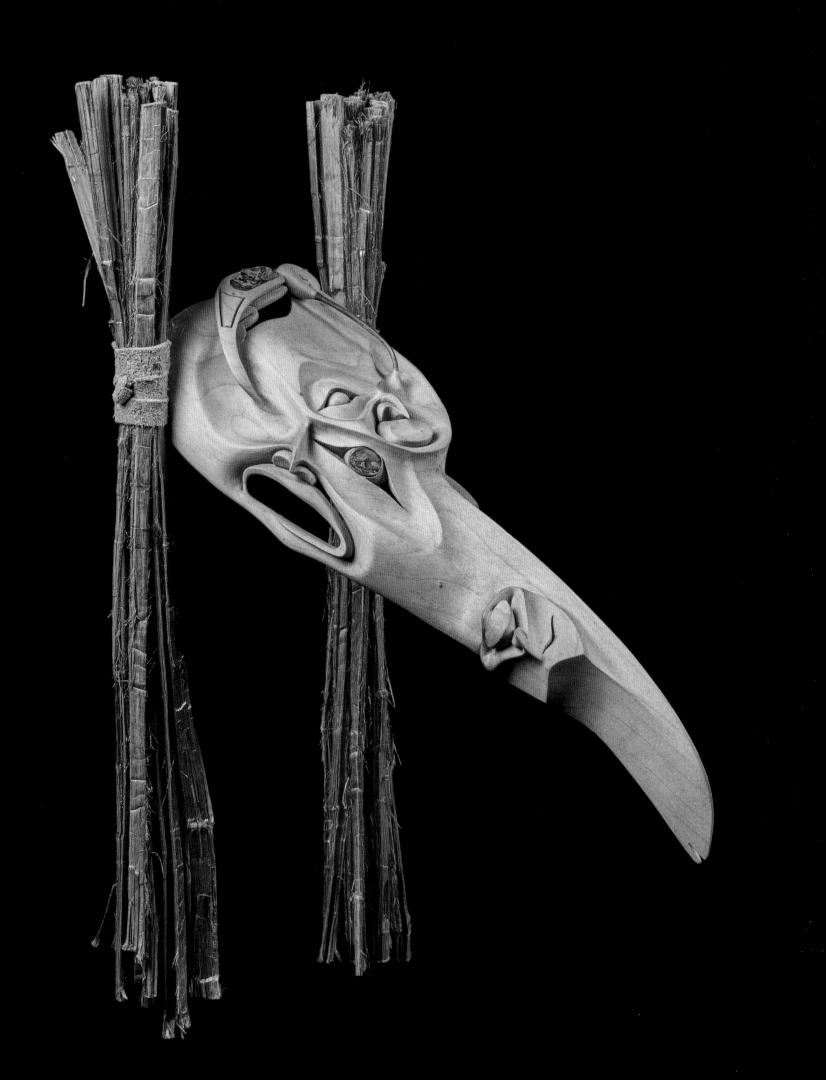

Tom Hunt
(Kwakwaka'wakw, b. 1964)

Tom Hunt was born in Vancouver, British Columbia. He is the son of George Hunt Sr. and Mary Hunt and comes from a rich extended family of artists. He began his first apprenticeship at the age of twelve with his father and then later worked with his brother, George Hunt Jr. During his summers, Hunt spent time learning from his grandfather Sam Henderson and practiced in Kwakwaka'wakw art styles, including the substyle of Blunden Harbour/Smith Inlet. In 1983, he worked under his uncle Calvin Hunt at the Copper Maker Gallery and built a stronger and more versatile set of skills. In addition, he has also worked as Susan Point's assistant on several of her larger projects. He has also completed several commissions, including clan house posts at the school in Quatsino and a welcome figure at the Klemtu ferry terminal. The Hoyts commissioned a set of three Hamat'sa dance masks from Hunt, which were completed in 1997.

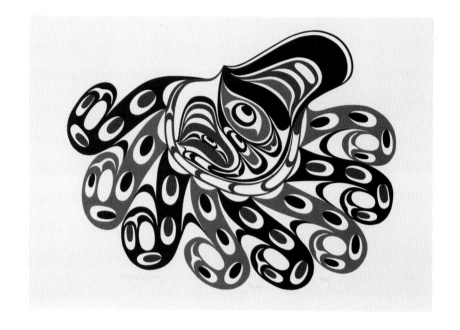

Takqua, 2005
Silkscreen; 15 × 21 in.
Ed. 103/200
Collection of George and Colleen Hoyt 39

Owl Mask, 1997
Wood, cedar bark, paint; 12 × 11 × 8 in.
Collection of George and Colleen Hoyt 41

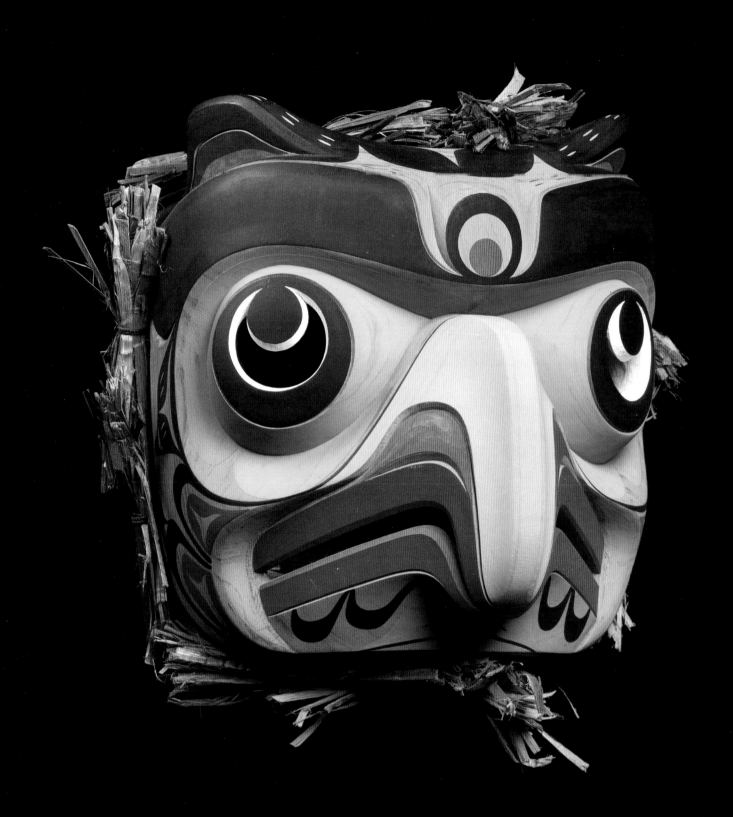

Gerry Sheena
(Interior Salish, b. 1964)

Gerry Sheena was born in Merritt, British Columbia. Although he was initially drawn to art, he was unsure if it could become a viable career. The Interior Salish are known for their basket weaving, so he relied heavily on self-instruction when he was first starting out as a carver. Sheena began to study Coast Salish techniques and visited museums. In 1988, he began his carving career and learned the basics from his brother, Roger Swakum. He then went on to study fine arts at Langara College before attending Emily Carr School of Art (now the Emily Carr University of Art + Design). Sheena also had the opportunity to learn from carvers Beau Dick and Susan Point. His research and years of carving experience have made Sheena a very versatile artist.

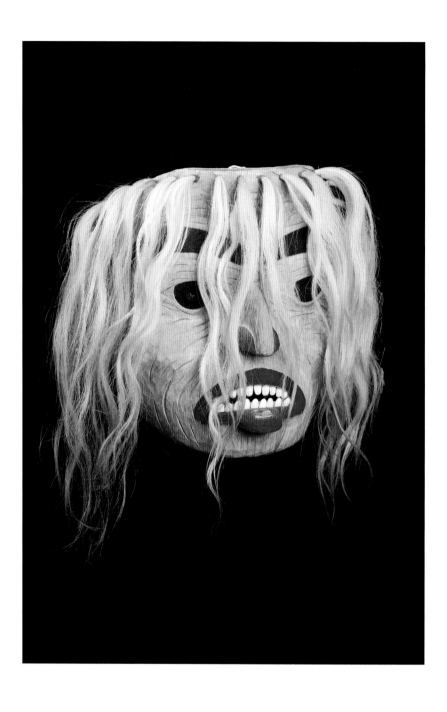

Elder Mask, 2003
Wood, abalone, copper, horsehair, paint; 12 × 13 × 4 in.
Collection of George and Colleen Hoyt 447

Gageet Mask, 1994
Wood, paint, horsehair, bear fur; 19 × 16½ × 4
Collection of George and Colleen Hoyt 448

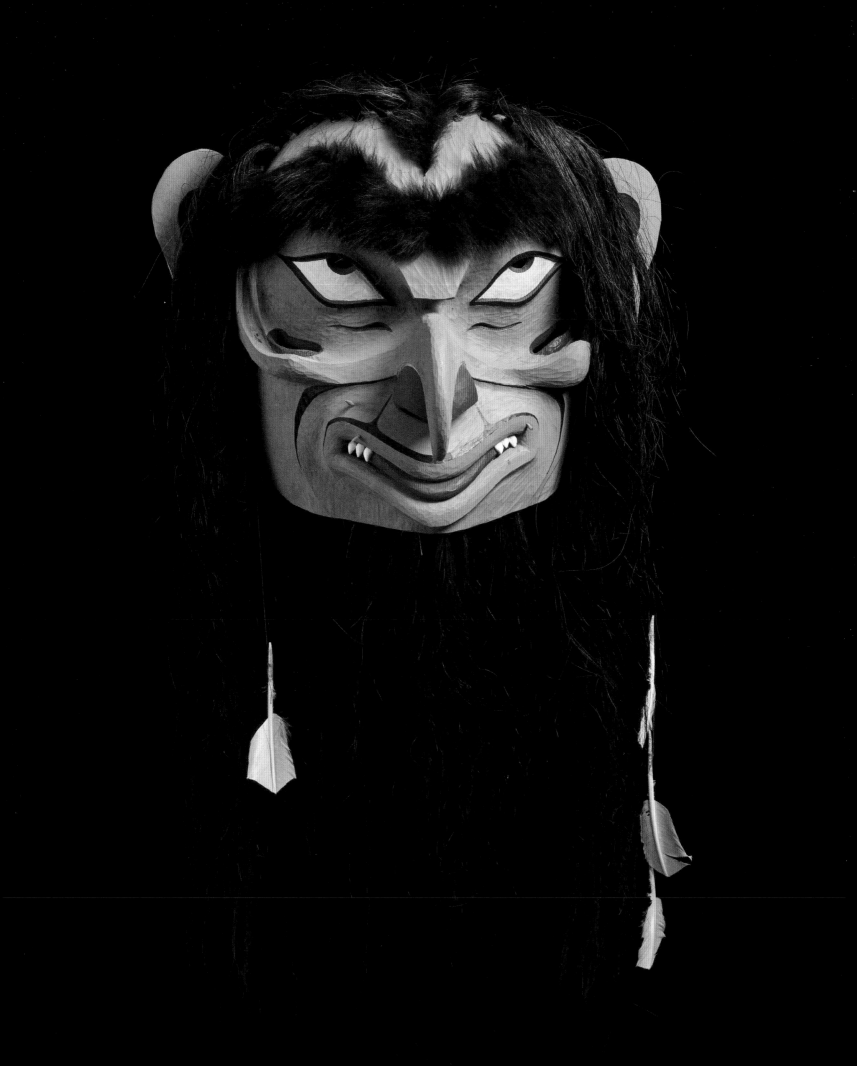

Isaac Tait

(Nisga'a, 1965-2000)

Born in Prince Rupert, British Columbia, Isaac Tait was the son of acclaimed artist Norman Tait. He worked with many different art forms including carving, jewelry, painting, and print-making. Tait began carving in the early 1980s and worked with his family on a number of projects. In 1986, he assisted his father and uncle, Robert Tait, on a pole commissioned for the Native Education College in Vancouver, BC. A year later, he joined his father and uncle once again, along with his cousin Ron Telek, to carve the Beaver Crest Pole for Stanley Park in Vancouver. This pole was significant to the Tait family and told the story of their clan. It was also left unpainted, which is common in many of Tait's and Telek's works.

Moon Mask, 1990
Yellow cedar; 12½ × 12 × 4 in.
Collection of George and Colleen Hoyt 33

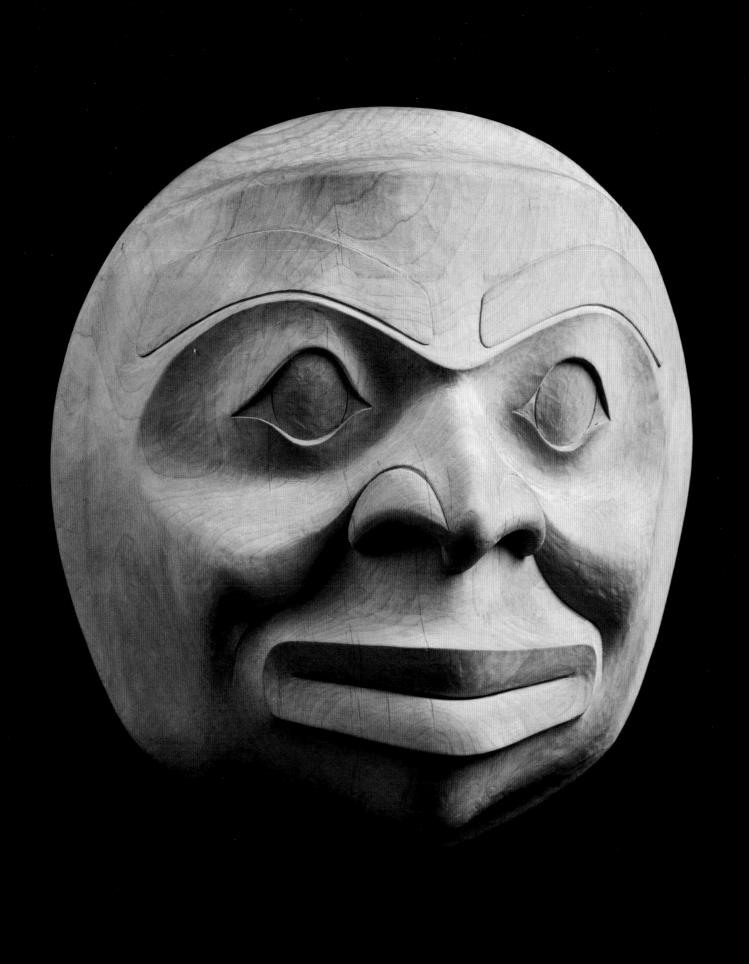

Manuel Salazar
(Coast Salish/Cowichan, b. 1966)

Manuel Salazar was born in Seattle, Washington. He is a member of the Cowichan First Nation, whose territory is near present-day Duncan, British Columbia. Salazar began working as a full-time artist when he was twenty-three and has apprenticed with artists Delmar Johnny and Art Vickers, among many others. Like other contemporary artists, Salazar has branched out to develop his own style by building upon common Salish elements and introducing bold, unusual graphics, creating something completely new. He has created many different designs and has produced a number of rawhide drums and limited-edition prints. In addition, he has been expanding his work to include carving and jewelry making.

Eagle within the Moon, 2003
Silkscreen; 17 × 16 in.
Ed. 66/128
Collection of George and Colleen Hoyt 282

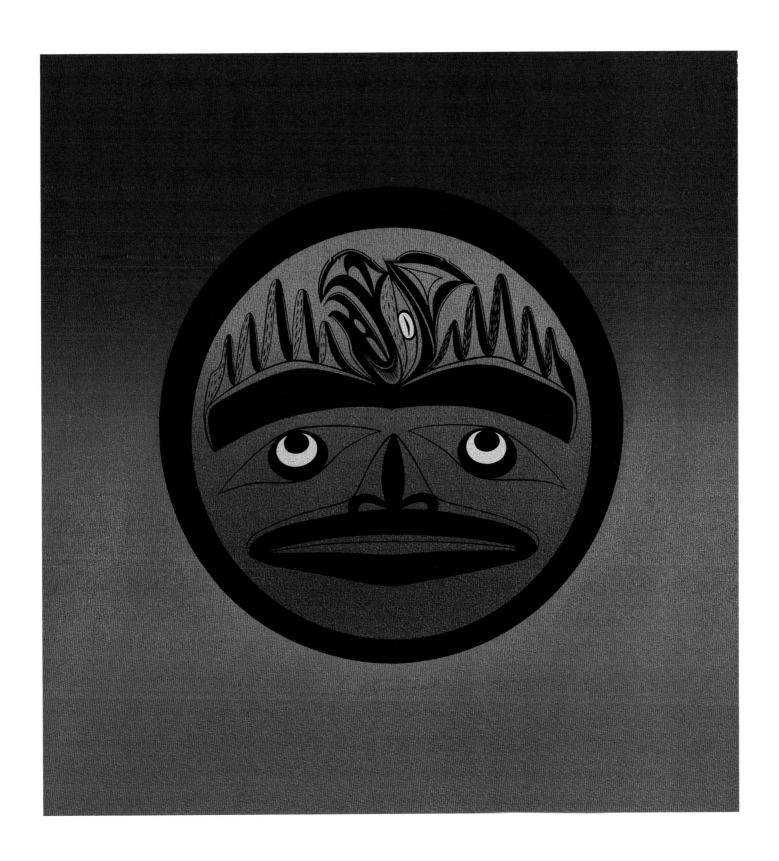

Kevin Cranmer

(Kwakwa̱ka̱'wakw, b. 1967)

Kevin Cranmer was born in Alert Bay, British Columbia, and was raised in Victoria. He is the nephew of accomplished Kwakwa̱ka̱'wakw artist Doug Cranmer and a relative of the Hunt family. When he was a child, he would accompany his father, Danny Cranmer, to the Arts of the Raven Gallery and watch him work. Kevin's first formal instruction came at the encouragement of his parents when he apprenticed with his cousin George Hunt Jr. He then began working with other members of the Hunt family and additional well-known artists. Later in his career, Cranmer began to take part in larger projects when he went to work in Thunderbird Park with artist Tim Paul. Today, Cranmer shares his wide range of skills to create masks, rattles, prints, and other objects for retail trade. He creates special ceremonial pieces for family use, as do many contemporary Northwest Coast artists.

Headdress Frontlet, 2010
Wood, abalone, paint; 10 × 5 × 5 in.
Collection of George and Colleen Hoyt 68

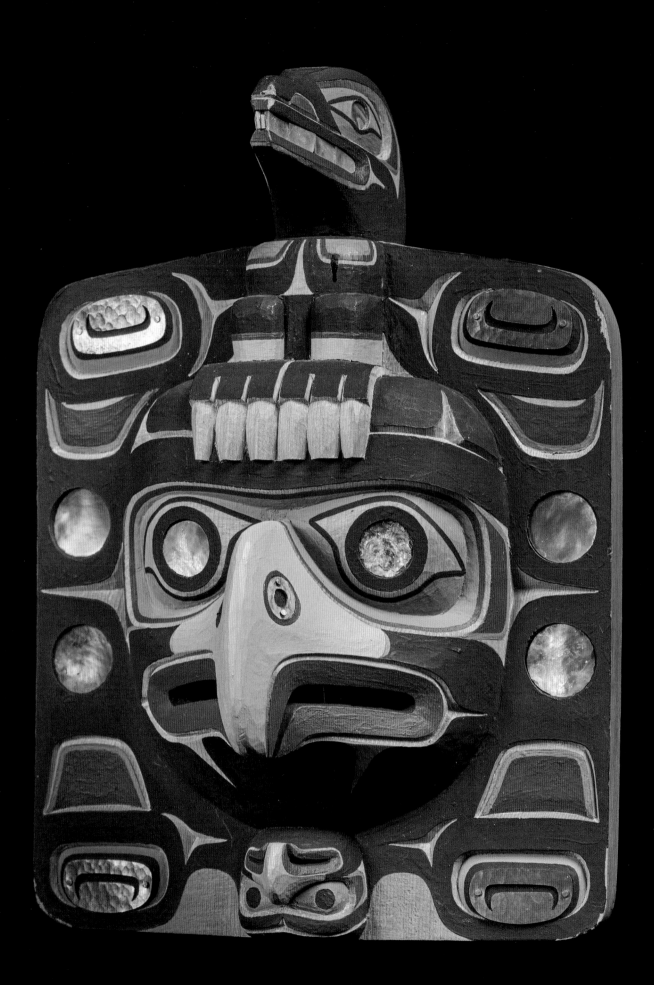

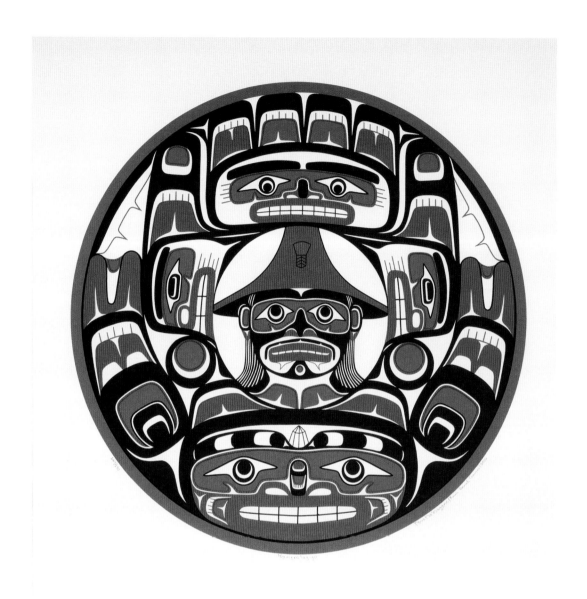

'N<u>a</u>mxxelagiyu, 2006
Silkscreen;. 17½ × 17½ in.
Ed. 164/170
Collection of the Hallie Ford Museum of Art, Salem,
Oregon, 2015.023.023
The George and Colleen Hoyt Northwest Coast
Indigenous Art Fund

This print depicts the story of the great sea mon-
ster 'N<u>a</u>mxxelagiyu, who lived at the mouth of the
Nimpkish River. After a great flood, the creature chose
to transform himself into a man named 'Namukusto'lis
and became one of the first ancestors of the 'Namgis.
Both forms are illustrated here with his human half
central to the body of the sea monster.

Pugwis and Loon Mask, 1991
Wood, copper, fur, paint; 17 × 26 × 12 in.
Collection of George and Colleen Hoyt 71

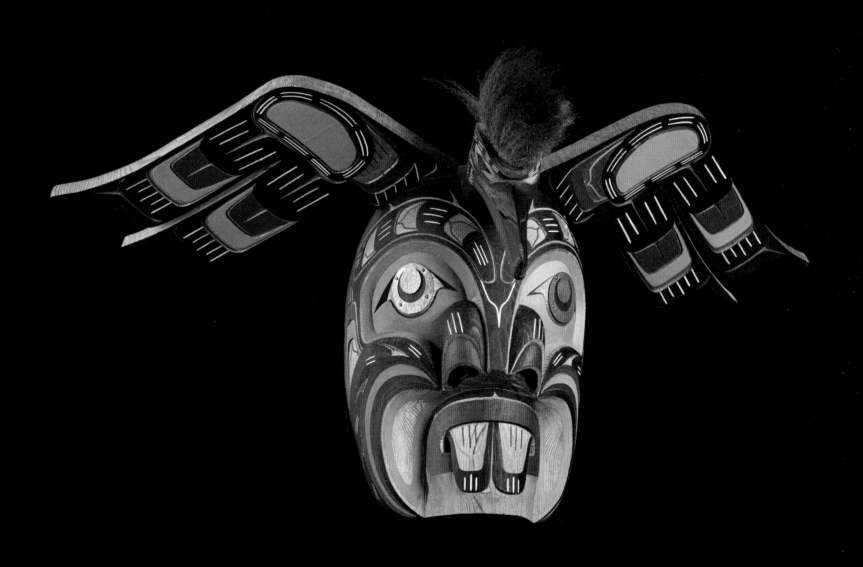

Wayne Edenshaw
(Haida, b. 1967)

Wayne Edenshaw was born in Masset, British Columbia. He began working with Haida art-forms when he was eight years old and apprenticed under his uncle Guujaaw, also known as Gary Edenshaw, on a number of projects over the years. Edenshaw learned by replicating the work done by previous master carvers before going on to develop his own style. However, his professional career did not begin until he worked as an assistant to Beau Dick. Together the two worked on several commissions in preparation for Expo 86. Edenshaw strives to create pieces that honor his own history and can stand as equals to the incredible work done by the master artists of the past.

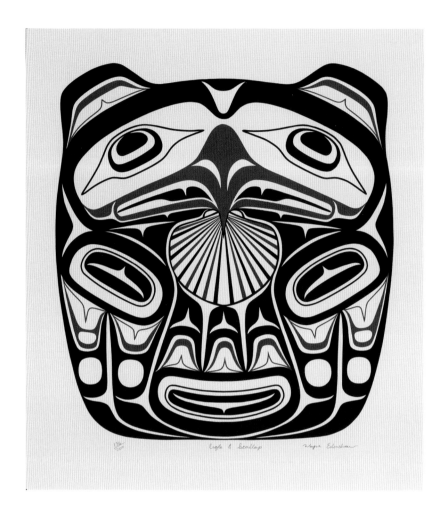

Eagle & Scallop, 2006
Silkscreen; 22 × 19½ in.
Ed. 136/200
Collection of George and Colleen Hoyt 77

Eagle's Heart, 2007
Silkscreen; 21 × 19½ in.
Ed. 175/200
Collection of George and Colleen Hoyt 78

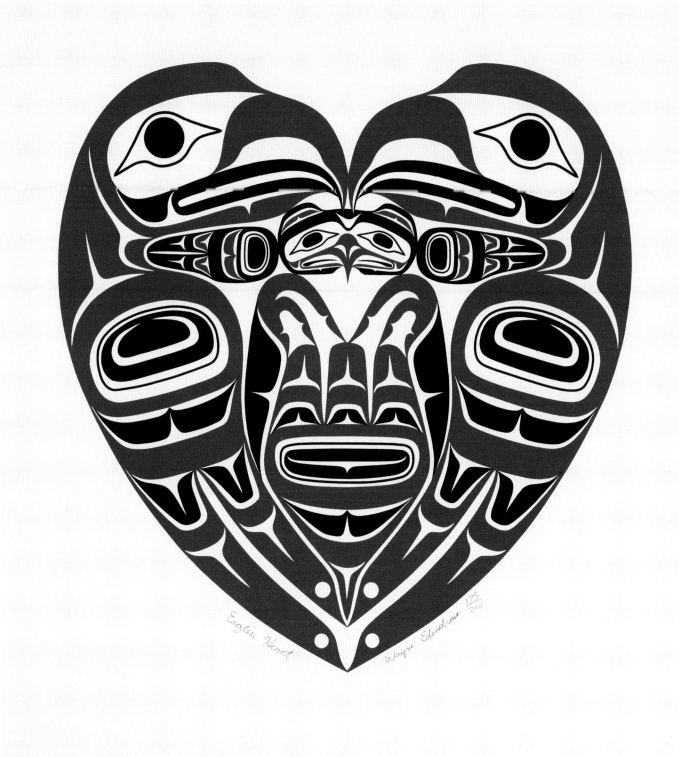

Eagles Heart Wayne Edenshaw 175/200

Joseph M. Wilson

(Coast Salish/Cowichan,
b. 1967)

Joseph M. Wilson was born in Alert Bay,
British Columbia, and raised in Koksilah. He
was drawn to art very early and took his first
design course with Doug Cranmer at the age
of twelve. Growing up near Alert Bay, he also
had the privilege of working with and watching
artists such as Bruce Alfred, Beau Dick, Stephen
Bruce, and Wayne Alfred. He found inspiration
at potlatches and from reading books, where
he noted that masks and other objects need to
be vivid enough for audiences to see properly.
By age seventeen, Wilson had begun pro-
ducing paintings and carvings and has since
apprenticed with master carvers such as Simon
Charlie, Charles Elliott, and Tim Paul. Wilson's
sculptures and two-dimensional designs are
known for their bold and unconventional col-
ors, inspired by the potlatch ceremonies he has
attended throughout his life.

Black Bear, 2007
Silkscreen; 20 × 15 in.
Ed. 99/200
Collection of George and Colleen Hoyt 72

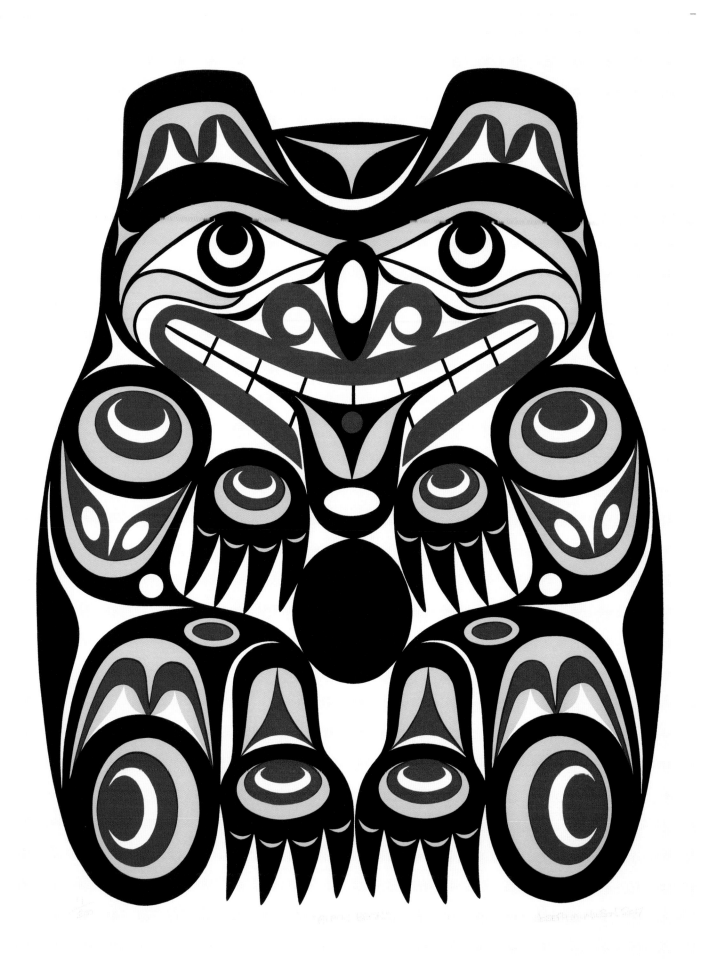

Lyle Campbell
(Haida, b. 1969)

Lyle Campbell was born in Masset, British Columbia, where he began drawing at a young age. After carving his first piece of wood at fourteen, he was inspired to learn more about the craft and eventually enrolled at the Kitanmax School of Northwest Coast Indian Art. Since graduating, he has gone on to work with many accomplished artists including Robert Davidson. While he is best known for his carving, Campbell also works with argillite, jewelry, painting, and printmaking. Over the years, he has transitioned into a new style full of bold colors and more fluid designs that blend together Haida myths and social issues. In 2021, Lyle Campbell and a team of carvers raised the first Haida pole in Prince Rupert in over thirty years. The pole was created in honor of his late mother, Alice Campbell, and raised in front of his childhood home, where his father still resides.

Ancestor Mask, 2013
Red cedar, goat wool, paint; 14 × 11 × 7 in.
Collection of George and Colleen Hoyt 2

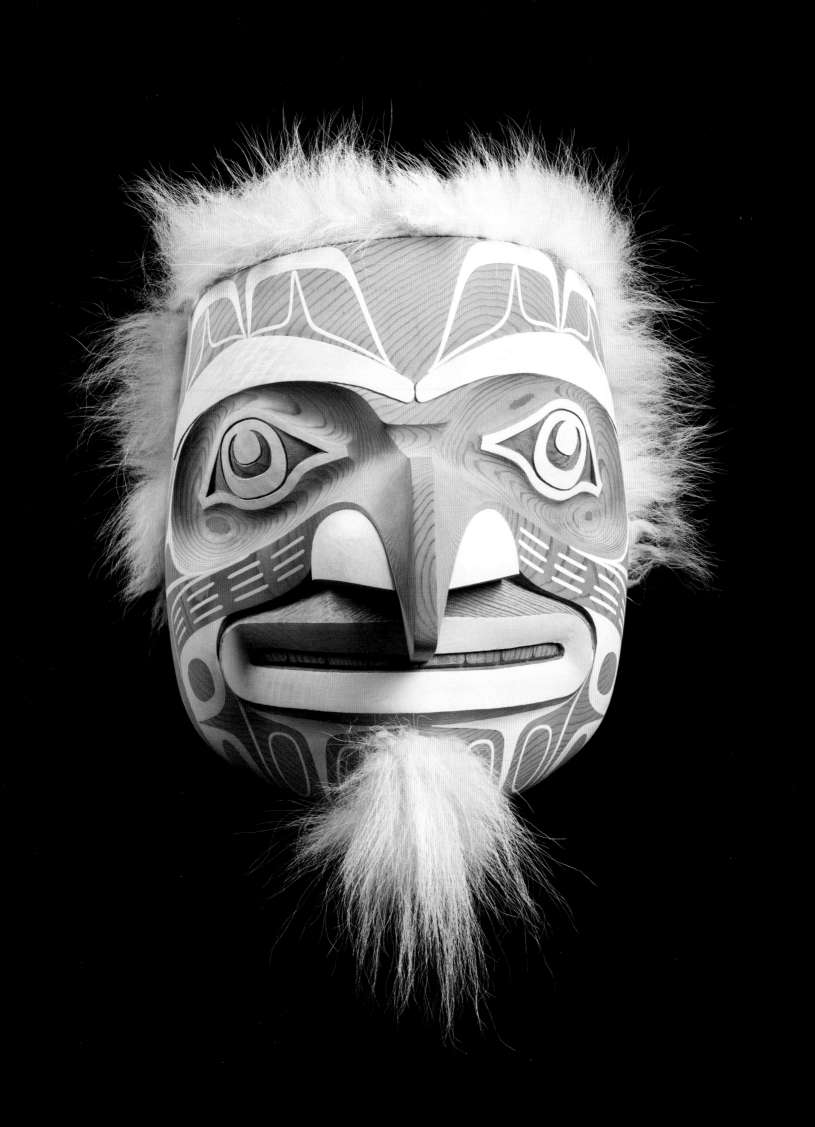

Douglas David

(Dakota/Nuu-chah-nulth/Sioux, b. 1971)

Douglas David was born in Seattle, Washington, and is the son of artists Joe David and Sandra Tuifua Bluehorse. Although he began carving with his father at a young age, his curiosity about art was initially sparked by the Plains dreamcatchers, painted shields, leather, and beadwork created by his mother. Over the years, David has gone on to find mentorship from his uncle George David, and Art Thompson. David works in a variety of mediums including masks, rattles, paddles, and bowls. His blend of cultural influences has helped him create a signature style.

Keeper of Lost Souls, 2015
Red cedar, cedar bark, abalone, paint; 14 × 10 × 5 in.
Collection of George and Colleen Hoyt 192

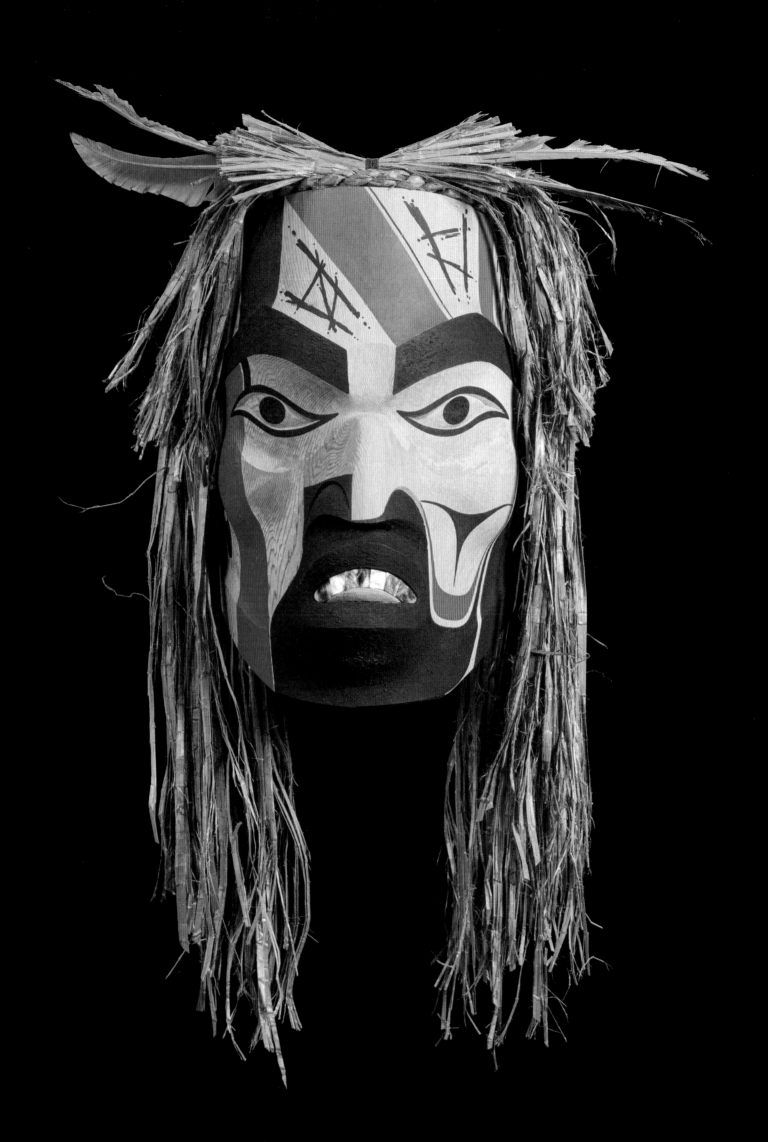

Andy Everson

(Coast Salish/K'ómoks/
Kwakwaka'wakw, b. 1972)

Andy Everson, also known as Nadgedzi, is a
Coast Salish artist who was born in Comox,
British Columbia. He practiced drawing at an
early age and was inspired to fully embrace his
mixed heritage by his grandmother. Everson
began his career as an artist in 1990 and holds
a master's degree in anthropology with an
emphasis in linguistics from the University of
British Columbia. He is known for creating
thought-provoking pieces that blend tradi-
tional Coast Salish designs with contemporary
iconography such as images from *Star Wars*.
Everson has worked on a number of individ-
ual projects as well as collaborations ranging
from public art sculptures to book illustra-
tions. He also enjoys printmaking and has also
branched out into giclée work, a form of digital
printmaking.

New Beginnings, 2016
Giclée print; 17 x 17 in.
Ed. 23/99
Collection of George and Colleen Hoyt 326

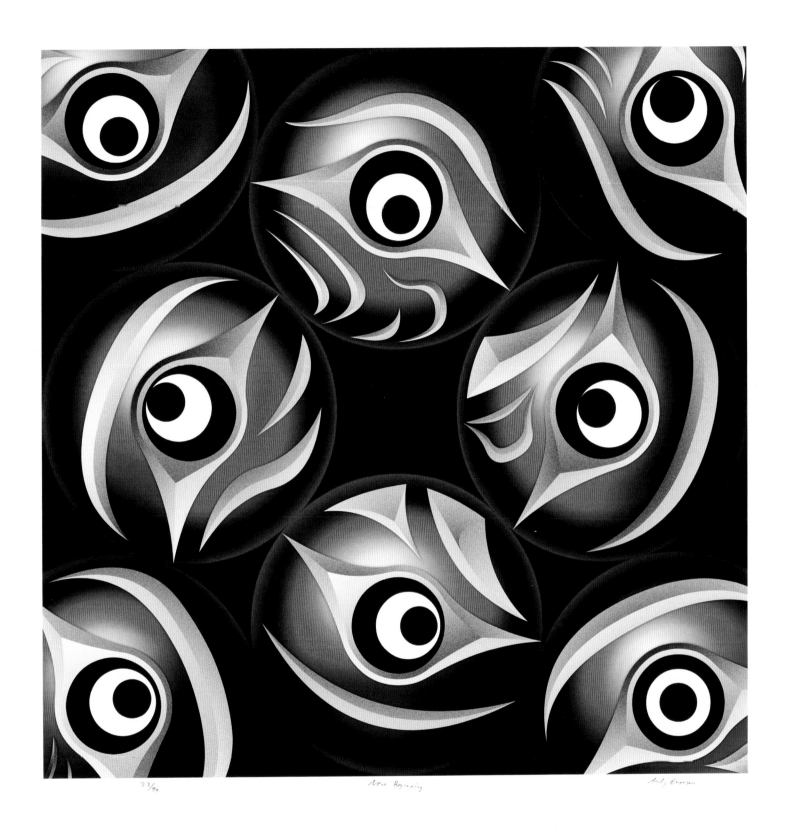

23/99 New Beginning Andy Everson

Maynard Johnny Jr.

(Coast Salish/Kwakwa̲ka̲'wakw/
Penelakut, b. 1973)

Maynard Johnny Jr. was born in Campbell
River, British Columbia, and has been cre-
ating art since he was seventeen years old.
While he considers himself self-taught, he
acknowledges that he has drawn inspiration
from many Northwest Coast artists such as Art
Thompson, Robert Davidson, Susan Point, and
Mark Henderson. In 2013, Johnny collaborated
with students at the University of Victoria on
an important project titled *Surviving Truth*.
The carved piece was a response to how First
Nations children were affected by Canadian
residential schools. In addition to his work as
an educator, Johnny has received numerous
awards for his graphic design work. He is inter-
nationally recognized for experimentation with
bold, unusual colors and design choices across
different mediums.

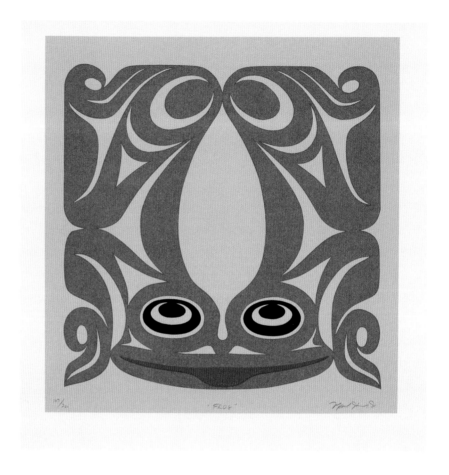

Frog, 2008
Silkscreen;. 15½ × 15 in.
Ed. 147/200
Collection of George and Colleen Hoyt 80

Raven's True Love, twenty-first century
Silkscreen; 27½ × 19 in.
Ed. 36/100
Collection of George and Colleen Hoyt 229

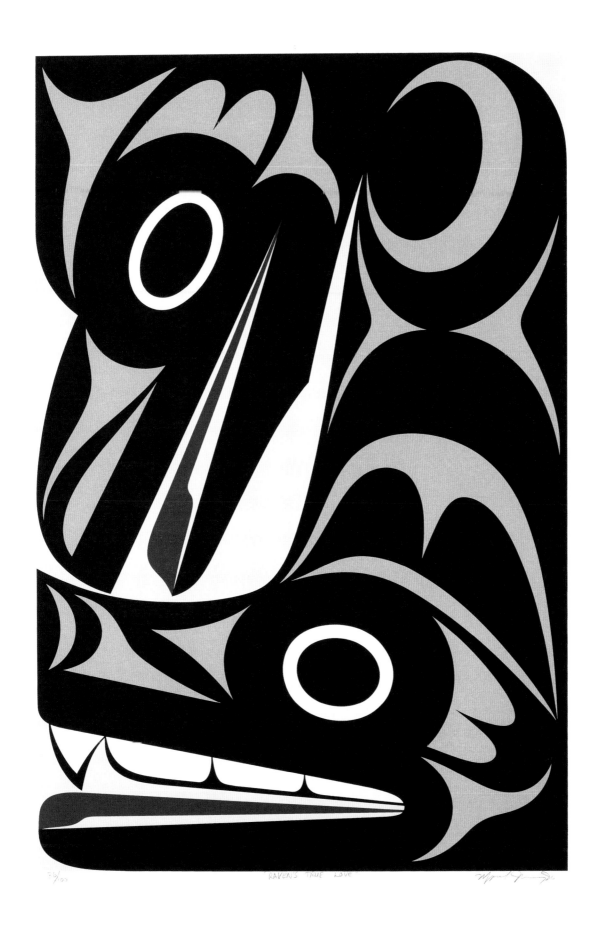

Qwalsius
(a.k.a. Shaun Peterson)
(Coast Salish/Puyallup, b. 1975)

Qwalsius, also known as Shaun Peterson, was born in Puyallup, Washington, and began his professional career in 1996. By 2008, he was included in the ground-breaking exhibit *S'abadeb, The Gifts: Pacific Coast Salish Art and Artists* at the Seattle Art Museum. His public art installations include the twenty foot welcome figure at the Tacoma Art Museum and other projects in the Seattle area. Qwalsius recognizes that materials that were once abundant are now scarce and works in multiple mediums including wood, glass, metal, and digital media.

Embracing the Moon, 2004
Silkscreen; 27½ × 21½ in.
Ed. 70/90
Collection of George and Colleen Hoyt 283

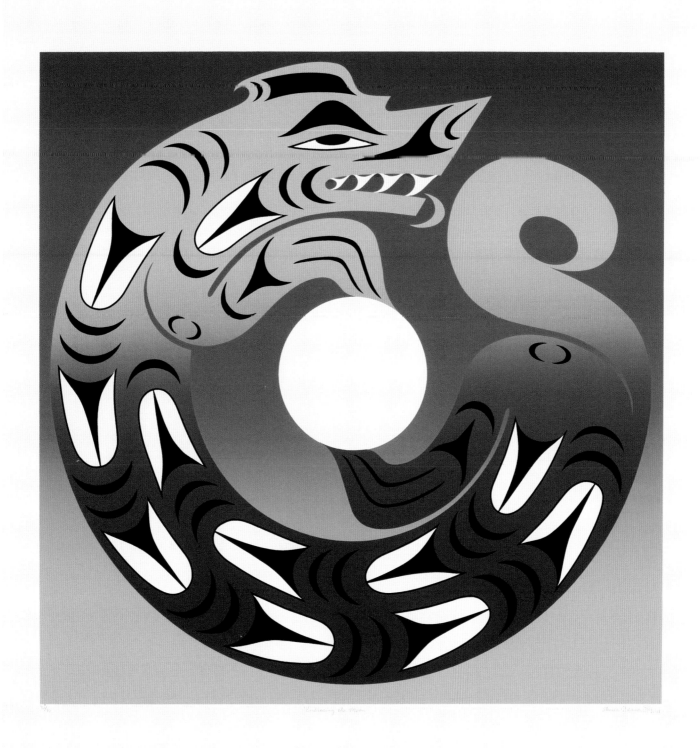

Andrea Wilbur-Sigo

(Coast Salish/Squaxin Island, b. 1975)

Andrea Wilbur-Sigo, whose name is some-times shortened to Andrea Wilbur, was born in Shelton, Washington. Wilbur-Sigo is known for her versatility and innovations combining dif-ferent mediums and technologies. She began her career at the age of eight when she sold her first piece, and she went on to become the first known female carver in her family. She has learned from and worked alongside many art-ists, including her father, Andy Wilbur-Peterson, Dempsey Bob, Archie Noisecat, David A. Boxley, and Joe David. Wilbur-Sigo also holds a degree in computer science, an education she has used to create laser-etched designs onto stones and shells. In 2011, Wilbur-Sigo was chosen as the lead artist for a new Chief Seattle memorial at the site of his grave on the Suquamish Reservation consisting of two twelve-foot-tall cedar story poles.

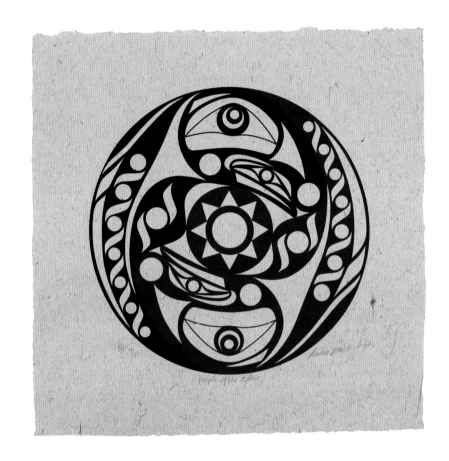

People of the Water, 2003
Silkscreen; 21½ × 22 in.
Artist's proof
Collection of George and Colleen Hoyt 287

Seawolf and Whale Bentwood Box, 1999
Wood, paint; 8 × 6 × 6 in.
Collection of George and Colleen Hoyt 51

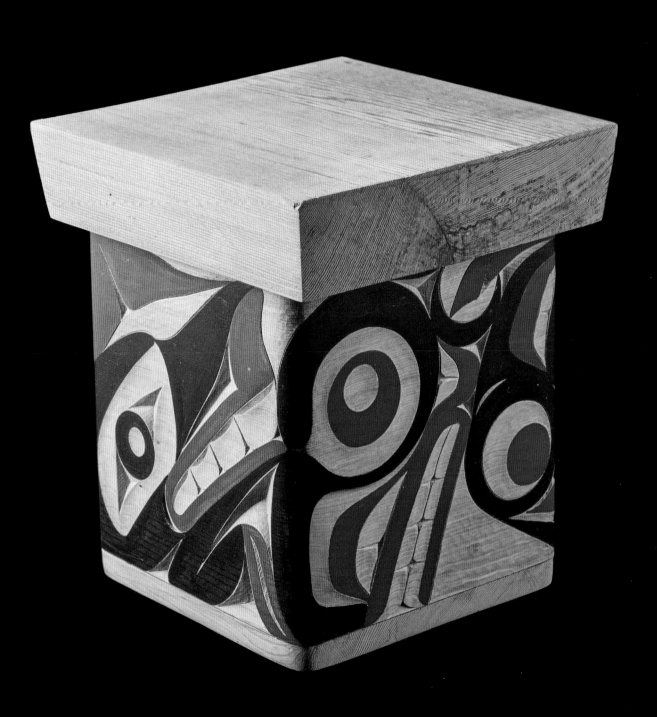

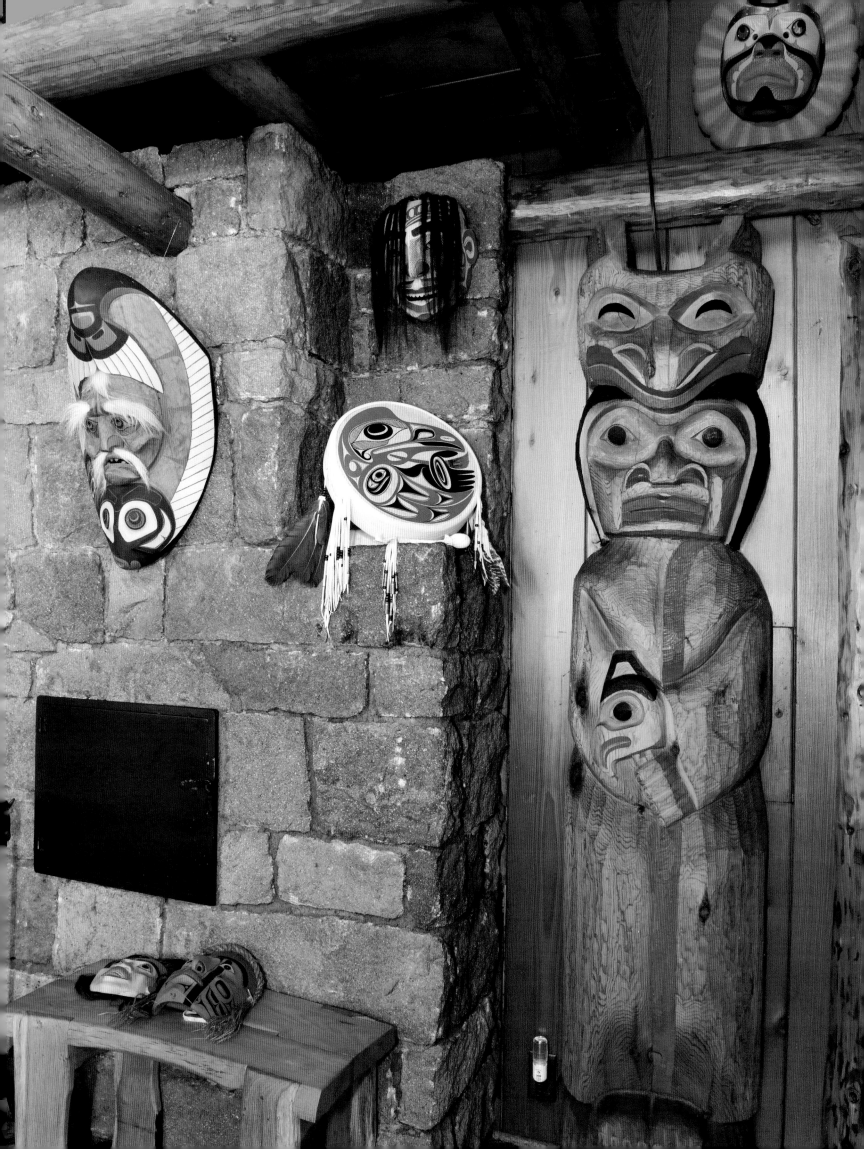

Ahlberg Yohe, Jill, and Teri Greeves. *Hearts of Our People: Native Women Artists*. Minneapolis: Minneapolis Institute of Art in Association with the University of Washington Press, 2019.

Ames, Kenneth M., and Herbert D. G. Maschner. *Peoples of the Northwest Coast: Their Archaeology and Prehistory*. London: Thames and Hudson, 1999.

Arnold, Grant, Monika Gagnon, and Doreen Jensen. *Topographies: Aspects of Recent B.C. Art*. Vancouver: Douglas & McIntyre, 1996. Exhibition catalog, Vancouver Art Gallery.

Art of Francis Dick (website). "About." Accessed March 30, 2022. https://francisdick.com/about/.

Martens, Darrin J. with Justin Barski, Linnea Dick, Peter Morin, and Beau Dick. *Beau Dick: Revolutionary Spirit*. Whistler, BC: Figure 1 Publishing. 2018. Exhibition catalog, Audain Art Museum.

Black, Martha. *Out of the Mist: HuupuKwanum Tupaat: Treasures of the Nuu-chah-nulth Chiefs*. Victoria, BC: Royal British Columbia Museum, 1999. Exhibition catalog.

Blanchard, Rebecca, and Nancy Davenport. *Contemporary Coast Salish Art*. Seattle: Stonington Gallery, University of Washington Press, 2005. Exhibition catalog.

Blunden Harbor Smith Inlet (website). "Kwakiutl Carvers of Blunden Harbor/Smith Inlet." Accessed March 22, 2022. http://blundenharborsmithinlet.com/.

Bob, Dempsey. "Artist Statement." Accessed March 29, 2022. http://www.dempseybob.com/Artist_Statement/artist_statement.shtml.

Boyd, Robert T., Kenneth M. Ames, and Tony A. Johnson, eds. *Chinookan Peoples of the Lower Columbia*. Seattle: University of Washington Press, 2013.

Boxley, David A. "About David Boxley." Accessed March 17th, 2022.http://www.davidboxley.com/about.

British Columbia Achievement Foundation. "2009 BC Creative Lifetime Achievement Award For Aboriginal Art." Accessed March 20, 2022. http://www.llbc.leg.bc.ca/public/PubDocs/bcdocs2017_2/681881/Lifetime_2009.pdf.

Brotherton, Barbara, ed. *S'abadeb/The Gifts: Pacific Coast Salish Art and Artists.* Seattle: University of Washington Press, 2008.

Brotherton, Barbara. "How Did It All Get There? Tracing the Path of Salish Art in Collections." In *S'abadeb/The Gifts,* edited by Barbara Brotherton, 68-139. 2008.

Bunn-Marcuse, Kathryn. "Form First, Function Follows: The Use of Formal Analysis in Northwest Coast Art History." In *Native Art of the Northwest Coast,* Townsend-Gault et al., eds., 404-443. 2013.

Campbell, Neil, Roy Arden, and Beau Dick. *Supernatural: Neil Campbell, Beau Dick: An Exhibition*. Vancouver: Contemporary Art Gallery, 2004. Exhibition catalog.

Canadian Indigenous Art Inc. "Floyd Joseph." Accessed March 30, 2022.https://canadianindigenousart.com/artist/floyd-joseph/.

CBC Arts. "Watch Artists Carve and Raise a Haida Memorial Pole in Prince Rupert." *CBC,* August 11, 2021. https://www.cbc.ca/arts/watch-artists-carve-and-raise-a-haida-memorial-pole-in-prince-rupert-1.6137375.

Cedar Hill Long House. "Art Thompson." Accessed March 30, 2022.https://cedarhilllonghouse.ca/artists/art-thompson/.

———. "Joe Wilson." Accessed April 2, 2022. https://cedarhilllonghouse.ca/artists/joe-wilson/.

———. "Lyle Campbell." Accessed March 17, 2022. https://cedarhilllonghouse.ca/artists/lyle-campbell/.

———. "Manuel Salazar." Accessed March 30, 2022. https://cedarhilllonghouse.ca/artists/manuel-salazar/.

———. "Robert Jackson." Accessed March 26, 2022. https://cedarhilllonghouse.ca/artists/robert-jackson/.

———. "Vernon Stephens." Accessed March 30, 2022. https://cedarhilllonghouse.ca/artists/vernon-stephens/.

C. N. Gorman Museum at UC Davis. "George Hunt Jr., Cormorant Rattle." May 18, 2020. https://gormanmuseum.ucdavis.edu/collection-piece/george-hunt-jr-cormorant-rattle.

Coastal Peoples Fine Arts Gallery. "Larry Rosso." Accessed March 18, 2022. https://coastalpeoples.com/archive-artist/?a=larry-rosso.

———. "Norman Tait and Lucinda Turner." Accessed March 15, 2022. https://coastalpeoples.com/archive-artist/?a=norman-tait-and-lucinda-turner.

———. "Ron Joseph Telek." Accessed March 22, 2022. https://coastalpeoples.com/archive-artist/?a=ron-joseph-telek.

Coast Mountain College. "Freda Diesing Biography." Accessed September 3, 2021. https://www.coastmountaincollege.ca/programs/explore/freda-diesing-school-of-northwest-coast-art/freda-diesing-biography.

Croes, Dale R., and Susan A. Point. *Susan Point: Works on Paper*. Vancouver: Figure 1 Publishing, 2014.

Daehnke, Jon. *Chinook Resilience: Heritage and Cultural Revitalization on the Lower Columbia River*. Seattle: University of Washington Press, 2017.

Da Vic Gallery Native Canadian Arts. "Doug Cranmer." Accessed November 9, 2021. https://nativecanadianarts.com/artist/doug-cranmer/.

———. "Freda Diesing." Accessed October 7, 2021. https://nativecanadianarts.com/artist/freda-diesing/.

Davidson, Robert. "Family." Accessed March 22, 2022. https://www.robertdavidson.ca/family.

———. "Robert Davidson: Eagle of the Dawn, Biography." Accessed January 25, 2021. https://www.robertdavidson.ca/biography.

Davidson, Robert, and Ulli Steltzer. *Eagle Transforming: The Art of Robert Davidson*. Vancouver: Douglas & McIntyre; Seattle: University of Washington Press, 1994.

Davidson, Sara Florence, and Robert Davidson. *Potlatch as Pedagogy*. Winnipeg: Portage & Main Press, 2018.

Dawkins, Alex. "Phil Janzé (1950–2016)." Lattimer Gallery, September 8, 2016. https://www.lattimergallery.com/blogs/news/phil-janze-1950-2016.

Dawkins, Alexander, and Corrine Hunt. *Understanding Northwest Coast Indigenous Jewelry: The Art, the Artists, the History*. Vancouver and Berkeley: Greystone Books, 2019.

Dick, Francis. "Beau Dick/Walas Gwa'yam." *BC Studies*, no. 194 (2017): 5. *Gale Academic OneFile* (accessed March 22, 2022). https://link.gale.com/apps/doc/A501487119/AONE?u=s8887317&sid=bookmark-AONE&xid=e0b818cd.

Doug LaFortune, Artist. "Bio." Accessed March 22, 2022. https://douglafortune.wordpress.com/bio/.

Douglas Reynolds Gallery. "Freda Diesing." Accessed October 7, 2021. https://douglasreynoldsgallery.com/collections/freda-diesing.

Duncan Sightseeing. "Simon Charlie (1920–2005)." Accessed March 13, 2022. http://www.duncansightseeing.com/simon-charlie/.

Duffek, Karen. "Value Added: The Northwest Coast Art Market since 1965." In *Native Art of the Northwest Coast*, Townsend-Gault et al., eds., 590-632. 2013.

Edenshaw, Gwaii. "The Power of Speech." In *Northwest Coast and Alaska Native Art*, Christopher Patrello, 54-55. Denver: Denver Art Museum, 2020.

Edwards, Ashley. "When Knowledge Goes Underground: Cultural Information, Information Poverty, and Canada's Indian Act." *Pathfinder: A Canadian Journal for Information Science Students and Early Career Professionals* 1, no. 2 (2022): 19–35.

Everson, Andy. "Artist Statement." Accessed March 30, 2022. http://www.andyeverson.com/andy.html.

Farr, Sheila. "Beyond the Totem: Modernism, Northwest Coast Native Art, and Robert Davidson." In *Abstract Impulse: Robert Davidson*. Seattle: Seattle Art Museum in association with University of Washington Press, 2013.

Fontaine, Lorena Sekwan. "Redress for Linguicide: Residential Schools and Assimilation in Canada." *British Journal of Canadian Studies* 30, no. 2 (2017): 183–204. http://dx.doi.org/10.3828/bjcs.2017.11.

Friday, Chris. *Lelooska: The Life of a Northwest Coast Artist*. Seattle: University of Washington Press, 2003.

Glass, Aaron. "From Cultural Salvage to Brokerage: The Mythologization of Mungo Martin and the Emergence of Northwest Coast Art." *Museum Anthropology* 29, no. 1 (March 2006): 20–43. https://doi.org/10.1525/mua.2006.29.1.20.

———. "History and Critique of the 'Renaissance' Discourse." In *Native Art of the Northwest Coast,* Townsend-Gault et al., eds., 487-417. 2013.

Gordon, Naomi. "Man's Hobby Becomes Life's Work." *Windspeaker* 21, no. 3 (2003). https://www.ammsa.com/publications/windspeaker/mans-hobby-becomes-lifes-work.

Hall, Edwin S. Jr., Margaret B. Blackman, and Vincent Rickard. *Northwest Coast Indian Graphics: An Introduction to Silk Screen Prints.* Seattle: University of Washington Press, 1981.

Halpin, Marjorie M. *Cycles: The Graphic Art of Robert Davidson, Haida.* Vancouver: UBC Museum of Anthropology, 1979.

———. "Northwest Coast Indigenous Art." *The Canadian Encyclopedia,* June 5, 2019. https://www.thecanadianencyclopedia.ca/en/article/northwest-coast-aboriginal-art.

Hanson, Eric, Daniel P. Games, and Alexa Manuel. "The Residential School System." *Indigenous Foundations,* September 2020. https://indigenousfoundations.arts.ubc.ca/residential-school-system-2020/.

Hare, Jan. "Pushing the Boundaries of Tradition in Art: An Interview with Susan Point." *BC Studies,* no. 135 (Autumn 2002):163. https://doi.org/10.14288/bcs.v0i135.1646.

Harnett, Cindy E., and Sarah Petrescu. "Obituary: Tony Hunt Jr.'s Work Attracted a World of Collectors." *Times Colonist,* October 15, 2017. https://www.timescolonist.com/local-news/obituary-tony-hunt-jrs-work-attracted-a-world-of-collectors-4655058.

Harris, Christie, Bill Reid, Robert Davidson, and Margaret B. Blackman. *Raven's Cry.* Vancouver: Douglas & McIntyre; Seattle: University of Washington Press, 1992.

Hitchcock, Don. 2018. "Canoes of the First Nations of the Pacific Northwest." October 3, 2018. https://www.donsmaps.com/canoesnwc.html

Holm, Bill. *Northwest Coast Indian Art: An Analysis of Form.* Seattle: University of Washington Press, 1965.

Hupacasath First Nation. "Interactive Places and Language Map." Accessed March 26, 2022. https://www.hupacasath.ca/about-us/interactive-places-language-map/.

Hunt, Richard. "About Richard." Accessed March 30, 2022. https://www.richardhunt.com/about.

Indian Residential School and History Centre. "The Indian Residential School Settlement Agreement." University of British Columbia website. Accessed March 23, 2022. https://irshdc.ubc.ca/learn/the-indian-residential-school-settlement-agreement/

Inuit Gallery of Vancouver. "Simon Dick." Accessed February 5, 2022. https://inuit.com/pages/simon-dick.

———. "Wayne Alfred." Accessed March 13, 2022. https://inuit.com/pages/wayne-alfred.

Jacknis, Ira. "Authenticity and the Mungo Martin House, Victoria, B.C.: Visual and Verbal Sources." *Arctic Anthropology* 27, no. 2 (1990): 1–12.

———. *The Storage Box of Tradition: Kwakiutl Art, Anthropologists, and Museums, 1881-1981.* Washington, DC: Smithsonian Institution Press, 2002.

Jacobs, Alex. "Chief Beau Dick: Carver, Artist, Advocate, Mentor, Storyteller, Walks On." *Indian Country Today,* April 22, 2017.

Jacobs, J. "1920–1927 Indian Act Becomes More Restrictive." Accessed March 26, 2022. http://www.fnesc.ca/wp/wp-content/uploads/2015/07/IRSR11-12-DE-1920-1927.pdf.

Johnson, Tony A. and Adam McIsaac, "Lower Columbia River Art." In Boyd et al., *Chinookan Peoples of the Lower Columbia,* 199-225. 2013.

Jonaitis, Aldona. *Art of the Northwest Coast, Second Edition.* Seattle: University of Washington Press, 2021.

Kisin, Eugenia. "Archival Predecessors and Indigenous Modernisms: Archives in Contemporary Curatorial Practice on the Northwest Coast." *RACAR* 42, no. 2 (2017): 72–86. https://doi.org/10.7202/1042947ar.

Kramer, Jennifer, with Gloria Cranmer Webster and Solen Roth. *Kesu: The Art and Life of Doug Cranmer.* Vancouver: Douglas & McIntire and Museum of Anthropology at the University of British Columbia; Seattle: University of Washington Press, 2012.

Kwakiutl Band Council. "Kwakiutl Traditional Carving." Accessed March 22, 2022. https://www.kwakiutl.bc.ca/kwakiutl-traditional-carving.

Lattimer Gallery. "Claude Davidson." Accessed March 22, 2022. https://www.lattimergallery.com/collections/claude-davidson.

————. "Doug Cranmer." Accessed November 17, 2021. https://www.lattimergallery.com/collections/doug-cranmer.

————. "Doug LaFortune Sr." Accessed March 31, 2022. https://nativeartprints.com/collections/doug-lafortune-sr.

————. "Ellen Neel." Accessed March 25, 2022.https://www.lattimergallery.com/collections/ellen-neel.

————. "Gerry Marks." Accessed March 30, 2022.https://www.lattimergallery.com/collections/gerry-marks.

————. "George Hunt Jr." Accessed March 22, 2022. https://www.lattimergallery.com/collections/george-hunt-jr.

————. "Larry Rosso." Accessed March 22, 2022. https://www.lattimergallery.com/collections/larry-rosso.

————. "Isaac Tait." Accessed March 22, 2022. https://www.lattimergallery.com/collections/isaac-tait.

————. "Norman Tait." Accessed March 13, 2022. https://www.lattimergallery.com/collections/norman-tait.

————. "Pat Dixon." Accessed February 12, 2022. https://www.lattimergallery.com/collections/pat-dixon.

Lawrence, Toby, India Young, and lessLIE. *Record, Recreate: Contemporary Coast Salish Art from the Salish Weave Collection*. Victoria, BC: Art Gallery of Greater Victoria, 2012. Exhibition catalog.

Lee, Tara. "Spotlight on Gerry Sheena: Carver and Former Artist-in-Residence at Vancouver's Skwachàys Lodge." *Inside Vancouver*, November 3, 2021. https://www.insidevancouver.ca/2021/11/03/a-conversation-with-gerry-sheena-carver-and-former-artist-in-residence-at-vancouvers-skwachays-lodge/.

Lelooska Foundation. "About Chief Lelooska." Accessed March 22, 2022. http://lelooska.org/about/chief/.

Macnair, Peter L., Robert Joseph, and Bruce Greenville. *Down from the Shimmering Sky: Masks of the Northwest Coast*. Vancouver: Douglas & McIntyre; Seattle: University of Washington Press, 1998. Exhibition catalog, Vancouver Art Gallery.

Macnair, Peter L., Alan L. Hoover, and Kevin Neary. *The Legacy: Tradition and Innovation in Northwest Coast Indian Art*. Vancouver: Douglas & McIntyre; Seattle: University of Washington Press, 1984. Exhibition catalog, British Columbia Provincial Museum.

Mcleod, Susanna. "Carving the Totem Story: Freda Diesing Regarded as One of the Finest First Nations Artists and Totem Pole Carvers." *Kingston Whig-Standard*, May 30, 2018.

McRae, Matthew. "Bringing the Potlatch Home: Museums, Repatriation and the Cranmer Potlatch." Canadian Museum for Human Rights. Accessed March 24, 2022. https://humanrights.ca/story/bringing-the-potlatch-home.

Moedhart Gallery. "Gerry Sheena." Accessed March 22, 2022. https://moedhart.com/gerry-sheena/.

Morin, Peter, Jeanne Martine Reid, and Mike Robinson. *Carrying On "Irregardless": Humour in Contemporary Northwest Coast Art*. Vancouver: Bill Reid Gallery of Northwest Coast Art, 2012. Exhibition catalog.

Native Arts and Culture Foundation. "David A. Boxley." Posted August 6, 2015. https://www.nativeartsandcultures.org/david-boxley

Neel, David. *The Great Canoes: Reviving a Northwest Coast Tradition*. Vancouver: Douglas and McIntyre, 1995.

Nyguen, Caressa. "Evergreen Longhouse to Host Annual Community Dinner." *The* Evergreen State College, November 5, 2019. https://www.evergreen.edu/events/post/Evergreen-longhouse-host-annual-community-dinner.

Pauls, E. Prine. "Northwest Coast Indian." *Britannica*, Accessed November 5, 2021. https://www.britannica.com/topic/Northwest-Coast-Indian.

Pegasus Gallery. "Doug Cranmer." Accessed November 18, 2021. http://www.pegasusgallery.ca/artist/doug_cranmer.html.

————. "Chief Tony Hunt." Accessed December 1, 2021. http://www.pegasusgallery.ca/artist/chief_tony_hunt.html.

Quintana Galleries. "'Namgis Portrait Mask Pendant by Kevin Cranmer, Kwakwaka'wakw." Accessed March 17, 2022. https://quintanagalleries.com/collections/northwest-coast-collection-1/products/namgis-portrait-mask-by-kevin-cranmer-kwakwakawakw.

Qwalsius (Shaun Peterson). "Artist Statement." Accessed March 30, 2022.http://www.qwalsius.com/our-story.

Royal BC Museum. "Thunderbird Park." Accessed March 24, 2022.https://royalbcmuseum.bc.ca/visit/exhibitions/thunderbird-park-0.

Roth, Solen. *Incorporating Culture: How Indigenous People are Reshaping the Northwest Coast Art Industry*. Vancouver and Toronto: UBC Press, 2018.

Salish Weave. "Andy Everson." Accessed March 26, 2022. https://salishweave.com/artist-work/andy-everson/.

———. "Andy Wilbur-Peterson." Accessed March 11, 2022. https://salishweave.com/artist-work/andy-wilbur-peterson/.

———. "Maynard Johnny Jr." Accessed March 24, 2022. https://salishweave.com/artist-work/maynard-johnny-jr/.

Scace, Matt. "Gitxsan Chief Involved in Landmark 1997 Supreme Court Case Dies at 85." *Prince George Post*, January 17, 2022. https://www.princegeorgepost.com/news/local-news/gitxsan-chief-involved-in-landmark-1997-supreme-court-case-dies-at-85/.

Sealaska Heritage Institute. "Art Resources." Accessed April 2, 2022. https://www.sealaskaheritage.org/institute/art/art-resources#lectures.

Seattle Art Museum. "Simon Dick." Accessed February 5, 2022. https://art.seattleartmuseum.org/people/15080/simon-dick;jsessionid=DCC23019531815FD61E19CA302AD947A.

Seattle Public Schools. "Andrea Wilbur Sigo, Squaxin Island." Accessed March 30, 2022. https://www.seattleschools.org/web/website-theme-art/andrea-wilbur-sigo/.

Sewid-Smith, Daisy. "Interpreting Cultural Symbols of the People from the Shore." In *Native Art of the Northwest Coast*, Townsend-Gault et al, eds., 15-25. 2013.

Shea, Carolyn. "Creating Cultural Revival." The Evergreen State College, Accessed March 19, 2021. https://www.evergreen.edu/magazine/creating-cultural-revival.

Shearar, Cheryl. *Understanding Northwest Coast Art: A Guide to Crests, Beings, and Symbols.* Vancouver: Douglas & McIntyre; Seattle: University of Washington Press, 2000.

Sheenan, Carol, and Daniel Baird. "Bill Reid." *The Canadian Encyclopedia.* Updated December 17, 2021. https://www.thecanadianencyclopedia.ca/en/article/william-ronald-reid.

Sheenan, Carol, and Michelle Filice. "Henry Hunt." *The Canadian Encyclopedia.* Updated November 6, 2015. https://www.thecanadianencyclopedia.ca/en/article/henry-hunt.

———. "Tony Hunt." *The Canadian Encyclopedia.* Updated November 26, 2015. https://www.thecanadianencyclopedia.ca/en/article/tony-hunt.

Sheenan, Carol, and David Joseph Gallant. "Walter Harris." *The Canadian Encyclopedia.* Updated July 25, 2019. https://www.thecanadianencyclopedia.ca/en/article/walter-harris.

Simon Fraser University's Bill Reid Centre for Northwest Coast Studies. "The Potlatch Ban." Accessed March 24, 2022. https://www.sfu.ca/brc/online_exhibits/masks-2-0/the-potlatch-ban.html.

Skelly, Julia. "Roy Henry Vickers." *The Canadian Encyclopedia.* Updated May 23, 2018. https://www.thecanadianencyclopedia.ca/en/article/roy-henry-vickers.

Skwachàys Lodge & Gallery. "Killer Whale." Accessed February 12, 2022. https://gallery.urbanaboriginal.org/killerwhale.html.

Smith, Janet. "Haida Artist James Hart wins $100,000 Audain Prize for Visual Art." *Stir*, November 8, 2021. https://www.createastir.ca/articles/audain-prize-jim-hart.

Spirit Gallery. "Dixon, Pat." Accessed February 12, 2022. https://spirit-gallery.com/native-artist/pat-dixon/.

———. "Smith, Russell." Accessed March 13, 2022. https://spirit-gallery.com/native-artist/russell-smith/.

Spirits of the West Coast Art Gallery. "Haida Argillite Carvings." Accessed March 24, 2022. https://spiritsofthewestcoast.com/collections/haida-argillite-carvings.

———. "Kevin Daniel Cranmer." Accessed March 17, 2022. https://spiritsofthewestcoast.com/en-us/collections/kevin-daniel-cranmer.

Stanbridge, Nicole, Dylan Thomas, Rande Cook, Francis Dick, and lessLIE. *Urban Thunderbirds.* Victoria, BC: Art Gallery of Greater Victoria, 2013. Exhibition catalog.

Stanley Park. "Beaver Crest Totem Pole in Stanley Park, Vancouver, BC, Canada." Accessed April 2, 2022. https://stanleyparkvan.com/stanley-park-van-attraction-totem-pole-beaver-crest.html.

Steinbrueck Native Gallery. "Tom Hunt." Accessed March 17, 2022. https://steinbruecknativegallery.com/tom-hunt/.

———. 2022. "Ron Telek." Accessed March 22, 2022. https://steinbruecknativegallery.com/ron-telek/.

Stewart, Hilary. *Looking at Indian Art of the Northwest Coast.* Seattle: University of Washington Press, 1979.

Stonington Gallery. "Andrea Wilbur-Sigo." Accessed March 30, 2022. https://stoningtongallery.com/artist/andrea-wilbur-sigo/#bio.

———. "Doug LaFortune." Accessed March 22, 2022. https://stoningtongallery.com/artist/doug-lafortune/#bio.

———. "Douglas David." Accessed March 22, 2022.https://stoningtongallery.com/artist/douglas-david/#bio.

———. "Greg Colfax." Accessed March 24, 2022.https://stoningtongallery.com/artist/greg-colfax/#bio.

———. "Maynard Johnny Jr." Accessed March 26, 2022.https://stoningtongallery.com/artist/maynard-johnny/#bio.

———. "Manuel Salazar." Accessed March 30, 2022.https://stoningtongallery.com/artist/manuel-salazar/#bio.

———. "Qwalsius—Shaun Peterson." Accessed March 26, 2022.https://stoningtongallery.com/artist/shaun-peterson/#bio.

———. "Stan Hunt." Accessed March 22, 2022. https://stoningtongallery.com/artist/stan-hunt/#bio.

Szeto, Winston. "Late Chief Delgamuukw Helped Transform Canada's Legal System and Recognition of Indigenous Rights." *CBC*, January 13, 2022. https://www.cbc.ca/news/canada/british-columbia/gitxsan-hereditary-chief-delgamuukw-death-1.6313183.

Thom, Ian M. *Challenging Traditions: Contemporary First Nations Art of the Northwest Coast*. Vancouver: Douglas & McIntyre; Seattle: University of Washington Press, 2009. Exhibition catalog, McMichael Canadian Art Collection.

Townsend-Gault, Charlotte. "Northwest Coast Art: The Culture of the Land Claims." *American Indian Quarterly* 18, no. 4 (1994): 445–67. https://doi.org/10.2307/1185391.

Townsend-Gault, Charlotte, Jennifer Kramer, and Ḳi-ḳe-in. *Native Art of the Northwest Coast: A History of Changing Ideas*. Vancouver and Toronto: UBC Press, 2013.

U'Mista Cultural Centre. "Bruce Alfred." Accessed March 8, 2022. https://www.umista.ca/pages/bruce-alfred.

———. "The History of the Potlatch Collection." Accessed March 24, 2022.https://www.umista.ca/pages/collection-history.

University of Victoria Legacy Art Galleries. Online collection database.https://collectionlegacy.uvic.ca/. Accessed May 24, 2022.

Valaskakis, Gail Guthrie, Madeleine Dion Stout, and Éric Guimond. *Restoring the Balance: First Nations Women, Community, and Culture*. Winnipeg: University of Manitoba Press, 2009.

Vickers, Roy Henry. "Artist Biography." Accessed March 20, 2022. https://royhenryvickers.com/pages/artist-biography.

Walsh, Andrea N. "Honouring Place, Honouring Self: The Art of Francis Dick in Retrospective." University of Victoria Legacy Art Galleries/Maltwood Art Museum and Gallery. March 15, 2000. https://legacy.uvic.ca/gallery/wp-content/uploads/2000/04/Catalogue.pdf.

Washbern, Dorothy. "Douglas David—Curator's Choice Spring 2021." *Coastal Peoples*, April 18, 2021. https://coastalpeoples.com/2021/04/18/douglas-david-curators-choice-spring-2021/.

Watson, Scott, and Lorna Brown. *Lalakenis/All Directions: A Journey of Truth and Unity*. Vancouver: Morris and Helen Belkin Art Gallery, 2016. Exhibition catalog.

Welcome Figure (website). "About." Accessed April 02, 2022. https://www.welcomefigure.net/about.

Wright, Robin Kathleen. *Northern Haida Master Carvers*. Vancouver: Douglas & McIntyre; Seattle: University of Washington Press, 2001.

Wyatt, Gary. *Seekers and Travellers: Contemporary Art of the Pacific Northwest Coast*. Seattle: University of Washington Press, 2012.

———. *Mythic Beings: Spirit Art of the Northwest Coast*. Vancouver: Douglas & McIntyre; Seattle: University of Washington Press, 1999.

———. *Spirit Faces: Contemporary Masks of the Northwest Coast*. Vancouver: Douglas & McIntyre, 1994.

Wyatt, Gary, ed. *Susan Point: Coast Salish Artist*. Seattle: University of Washington Press, 2000. With essays by Michael Kew, Peter Macnair, Vesta Giles, and Bill McLennan.

Zaunscherb, Samantha. "Simon Charlie." Coastal Peoples Fine Art Gallery. June 9, 2019. https://coastalpeoples.com/artists/simon-charlie/.

Index of Artists

The artists below are represented in the George and Colleen Hoyt Collection as of 2022. Those who were included in the *Legacy: Tradition and Innovation in the 1970s Northwest Coast Indian Art* book published by the Royal British Columbia Museum in 1984 (discussed in the essay) are indicated for reference purposes.

Bruce Alfred (b. 1950) Kwakwaka'wakw [*Legacy*] (see page 114)

Eugene Alfred (b. 1970) Northern Tutchone/Tlingit

Wayne Alfred (b. 1958) Kwakwaka'wakw (see page 160)

Patrick Amos (b. 1957) Nuu-chah-nulth

Rylan Amos (b. 1977) Hesquiaht/Nuu-chah-nulth

Stan Bevan (b. 1961) Tahltan-Tlingit/Tsimshian

Jim Blaney (1925–1995) Coast Salish/Homalco

Dempsey Bob (b. 1948) Tahltan-Tlingit [*Legacy*] (see page 92)

David A. Boxley (b. 1952) Tsimshian (see page 132)

Gene Brabant (b. 1946) Cree

Jennifer Brady-Morales (1952–2010) Tlingit/Tsimshian

Lyle Campbell (b. 1969) Haida (see page 192)

Kelly Cannell (b. 1982) Coast Salish/Musqueam

Thomas Cannell (b. 1980) Coast Salish/Musqueam

Frank Charlie (b. 1952) Nuu-chah-nulth/Tla-o-qui-aht

Jim Charlie (b. 1967) Coast Salish/Squamish

Simon Charlie (1919–2005) Coast Salish/Cowichan [*Legacy*] (see page 42)

Alvin Child (b. 1962) Haida

Greg Colfax (b. 1948) Makah (see page 96)

Rande Cook (b. 1977) Kwakwaka'wakw

Todd Couper (b. 1974) Māori

Doug Cranmer (1927–2006) Kwakwaka'wakw [*Legacy*] (see page 60)

Kevin Cranmer (b. 1967) Kwakwaka'wakw (see page 184)

Douglas David (b. 1971) Nuu-chah-nulth/Dakota/Sioux (see page 194)

Joe David (b. 1946) Nuu-chah-nulth [*Legacy*] (see page 82)

Claude Davidson (1924–1991) Haida (see page 54)

Reg Davidson (b. 1954) Haida [*Legacy*] (see page 142)

Robert Davidson (b. 1946) Haida [*Legacy*] (see pages 86)

Sara Davidson (b. 1973) Haida/Settler

Sammy Dawson (b. 1976) Kwakwaka'wakw

Andrew Dexel (b. 1982) Interior Salish/Nlakapamux

Beau Dick (1955–2017) Kwakwaka'wakw [*Legacy*] (see page 150)

Francis Dick (b. 1959) Kwakwaka'wakw (see page 170)

Simon Dick (b. 1951) Kwakw<u>aka</u>'wakw (see page 126)

Freda Diesing (1925–2002) Haida [*Legacy*] (see page 56)

Pat Dixon (1938–2015) Haida [*Legacy*] (see page 72)

Wayne Edenshaw (b. 1967) Haida (see page 188)

Andy Everson (b. 1972) Coast Salish/K'ómoks/Kwakw<u>aka</u>'wakw (see page 196)

Charles George Jr. (1910–1982) Kwakw<u>aka</u>'wakw [*Legacy*] (see page 40)

John Goodwin (a.k.a. Nytom) (b. 1948) Makah

Phil Gray (b. 1953) Cree/Tsimshian

Stan Greene (b. 1953) Niimíipuu/Semiahmoo/Stó:lō

Charles B. Greul (1921–2000) Canadian, non-Indigenous

Ron Hamilton (a.k.a. Ḳi-ḳe-in) (b. 1948) Nuu-chah-nulth [*Legacy*] (see page 98)

Walter Harris (1931–2009) Gitxsan [*Legacy*] (see page 64)

Jim Hart (b. 1954) Haida [*Legacy*] (see page 146)

Bill Henderson (b. 1950) Kwakw<u>aka</u>'wakw

Mark Henderson (1953–2016) Kwakw<u>aka</u>'wakw

Barry Herem (b. 1941) American, non-Indigenous

Francis Horne Sr., (b. 1954) Coast Salish/Lummi/Tsawout

John Hudson (b. 1967) Tsimshian

George Hunt Jr. (b. 1958) Kwakw<u>aka</u>'wakw (see page 162)

Tony Hunt Jr. (1961–2017) Kwakw<u>aka</u>'wakw (see page 172)

Tony Hunt Sr. (1942–2017) Kwakw<u>aka</u>'wakw [*Legacy*] (see page 78)

Calvin Hunt (b. 1956) Kwakw<u>aka</u>'wakw [*Legacy*] (see page 156)

Henry Hunt (1923–1985) Kwakw<u>aka</u>'wakw [*Legacy*] (see page 50)

John Henry Hunt (b. 1974) Kwakw<u>aka</u>'wakw

Richard Hunt (b. 1951) Kwakw<u>aka</u>'wakw [*Legacy*] (see page 128)

Stan Hunt (b. 1954) Kwakw<u>aka</u>'wakw (see page 148)

Tom Hunt (b. 1964) Kwakw<u>aka</u>'wakw (see page 176)

Norman Jackson (b. 1957) Tlingit

Robert Jackson (b. 1948) Gitxsan [*Legacy*] (see page 102)

George James Sr. (b. 1948) Kwakw<u>aka</u>'wakw

Phil Janzé (1950–2016) Gitxsan [*Legacy*] (see page 116)

Maynard Johnny Jr. (b. 1973) Coast Salish/Kwakw<u>aka</u>'wakw/Penelakut (see page 198)

Floyd "Tyee" Joseph (b. 1953) Coast Salish/Squamish (see page 138)

Stan Joseph (b. 1950) Coast Salish/Squamish

David Mungo Knox (b. 1974) Kwakw<u>aka</u>'wakw

John Laford (1954–2021) Ojibwe

Doug LaFortune (b. 1953) Coast Salish/Tsawout/Lummi (see page 140)

James Lewis (Dates unknown) Tahltan-Tlingit/Tsimshian

Gerry Marks (1949–2020) Haida [*Legacy*] (see page 110)

Mungo Martin (1881–1962) Kwakw<u>aka</u>'wakw [*Legacy*] (see page 38)

Ned Matilpi (b. 1957) Kwakw<u>aka</u>'wakw/Tlingit

Clarence Mills (b. 1958) Haida

Ken Mowatt (b. 1944) Gitxsan

Earl Muldoe (1936–2022) Gitxsan [*Legacy*] (see page 70)

Rocky O'Brien (Dates unknown) Tsimshian

Marvin Oliver (1946–2019) Isleta Pueblo/Quinault

Eric Parnell (b. 1961) Haida

Duane Pasco (b. 1932) American, non-Indigenous

Tim Paul (b. 1950) Hesquiaht/Nuu-chah-nulth [*Legacy*] (see page 120)

Shaun Peterson (a.k.a. Qwalsius) (b. 1975) Coast Salish/Puyallup (see page 200)

Susan Point (b. 1952) Coast Salish/Musqueam (see page 134)

Jack Pollard (b. 1960) Haida

Mark Preston (b. 1960) Tlingit

Heber Reece (b. 1955) Tsimshian

Bill Reid (1920–1998) Haida [*Legacy*] (see page 46)

Christina Roberts (Dates unknown) Kwakwaka'wakw

Larry Rosso (1944–2006) Carrier (see page 80)

Manuel Salazar (b. 1966) Coast Salish/Cowichan(see page 182)

Ryan Scoular (b. 1984) Kwakwaka'wakw

Gerry Sheena (b. 1964) Interior Salish (see page 178)

Dwayne Simeon (b. 1960) Kwakwaka'wakw/Squamish

Jay Simeon (b. 1976) Blackfeet/Haida

Don "Lelooska" Smith (1933–1996) Cherokee descent (see page 68)

Fearon Smith, Jr. (a.k.a. Tsungani) (b. 1948) Cherokee descent

Russell Smith (1950–2011) Kwakwaka'wakw [*Legacy*] (see page 124)

Steve Smith (b. 1968) Kwakwaka'wakw

Terry Starr (b. 1951) Tsimshian

Vernon Stephens (b. 1949) Gitxsan [*Legacy*] (see page 112)

Moy Sutherland (b. 1974) Nuu-chah-nulth/Tla-o-qui-aht

Isaac Tait (1965–2000) Nisga'a (see page 180)

Norman Tait (1941–2016) Nisga'a [*Legacy*] (see page 74)

Russell Tate (b. 1966) Ditidaht/Nuu-chah-nulth

Ron Telek (1962–2017) Nisga'a (see page 174)

Dylan Thomas (b. 1986) Coast Salish/Lyackson First Nation

Art Thompson (1948–2003) Ditidaht/Nuu-chah-nulth [*Legacy*] (see page 106)

Roi Toia (b. 1966) Nga Puhi (Māori)

Roy Henry Vickers (b. 1946) Tsimshian (see page 90)

Sean Whonnock (b. 1966) Kwakwaka'wakw

Andy Wilbur-Peterson (b. 1955) Coast Salish/Skokomish (see page 154)

Andrea Wilbur-Sigo (b. 1975) Coast Salish/Squaxin Island (see page 202)

Francis Williams (1936–2003) Haida

Sanford Williams (b. 1967) Mowachaht/Nuu-chah-nulth

Joseph M. Wilson (b. 1967) Coast Salish/Cowichan (see page 190)

Lyle Wilson (b. 1955) Haisla

Don Yeomans (b. 1958) Haisla/Haida [*Legacy*] (see page 166)

Wayne Young (1958–2012) Nisga'a/Haida

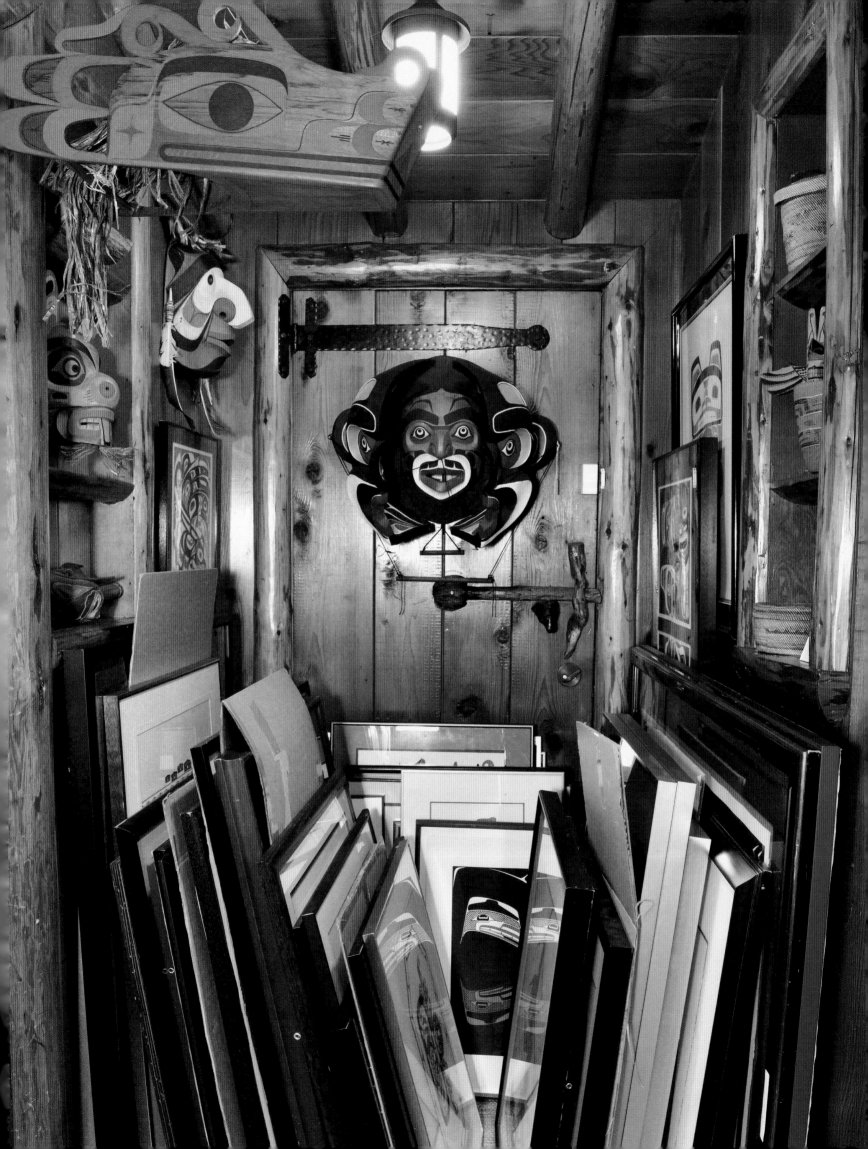

Rebecca J. Dobkins is Curator of Indigenous art at the Hallie Ford Museum of Art and Professor of Anthropology at Willamette University, where she has taught since 1996. She has curated over two dozen exhibitions and authored several related books, including *Crow's Shadow Institute of the Arts at 25* (Hallie Ford Museum of Art, 2017). Her book, *The Art of Ceremony: Voices of Renewal from Indigenous Oregon*, which grew out of an earlier exhibition project with all of the federally recognized tribes in Oregon, will be published by the University of Washington Press in fall 2022.

Tasia D. Riley is a research assistant at the Hallie Ford Museum of Art and received her B.A. in Anthropology and Archaeology from Willamette University in 2021. Tasia's contributions to this volume include the compilation of artist biographies and selected object descriptions. Tasia is interested in decolonization efforts and cultural resource management. She is of Tlingit, Filipino, and Irish background.

TRANSFORMATIONS: The George and Colleen Hoyt Collection of Northwest Coast Art was organized by the Hallie Ford Museum of Art at Willamette University in Salem, Oregon. The exhibition was held from September 17 to December 17, 2022. Financial support for the exhibition and book was provided by funds from the George and Colleen Hoyt Northwest Coast Native Art Fund; by an endowment gift from the Confederated Tribes of Grand Ronde, through their Spirit Mountain Community Fund; by gifts from several anonymous donors through the HFMA Exhibition Fund; by advertising support from the *Oregonian*/Oregon Live; and by general operating support grants from the City of Salem's Transient Occupancy Tax funds and the Oregon Arts Commission.

Designed by Phil Kovacevich

Copyedited by Nick Allison

Photography by Frank Miller, unless otherwise noted.

Photographs by Dale Peterson: frontispiece, pp. 15, 17, 204, and 214

Printed in the United States by Shapco Printing, Minneapolis, Minnesota.

Front cover: David A. Boxley (Tsimshian, b. 1952) *Legend Adaox*, 1988. Ash, alder, paint; 26½ × 25 × 6 in. Collection of George and Colleen Hoyt 1

Page 7: Susan Point (Musqueam/Coast Salish, b. 1952) *Beyond the Edge*, 2015. Silkscreen; 31 × 31 in. Ed. 37/110 Collection of George and Colleen Hoyt 379

Page 9: Phil Janzé (Gitxsan, 1950–2016) *Bear Mask*, twentieth century. Wood, paint, leather, human hair; 11½ × 8 × 7½ in. Collection of the Hallie Ford Museum of Art, Salem, Oregon, 2016.004 The George and Colleen Hoyt Northwest Coast Indigenous Art Fund

Back cover: Richard Hunt (Kwakwa̱ka̱'wakw, b. 1951) *Baby Red Snapper*, 2006. Wood, paint; 16 × 24 × 12 in. Collection of George and Colleen Hoyt 566

On the hardcover: Robert Davidson (Haida, b. 1946) *Southeast Wind*, 2004. Silkscreen; 60 × 40 in. Ed. 47/83 Collection of George and Colleen Hoyt 443

Library of Congress Control Number: 2022913505

ISBN: 9781930957855